D0112054

PERSPECTIVE
FOR ARTISTS

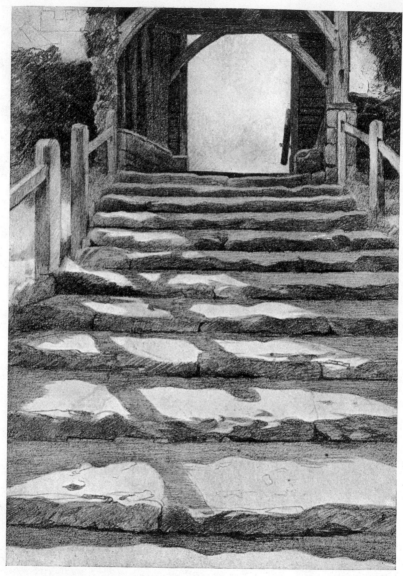

A LYCH GATE

PERSPECTIVE FOR ARTISTS

THE PRACTICE & THEORY OF PERSPECTIVE AS
APPLIED TO PICTURES, WITH A SECTION
DEALING WITH ITS APPLICATION
TO ARCHITECTURE

BY

REX VICAT COLE

ILLUSTRATED BY 436 DRAWINGS & DIAGRAMS
BY THE AUTHOR & 36 PICTURES
CHIEFLY BY OLD MASTERS

DOVER PUBLICATIONS, INC.

NEW YORK

Published in Canada by General Publishing
Company, Ltd., 30 Lesmill Road, Don Mills,
Toronto, Ontario.
Published in the United Kingdom by Constable
and Company, Ltd., 10 Orange Street, London WC 2.

This Dover edition, first published in 1976, is
an unabridged and unaltered republication of the
work originally titled *Perspective* and published by
Seeley, Service & Co., Ltd., London, in 1921. The
present edition is published by special arrangement
with Seeley, Service & Co.

International Standard Book Number: 0-486-22487-2
Library of Congress Catalog Card Number: 77-157431

Manufactured in the United States of America
Dover Publications, Inc.
180 Varick Street
New York, N.Y. 10014

PREFACE

IN our Art School days we looked upon Perspective with grave suspicion. We feared that cobwebbed in those entanglements of line there lurked our old enemies, Euclid and Geometry. My own distrust has never been wholly dispelled ; for which reason, out of sympathy for a new generation of art students, I have tried to set down the matter in plain words and to divest it of some problematical exercises dear only to the mathematical mind. These, in truth, sometimes lead to a negative result—the " which is impossible " of Euclid—or they have but little bearing on our art. Dr. Johnson has said : " Long calculations or complex diagrams affright the timorous and inexperienced from a second view, but if we have skill sufficient to analyse them into simple principles, it will be discovered that our fear was groundless."

A knowledge of Nature's perspective is essential to the artist. Her laws are not difficult to understand if they are taken one at a time, together with an explanation of the reasoning on which they are based.

This is the method which I have followed in Part I. With the aid of some common sense on the part of the reader, it should be sufficient for all ordinary purposes.

It is, however, necessary, in dealing with the drawing of architectural details, to resort to some elaboration—elevations and ground plans must be used ; expedients for simplifying the work here come into play. In order to prevent these seeming to confuse the issue they have been kept together in Part III.

I have known students to attend a course of well-delivered lectures on Perspective and yet say they did not understand a single word of what the lecturer was talking about.

This confusion may arise from the fact that some knowledge of geometry has been taken for granted by the lecturer ; or because ground plans, station points, and a host of intricacies are commonly used as the starting-point for the building up of the object to be

drawn, instead of the object being first sketched and then put into correct perspective. The former method often leads to a most ungainly representation of cubes and circles that cannot but repel the student instead of interesting him from the very beginning.

In most fine pictures which have stood the test of time, one sees a keen appreciation of the possibilities of perspective. As the struggles of the early masters in formulating the science are full of interest, I have tried in Part II to tell the tale of Perspective as we see it in the works of the great old painters. It is told of an early Italian painter that to his long-suffering wife's entreaty not to burn the midnight oil he simply murmured, " Oh, this perspective—this beautiful perspective." No doubt he had just discovered a new vanishing point.

Although in our day few discoveries remain to be made in the science, several deductions might gain by revision ; and we can present the principles in a simple form. This being my aim I have cribbed without a blush from the teaching of my old friend, L. A. Pownall, and I hope I have remembered verbatim some of the expositions which he so pithily expressed.

I have also referred to my well-thumbed copy of Cassagne's " Practical Perspective " and Wyllie's " Laws of Nature "—which affords delightful reading. More recently I have profited by the work of the late G. A. Storey, Professor of Perspective at the Royal Academy, and by Middleton's architectural essays on " The Principles of Architectural Perspective."

CONTENTS

PART I

NATURE'S PERSPECTIVE AS SEEN AND USED DAILY BY PAINTERS

LIST OF ILLUSTRATIONS

PERSPECTIVE
FOR ARTISTS

PART I

NATURE'S PERSPECTIVE AS SEEN AND USED DAILY BY PAINTERS

CHAPTER I

THE PRINCIPLE OF PERSPECTIVE IN THEORY

" If you do not rest on the good foundation of nature, you will labour with little honour and less profit."—LEONARDO DA VINCI.

LINEAR Perspective is a study that deals with the appearance of objects[1] as regards their size and the direction of their lines seen at varying distances and from any point of view. When practising it we are not concerned with their apparent changes of colour or tone, though those also help us to recognise the distance separating us, or that of one object from another.

Visual rays.—The Theory of Perspective is based on the fact that from every point of an object that we are looking at, a ray of light

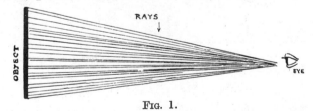

FIG. 1.

is carried in a straight line to our eye.[2] By these innumerable rays we gain the impression of that object (Fig. 1).

[1] " Objects " is a mean word to use, because perspective laws also apply to the surface of the earth, the sea, and the sky, and all living things. It is used for convenience.

[2] We see objects at a different angle according to whether we have both eyes open, the left shut, or the right shut. When drawing objects very close at hand look with one eye only.

Tracing on glass.—If we look at an object through a sheet of glass we can trace on that glass the apparent height or width of that object (Fig. 2); in other words, we can mark off on the glass those

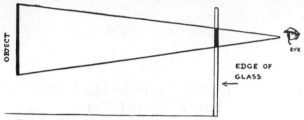

FIG. 2.—Upright sheet of glass, object, and eye; showing the rays from the extremities of the object passing through the glass and marking its height on it.

points where the rays from the extremities of the object on the way to our eye pass through it.

Height of objects at varying distances traced on glass.—If we now place two objects of similar height one behind the other (Fig. 3) our tracing of each discovers the one farthest off to appear on the glass shorter than the one close at hand. Fig. 3 makes it evident

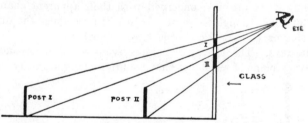

FIG. 3.—Side view (i.e. elevation) of posts, an upright glass, and painter's eye.

that this apparent difference in size is due to the fact that the converging rays from the further object have the longest distance to travel, and so are nearly together where they pass through the glass. On the other hand, the rays from the object close to the glass have only just started on their journey and so are still wide apart.

Width of objects traced.—Let us repeat the experiment with two pencils of equal length lying on a flat surface, one behind the other. We shall be satisfied that their apparent length, as traced on the

glass (Fig. 4), is also determined by these rays, and that the near one looks longer than the distant one.

We have seen that the height and width of objects as they appear to us is determined by the converging rays from their extremities to our eye ; that objects really equal in size appear shorter and narrower when further away.

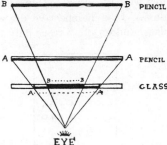

FIG. 4.—Two pencils, glass, and eye, as seen from above (i.e. ground plan).

Depths of objects on a level surface traced.—It only remains to find out that the depths on a receding surface are governed by the same laws.

Fig. 5 represents three pinheads in a row, one behind the other, on the far side of the glass from the position of the eye. Notice, however, that the eye is above the pins (i.e. looking down on them),

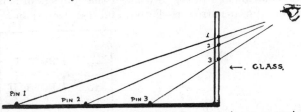

FIG. 5.—Side view (i.e. elevation) of the painter's eye, an upright glass, and a level board on which three pins are equally spaced.

and so the points where their rays cut the glass are one above the other in regular order, the nearest pin (3) appearing the lowest down on the glass.

Since the pins were placed at equal distances apart, their spacing, as shown on the glass, would also fix the depths of the ground surface between them (Fig. 6).

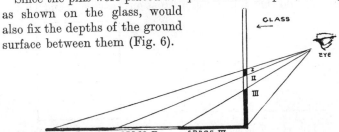

FIG. 6.—Same as Fig. 5, showing the spaces between the pins and as they appear on the glass.

Theory of tracing applied to measurements on a canvas.—Up to now we have supposed ourselves tracing objects through a sheet of glass. In a perspective drawing our canvas is supposed to be a glass, and on it we trace only those objects that we can see through

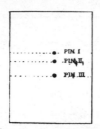

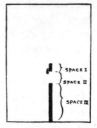

FIG. 7.—The glass (as in Fig. 5) with the pins traced on it, seen full-face.

FIG. 8.—The glass (as in Fig. 6) showing the spaces traced on it.

it without moving our heads. But painters should be practical; so set up a canvas and prove to yourself that objects of equal size when far off appear narrower, shorter, and less deep than the near

FIG. 9.—Posts the same height, one behind the other.

FIG. 10.—Front view of canvas. Posts marked on edge and carried across to required position.

ones, and that the spaces between them undergo a corresponding reduction. To do this, follow the instructions in Figs. 9 and 11.

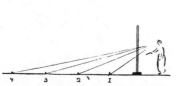

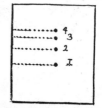

FIG. 11.—Four nails evenly spaced.

FIG. 12.—Front view, showing nails marked on edge of canvas and carried across to required position.

Fig. 9. Be yourself the " Painter." See that your canvas is vertical and so placed that the posts are just visible at one edge. With one eye shut and head still, mark off the heights of the posts where they seem to touch the canvas.

Fig. 11. Behave as in the last exercise ; tick off the position of each nail on the edge of the canvas.

These nails might represent the cracks between floor-boards, and our drawing shows that each board would appear one above the other (Fig. 13), necessarily narrower from No. 1 the nearest to 4 the farthest away.

Fig. 13.

Theory of tracing to explain why parallel receding lines appear to meet.—Some people, when looking down a long straight length of railway track, have been curious to understand why the lines appear to get narrower and finally to meet in the far distance, though they know that the lines are actually parallel.

It can be explained by tracing in this way—Fig. 14 shows that a piece of the railway line on the glass would appear as an upright line, the near end of the line being the lowest on the glass.

The tracing on the glass would look like this (Fig. 15).

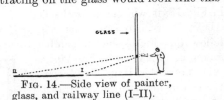

Fig. 14.—Side view of painter, glass, and railway line (I–II).

Fig. 15.

Fig. 16 shows how wide the near and far part of the track respectively would look on the glass, so that a front view of the glass (Fig. 17) would be like this.

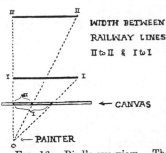

Fig. 16.—Bird's-eye view. The dots on the glass showing where the rays pass through it.

Fig. 17.

(In Fig. 14 we proved that the far end of the rail appeared higher up on the glass than the near end.)

As we have secured the width of a piece of the track at its near

FIG. 18.

and far end, we can join the ends on each side to make the rails. The tracing on the glass (Fig. 18) shows the rails getting closer and closer as they recede, and we see that they would, if longer, appear to meet. The spot on the glass where the receding lines appear to end

FIG. 19.

(or meet) is at the same level as your eye (Fig. 19).

The trace of a level receding surface seen from below.—In former

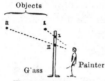

FIG. 20.—Two objects (I, II) above the painter's eye, with their position as seen through the glass.

exercises we have had our eye higher than the objects we traced (so that we looked down on them) and the near objects became the lowest on the glass, as in Figs. 4 and 5. The reverse happens when our eye is lower than the object (Fig. 20).

Let us again draw our piece of railroad as in Fig. 18, it will serve as the floor of a room. Above it we can draw the ceiling if we still follow out Fig. 4, but remember to make the

far end *below* the near end, as explained in Fig. 20.

Our drawing (Fig. 21) shows that if we look *down* on level surfaces their receding lines must be drawn running up the canvas (from their near end to their far end). On the other hand, if we see their under side the lines must be made to run down the canvas as they recede.

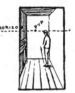

FIG. 21.

AN EXPLANATION OF TERMS USED IN PERSPECTIVE

THE HORIZON

The visible horizon in Nature is that immense and distant circle

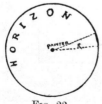

FIG. 22.

that appears to be the extremity of our globe. Perched on a masthead we could, by moving round, examine the far distance where the sky and sea seem to meet, until piece by piece the whole circumference had come under our scrutiny (Fig. 22). On land we rarely get anything but an interrupted view of a portion of the horizon.

When standing or sitting on flat land the surface between us and the distant horizon is so foreshortened that mere hedges and bushes may hide miles of country and blot out the horizon.

From a hill-top we look down upon the flat land, and the former

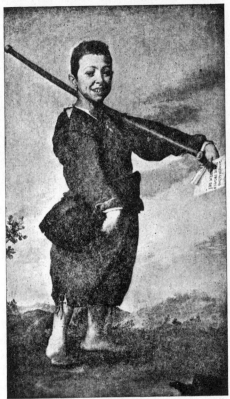

Illus. I. *Ribera. (Photo Mansel.)*
THE CLUBBED FOOT.
Example of a low horizon.

narrow strip between us and the horizon looks deeper ; also from this height we see more distant land.

If the sea forms the boundary of our view the tips only of ship's masts may be seen beyond the apparent meeting of sky and sea. This explains that the curvature of the earth between us and the horizon is a real consideration for the landscape and sea painter,

and it provides a reason for our seeing more distance from a height than from a slight rise.

The horizon on our picture.—Though the horizon in Nature is a curved line, it is usual in pictures to represent it as perfectly level and straight ; the reason being that we can only see a small stretch of so large a circle at one time without moving our heads (Fig. 23).

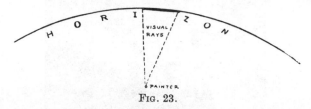

FIG. 23.

We draw this level line of the horizon straight across our picture. It is a matter of artistic taste and judgment whether we place it low, high, or in the centre of our canvas. It is essential, however, to understand that the position of the horizon line in relation to all the objects in our picture affords evidence of how high up we ourselves were when painting the scene. For instance, if we stand while we paint a whole length figure (on level ground) the horizon

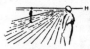 line would be cut by the head of our portrait (Fig. 24). But if we sit to paint him then the horizon line will pass through his waist (Fig. 25), 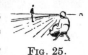 and we should get a more fore-

FIG. 24.

FIG. 25.

shortened view of the floor. It would be an absurd proceeding to begin a painting of an imaginary scene without first fixing the place where you suppose yourself to be painting it from. The relative position of the horizon line and the principal figures or other objects must be decided on at the onset ; after that the locality and size of all additional objects will be governed by the horizon.

When you are painting an actual scene, you will draw the horizon line, whether it is visible or not in Nature, on your picture as soon as you have decided on the size of the principal objects. The horizon in Nature will be at the exact height of your eye, i.e. at that height where neither the upper nor lower surface of a level board (but only its near edge) would be visible.

We may consider the horizon as a distant imaginary line parallel to the front of our face and stretching across the view at the actual

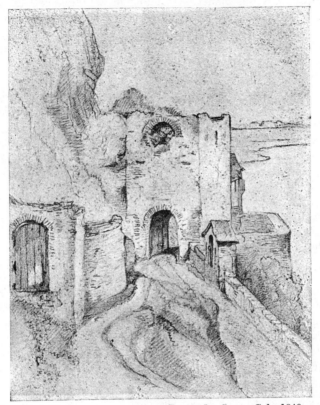

Illus. II. *Drawn by George Cole,* 1840.

COCHEM, ON THE MOSELLE.

Example of a high horizon.

height that our eye is from the ground[1] (Illus. II, III) ; so if stand-

ing in a room our horizon would be roughly
5 ft. 6 in. from the floor (Fig. 26), or if we
are sitting 3 ft. 6 in. (Fig. 27).

If our model is standing on a throne and

Fig. 26. we sit to paint on a low stool, our horizon is Fig. 27.

about the level of his feet. Out of doors a slight rise on other-
wise level ground would present a similar effect (see Illus. I).

In a room we can find the horizon by measuring the height of our
eye from the ground and chalk-marking that height on the wall
facing us. Out of doors on hilly ground a stick with the height of
our eye marked on it can be stuck in the ground just in front of us ;
where that mark cuts the view will be the horizon.

Note.—Michael Angelo de Carravaggio in his picture, " Christ
carried to the tomb," used so low a horizon that no space of ground
is seen between the standing figures, their feet being all on a hori-
zontal line. Rubens painted his " Henry IV setting out for the
war in Germany " with the spectator's eye level with the waist of
the figures ; thus making the figures important though they occupy
only half the height of the canvas, and leave room for the full height
of the columns and archways overhead. Leonardo da Vinci con-
ceived his picture, " The Virgin, Saint Anne, and the Infant Jesus,"
as though the spectator's eye was at the level of the seated figure ;
but he chose to place the latter high up on the canvas. In this way
the horizon, though a low one, is actually three-quarters of the way
up the canvas. These examples should clear up any confusion in
regard to the position of the horizon (representing the height of the
spectator's eye) in the scene to be painted, and its position on the
canvas.

The Principal Vanishing Point (" P.V.P.")

If you were to look down the barrel of a gun, holding it quite
level (Fig. 28), the point you aimed at would in
Perspective be called the Principal Vanishing Point
(P.V.P.), and it would be on that imagined line
that represents the horizon. It is the spot that a
level line running directly away from us tends to.

Fig. 28.

[1] " From the ground," more correctly " from the
sea-level " ; because if we went up a mountain to
see the view, the horizon would still be on a line
with our eye, so it would be the height of our eye
plus the mountain, Illustration III makes this clear.

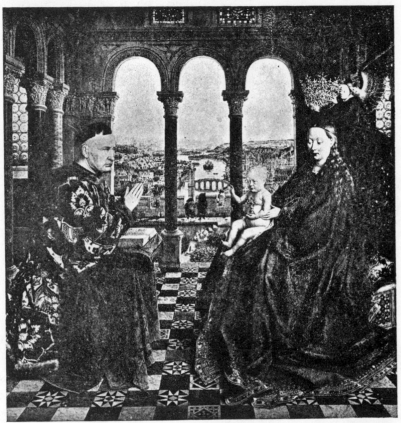

Illus. III. *Van Eyck.* (*Photo Mansel.*)

LA VIERGE AU DONATEUR.

The horizon (as shown by the distant view) passes behind the heads of the figures. The painter must also have been sitting, because if he had been standing his horizon would have been above their heads (see Chap. II). The lines of the pavements, capitals, and plinth of the columns all tend towards one spot on the horizon at its centre. For explanation of this, see Rules I, II, Chap. II. To obtain the depth of each tile, see end of Chap. II. The drawing of their pattern is explained in Chap. XVI.

A good example of this is seen in the line of the central row of the pavement in Van Eyck's picture (Illus. III).

In a composed picture we can place the P.V.P. where we like on the horizon, but we must remember that it represents the point immediately in front of us (Fig. 29) that we were supposed to be looking at. Theoretically it is half-way between one side of our picture and the other,[1] but this need not hamper us.

Fig. 29.—Back view of painter looking at his subject.

If you see on a picture the representation of what was in Nature a level receding line, drawn as a vertical line, then you will know that the far end of it points to the P.V.P. on the horizon, and that the painter was straight in front of that spot and looking at it (Fig. 30).

Fig. 30.

From this picture we know that the painter stood at his work, and looked straight down the line marked **X**.

The Station Point and Line of Sight

The term Station Point is used to designate that place where the painter stood or was supposed to stand (Fig. 29).

If you sat astride a very long straight level wall looking down it, then the far end of the wall would seem to end at the P.V.P., and

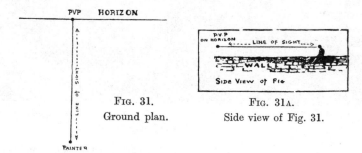

Fig. 31.
Ground plan.

Fig. 31A.
Side view of Fig. 31.

the spot you sat on would be the "station point," while the length between these would be the "line of sight" (Figs. 31 and 31A). This being so, we will in future call the station point "Painter."

[1] It is so placed in Van Eyck's picture just mentioned. The painter was over the central row of tiles, immediately facing the central arch (Illus. III)

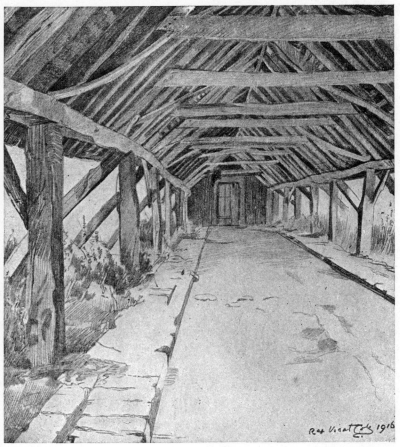

Illus. IV. *Drawing by the Author.*

A DRYING SHED IN A BRICKYARD.

Example of receding lines meeting at the P.V.P.

Vanishing Points

The P.V.P. is, as we have said, on the horizon and directly facing us. All level receding lines that are in Nature at right angles to the front of our face (i.e. parallel to our "line of sight") seem to steer to that P.V.P. (Illus. IV) as will be explained in Chap. II. But there are level lines in Nature placed at other angles than this, and they tend to other spots on the horizon (Illus. V). Each level line

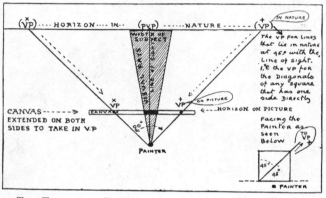

The Theory of Perspective explained by a Diagram.

Fig. 32.—A bird's-eye view of the horizon, canvas, painter, and three vanishing points in Nature and on the canvas. It will be seen from this diagram that the distance along the horizon in Nature, from the P.V.P. to the V.P. for the diagonals of a square, is the same, as from the P.V.P. to "painter"; consequently (as the diagram proves) the distance along the horizon on the picture, from P.V.P. to V.P. for diagonals, is the same as from P.V.P. to "painter." From this we learn that the V.P. for the diagonals of a square (provided that one side of the square is parallel to the horizon) is the same distance from the P.V.P. as the painter is from his canvas.

(or set of parallel lines) has its own V.P. to which it runs. Besides these level lines there are others on inclined planes that run to vanishing points above or below the horizon, according to their position. Some of these level receding lines will be at such an angle that the points they run to will be further to the left or right than the width of ground we propose to paint, and consequently will be outside the extremities of our picture as V.P.+ in Fig. 32). As for some of the inclined planes, the lines of these will sometimes tend

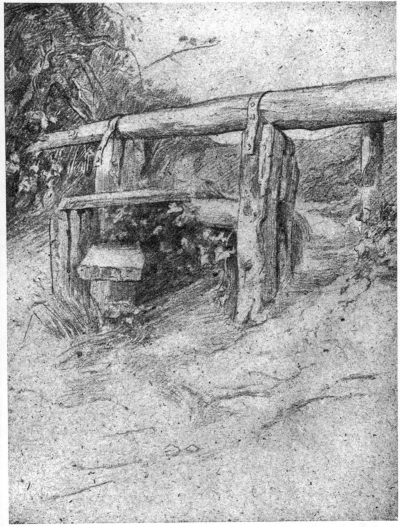

Illus. V. *Drawing by the Author.*
 A STILE.
 Lines receding to three separate V.P.'s on the horizon.

to points far above or below that portion of the ground or sky we wish to include in our picture. In practice we may draw the scene on a small scale in the middle of a large sheet of paper so as to have room for these outside V.P.'s on the margin. Then we can " square up " (see Note 1 in Appendix) the little picture and enlarge it on the selected canvas. Another way is to use the floor as an extension of your canvas.

CHAPTER II

THE RULES OF PERSPECTIVE AND THEIR APPLICATION

" Rules are to be considered as fences placed only where trespass is
expected."—SIR JOSHUA REYNOLDS.

RECEDING parallel lines.—We know that objects as they are
seen closer at hand appear to be successively larger than
others (of a similar size) that are further away. Test this state-
ment by holding a flat ruler in front of you, with one end nearer
to your face than the other, then the near end will
seem to be wider than the far end, as Fig. 33A
explains.

If you join the near and far end by straight
lines, one on either side (Fig. 33B), you will com-
plete your representation of the outline of the
ruler, and you will have satisfied yourself that FIG. 33A. FIG. 33B.
the width of the ruler at any particular point is determined by
the receding side lines. Again, if you continue those side lines
until they meet, you will appreciate the truth of Rule I.

RULE I.—ALL RECEDING LINES THAT ARE IN NATURE PARALLEL
TO ONE ANOTHER APPEAR (IF CONTINUED FAR ENOUGH) TO MEET AT
ONE AND THE SAME POINT (Fig. 34).

FIG. 34.

Receding level lines.—Now hold
the ruler with one end nearer to
you but *quite level* (as the surface
of water lies). Your
drawing of it in this
position will show that the point to which the sides
tend is at the same height from the ground as
your eye is ; in other words they would eventually
meet on the horizon (Fig. 35). This makes Rule II
easy to understand.

FIG. 35.

33

Receding lines that are parallel and level.

RULE II.—ALL RECEDING LEVEL LINES IN NATURE APPEAR (IF CONTINUED) TO END ON THE HORIZON. IF THEY ARE ALSO (IN NATURE) PARALLEL TO ONE ANOTHER (RULE I) THEY APPEAR TO MEET AT THE SAME SPOT ON THE HORIZON.

The gist of the matter is that because they (i.e. these particular receding lines) are in Nature parallel to one another (Rule I) they tend to the same spot, and if they happen to be level lines (Rule II) that spot *must* be on the horizon (Illus. IV, V, VI).

Level planes.—If you think of it, level planes must end at the horizon (not above or below it); because the horizon is at the height of your eye, and level surfaces are only visible so long as they are above or below your eye.

At the exact height of your eye you could not see either their upper or under surface but only their edge (Fig. 36).

Receding parallel lines inclined upwards.—Now tip up the far end of the ruler, without turning it to one side or the other, and you notice that the receding lines tend to a spot that is higher up than the former one, when the ruler was level (Fig. 37).

FIG. 36.

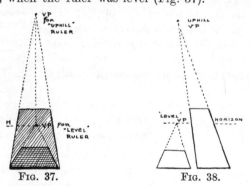

FIG. 37. FIG. 38.

This merely means that if the ruler is inclined upwards you see it less foreshortened, but your horizon remains the same height. It can be remembered by Rule III (see Figs. 37, 38; Illus. VII).

RULE III.—ALL RECEDING LINES THAT ARE IN NATURE PARALLEL TO ONE ANOTHER IF INCLINED UPWARDS APPEAR EVENTUALLY TO MEET AT A SPOT THAT IS IMMEDIATELY ABOVE THAT SPOT WHERE THEY WOULD HAVE MET IF THEY HAD BEEN LEVEL LINES.

Receding parallel lines inclined downwards.—If you tip the far end of the ruler downwards instead of up, just the reverse happens, and the spot to which the side lines tend will be below the horizon instead of above it; write Rule IV thus:

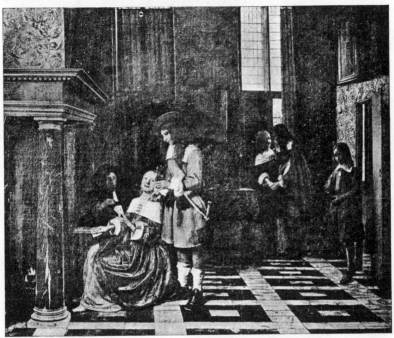

Illus. VI. *Pieter de Hooge.* (*Photo Mansel*).
 A DUTCH INTERIOR.

Lines of the sides of the room, and pavement meeting at the P.V.P. on the horizon. The horizon line cuts through the heads of the standing figures, showing that the painter was standing. The P.V.P. is just over the head of the woman showing her cards. So she was immediately opposite the painter, as we see by the lines of the pavement.

RULE IV.—ALL RECEDING LINES THAT ARE IN NATURE PARALLEL TO ONE ANOTHER IF INCLINED DOWNWARDS WOULD APPEAR (IF CONTINUED) TO MEET AT A SPOT IMMEDIATELY UNDER THAT SPOT WHERE THEY WOULD HAVE MET IF THEY HAD BEEN LEVEL LINES.

Of course, if you tip the far end of the ruler only a little downward you will still see its top side but very foreshortened (Fig. 40A);

if you tip it still further you will see the under side, and the spot
that the sides tend to will be still lower down.

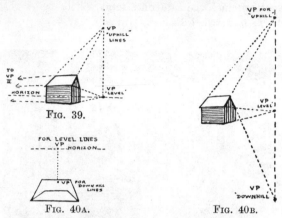

FIG. 39.

FIG. 40A. FIG. 40B.

Level receding lines pointing to the right or left.—It is obvious
that if you hold the ruler level but point it to the right—so that
one corner of it is nearest to your face—the side lines of it will tend
to a spot on the horizon on the right-hand side. You will, however,
notice the two ends (because they recede) also tend to a spot on
the left-hand side of the horizon (Fig. 41).

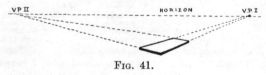

FIG. 41.

Note.—If the ruler points to the left side instead of the right, then
exchange the words "left" and "right" in the above paragraph.

Level lines receding to the principal vanishing point.—We have
learnt that all lines that are in Nature level, and receding, appear
to end somewhere on the horizon. If we stand
on a line that is running directly away from us,
such as the crack between two floor-boards, and
look down its length we shall find it tends to
the "principal vanishing point" on the horizon
(Fig. 42). At this P.V.P. the floor-board and
all other lines (in Nature) parallel to it—such as
the sides of the room—meet (see Illus. VIII).

FIG. 42.

If we were drawing such a room we should first mark on the far

wall itself a line showing the height of our eye (the horizon) as we
stand or sit at our easel. Then we should sketch in the proportions
of the room, including this horizon line.

The next step would be to put a pin in our drawing where the

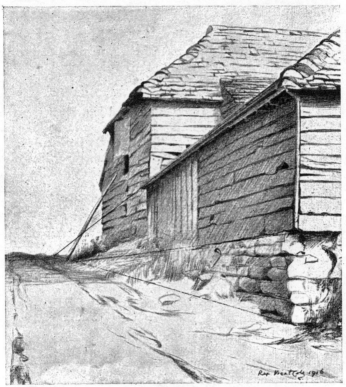

Illus. VII. *Drawing by the Author.*

THE BARN END.

The lines of the receding walls being parallel and level, meet at
one spot on the horizon (P.V.P.). The sides of the road would also
have met at the same spot if the road had also been level, but be-
cause it runs uphill its V.P. is above the horizon and immediately
over the P.V.P.

P.V.P. would come on the horizon, and with one end of a ruler
touching it, draw every line that in the room is parallel to the floor-
board (Fig. 43).

The end wall is directly facing us, and consequently not a receding

surface, so the lines, where the ceiling and floor touch it, are drawn parallel to the horizon line.

FIG. 43. FIG. 44.

Suppose we sketch the same room from a new position so that we look diagonally across the floor to the left-hand wall. The lines of the floor-boards will tend to a point on the right side of the horizon outside our picture. From this position the end wall becomes a receding surface (because one end is a bit nearer to us than the other), therefore the lines where the floor and ceiling meet it, will tend to a point far away on the left of the horizon.[1]

We make our drawing by first sketching the proportions of the room, including the horizon line. That done the direction of one floor-board is copied, and its line continued till it meets the horizon line. To that point of junction (V.P.) draw all lines that are (in the room) parallel to the floor-board. Then copy one of the receding lines of the end wall and continue it till it meets the horizon. Make all lines that are parallel to it in the room meet at that point. Rectangular objects, such as boxes, tables, etc., would of course be drawn in the same way.

USE OF RECEDING LINES TO FORM A SCALE

Horizontal scale.—We have learnt (Rule I) that receding lines, if they are parallel in Nature, appear to meet at a distant point.

Therefore the converging lines we draw to represent them must also give us the apparent width between these lines at any point from the foreground to the far distance (Fig. 45).

If the lines were on the side of a wall instead of lying on the floor, a corresponding height

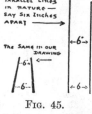

FIG. 45.

[1] The perspective method for fixing the exact position of the two vanishing points for a rectangular object is detailed in Chap. XXII. When drawing from Nature we need no other aid than a hinged foot-rule. This is held at arm's length and the angle adjusted until one arm corresponds to the receding line we wish to draw, and the other to a vertical or level line on the object. The angle gauged in this way is traced on our drawing. The foot-rule must not be held so that it is itself foreshortened.

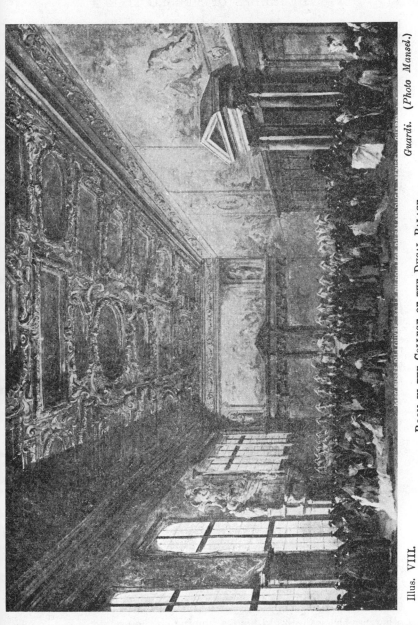

Illus. VIII.

ROOM IN THE COLLEGE OF THE DUCAL PALACE.
Example of Rule II.

Guardi. (*Photo Mansel.*)

between them instead of width would be represented as in Fig. 46.

Two such receding scales in our picture—one vertical the other

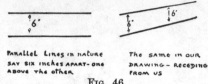

FIG. 46.

horizontal—will enable us to decide how tall or wide objects should be just at the very spot where we wish to introduce them.

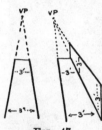

FIG. 47.

An easy way of remembering this vertical scale is to think of it as a wall of a given height that stretches from us to the far distance. The horizontal scale might be a pavement or a railway line.

The scale on level ground.—It does not matter how far to the right or left we place the V.P. for such a receding scale, we may use an existing V.P. or place a new one at a convenient spot (Fig. 47). If the receding scale is to run on level ground, its V.P. of course must be somewhere on the horizon.

THE HEIGHT OF FIGURES AND THE RECEDING SCALE

On inclined planes.—If the scale is required on a plane running uphill or downhill, then the V.P. will either be the one we used for

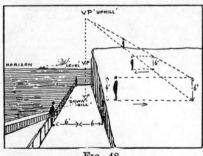

FIG. 48.

the lines on that plane, or a new one at the same level (Fig. 48) ; otherwise the scale would not be running on the ground.

In practice we draw a figure the height it should be in our picture, then we take receding lines from his head and feet to the V.P. we used for the ground he is standing on.

When introducing additional figures we place their feet where they are to stand, then walk them across (keeping parallel to the horizon) to the scale to see how tall they should be (Fig. 49A).

The height of figures with a low horizon would be found by the receding scale, and since the lower line of the scale and the horizon

Illus. IX. *E. W. Cooke, R.A.*

PENCIL DRAWING.

Example of a low horizon with heads on horizon. For explanation of figures on sloping sand or wading, look up chapter on " Inclined Planes."

line would run close together, some degree of precision in workmanship becomes a necessity.

When the feet of the figure are on the horizon the scale can be dispensed with, as the lower line would run on the horizon line (Figs. 49B and 49C).

If the head of the " painter " is the same height as the head of the figures he is painting, and they are on level ground, then the receding scale to find their height is unnecessary, since the top line of the scale would run along the horizon line (Fig. 49D). In such a case the height of figures is found by placing their feet where they are to stand and their heads on the horizon (Fig. 49E).

There is another way of finding the height of figures when looking down on them—thus, draw one figure the height it should be (compared with a doorway, for instance), then see what proportion of

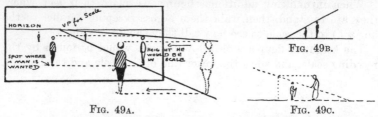

FIG. 49A. FIG. 49B. FIG. 49C.

the space from his feet to the horizon is occupied by the man. To introduce another figure place his feet on the correct spot, and then allot to the man the same proportion of the space from his feet to the horizon as you gave to the first man (Figs. 49F and 49G).

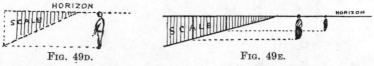

FIG. 49D. FIG. 49E.

A scale representing 1 ft. if drawn along the base of a picture and up one side will be found a convenience in architectural subjects. Usually a 6-ft scale (upright) will suffice. If we know how tall a 6-ft. man would look at a certain spot, we can calculate the height of any other object, such as a child, a horse and cart, or a cottage at that spot. In like manner we can calculate the width of a road, pavement, etc., by making our phantom man lie down at that spot (Fig. 50).

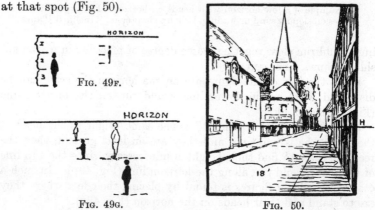

FIG. 49F.

FIG. 49G. FIG. 50.

Illus. X. *Vicat Cole, R.A.*

SKETCH FROM RICHMOND HILL.

Example of a very high horizon.

The " painter " was standing on ground about twelve feet above the terrace. We arrive at this conclusion by reasoning thus : If we stood on the terrace our head would be on the level of the horizon, and so would the head of the figure leaning against the balustrade. In this drawing the figure only occupies one-third of the space from his feet to the horizon, that is to say, another man could stand on this one's head, and yet another man on top of him; before the third man's head would be level with the horizon. If each man were six feet high the " painter's " head must have been eighteen feet above the terrace-level.

The height of other figures on the terrace could be found by the receding scale as before. Another way would be to divide the space from the terrace (where the new man's feet are to be) to the horizon line, into three parts, and to give one part to the man (Fig. 49H).

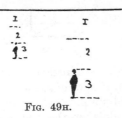

FIG. 49H.

CHAPTER III

DEPTHS

TWO very practical ways for finding depths on a receding surface are (A) by the use of diagonal lines with a receding scale ; (B) by a scale on the base-line or parallel to it. The former in particular is useful when sketching a foreshortened row of posts, trees, etc., for it marks the distance between each with sufficient accuracy, and all the lines can be drawn rapidly freehand.

(A) **Depths found by diagonals and a receding scale.**—The construction of a gate may include two uprights, some rails, and one or more cross-bars (Fig. 51). The centre is at the meeting of the cross-bars.

FIG. 51.　　　　FIG. 52.　　　　FIG. 53.

Therefore to find the centre of a gate or any other rectangular form we draw diagonal lines from corner to corner (Fig. 52). This applies equally well to any rectangular shape seen foreshortened (Fig. 53). If we add an upright where the diagonals meet (Fig. 54) we divide the form into two halves, of which the nearer appears to be the larger. Suppose you had a gate with one-cross bar (Fig. 55) and wished to add another half of a gate to its length, then (remembering

FIG. 54.　　　　FIG. 55.　　　　FIG. 56.

that the diagonal line determined the centre) you could utilise half the existing gate for a new diagonal. This would start at the junction of the central upright and the top rail (Fig. 56) and would pass through the middle of the end upright, meeting the new bottom rail where the new upright is to come (Fig. 57).

By the use of two diagonals you might also fix the meeting-place for the new upright with the top rail, but this is unnecessary.

44

If you would like to add a whole gate to another, instead of half at a time (as we did), then continue the three bars and make a new diagonal (Fig. 58) from the top corner of one end-post and pass it through the centre of the other end-post. Where it touches the bottom rail make the new post.

Our essay on the construction of a gate will enable us to draw a

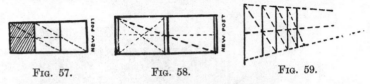

FIG. 57.　　　　　FIG. 58.　　　　　FIG. 59.

receding row of posts or trees. Proceed thus (Fig. 59): Draw post 1. Fix height and centre of future posts by lines receding to V.P. from top, bottom, and middle of post 1. Draw post 2. From top of post 1 take a diagonal through centre of post 2—where it touches receding line on ground plant post 3. Carry on by drawing another diagonal from the top of post 3 and each post as it is erected.

Applied to a colonnade, etc.—When sketching an avenue of evenly-spaced trees or a colonnade make a receding scale of three lines, as in Fig. 59—it would be most inconvenient to take in the tops of the trees (Fig. 60).[1]

Our vertical scale will do equally well for level surfaces (Fig. 61); or we can make it on the ground (Fig. 62). If Fig. 59 is looked at from the side it will lie flat and be similar to Fig. 62.

FIG. 60.

Many examples of the

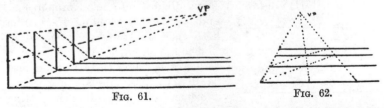

FIG. 61.　　　　　　　FIG. 62.

[1] Turner delighted in the regularity of these receding spaces. His pictures show this not only in the architecture that he drew so beautifully, but also in his choice of subjects where trees line a roadway. He knew just where to break the monotony of too even a distribution without disturbing the feeling of sequence given by an avenue. One calls to mind his embankment on the Seine ("Rivers of France") and "Mortlake Terrace—Summer Evening."

use of diagonal lines in conjunction with the receding scale will crop up as we get on with our subject. These should be enough to explain the principle. But I wanted to make it clear that receding lines in perspective not only form a scale for measuring heights and widths, but with the addition of the diagonal line give the depth measurement.

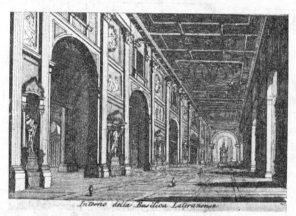

Illus. XI. *From an Engraving by Domenico Pronti.*

In this subject the width of the arches would be found by a receding scale on the pavement of the same width as one of the arches. The length of one arch and pier would then be drawn, and their comparative measurements obtained on the base-line, as in Fig. 65.

(B) **Depths found by a scale on the base-line.**—If (Fig. 63) we saw a line (I–II) full-face, it being divided into equal proportions,

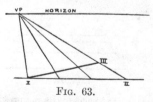

Fig. 63.

and we carried receding lines from both ends (I–II) and from each division to a V.P. on the horizon; then a foreshortened line (I–III) would also be divided into similar proportions in perspective; each division getting regularly shorter from the nearest to the farthest end of the line.

The foreshortened line is more often the one we have to divide into certain proportions as in Fig. 64, line 1–2. To do so, take a line from the near end 1 to the horizon line, thus making a V.P. From

the V.P. take a line to the far end 2, continuing it sufficiently far to enable the line 1–3 to be drawn horizontally. Line 1–3 now represents the foreshortened line seen full-face. Divide 1–3 into required proportions, and from each division take lines to the V.P. They will divide line 1–2 into like proportions.

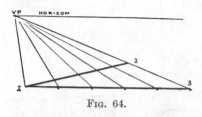

FIG. 64.

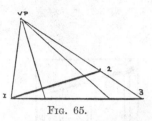

FIG. 65.

The division of a receding line into equal or unequal spaces.—
Unequal divisions are obtained in a similar way (as in Fig. 65).

The divisions marked on the full-face line might represent the ground plan of the length of a colonnade with the spaces between the columns ; then the same divisions would on the foreshortened

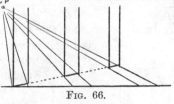

FIG. 66.

line be the perspective ground plan of their width. On these the columns would be raised (Fig. 66).

ANOTHER WAY OF USING DIAGONAL LINES TO FIND DEPTHS

(1) **Of vertical spaces.—**Fig. 67 represents a foreshortened rectangular form (say a window) in an upright position. If we draw a

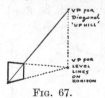

FIG. 67.

diagonal from the near bottom corner to the far top corner, then that diagonal is a receding line inclined upwards, and its vanishing point will be found by continuing its course until it meets a vertical line that starts from V.P. 1.

(Rule III says that a line inclining upwards tends to a V.P. immediately above the point it would tend to if it were a level line.) It is evident (Fig. 68) that the diagonals of any number of shapes equally proportioned would in Nature be parallel

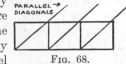

FIG. 68.

lines, and therefore when seen receding (Rule I) would meet at the same point, as in Figs. 69 and 70.

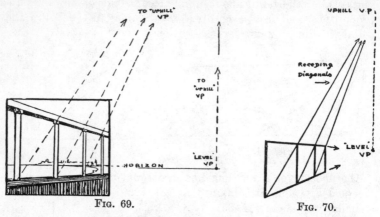

FIG. 69.　　　　　　　　　　FIG. 70.

In order to find the apparent depths of equally proportioned spaces on a receding row we must find the " uphill " V.P. for the

FIG. 71.—As in Fig. 68, but the dotted lines would have a V.P. as well as the other set of diagonal lines.

first space, and from that V.P. draw perspective diagonals to the far bottom corner of each space as it is made. The intersection of the diagonals with the top receding line will mark the depth for each succeeding space.

The above Figs. 67–69 can be worked equally well with a " downhill " V.P. In some cases this may be more convenient. The diagonal of the first space must of course be taken from the top near corner to the " downhill " V.P. (immediately under the V.P. for the level lines). The depths of succeeding spaces will be fixed at those points where the diagonals cut the bottom receding line.

If you find the V.P.'s for inclined lines come inconveniently high or low you can take an extra receding line to the level V.P., so as to cut off a portion of the height of the first space and others to come. Use that new line to run the diagonals to, instead of the top line (if an " uphill " V.P. is being used) or bottom line (for a " downhill " V.P.). Fig. 73.

FIG. 72.

In Fig. 74 we see that the diagonals taken to the bottom line and those taken to the new line both pass through the top receding line at the same points.

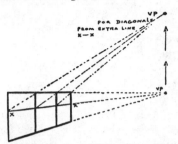

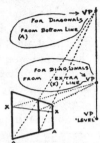

FIG. 73.—An additional receding line used instead of the bottom line.

FIG. 74.—Drawn merely to prove that the method used in Fig. 73 is above suspicion.

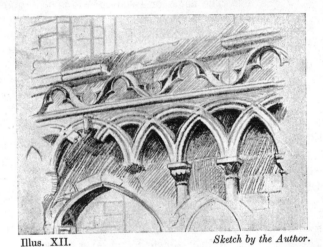

Illus. XII. *Sketch by the Author.*

ARCADE AT BOLTON ABBEY.

Its proportions could be found by one of the methods explained for finding depths.

(2) **Of level spaces.**—Our examples (Figs. 67–72) have been of vertical spaces. The depth of spaces on level ground are found in a similar way. No further explanation is necessary than what Fig. 75 affords.

Diagonal V.P. on inclined planes.—A space that would be level

as we walk across it from one side to the other (A to B, Fig. 76A) but uphill (or downhill B to C) as we walk from the near-end to the far-end must have its V.P. for the diagonal at the same level as the P.V.P. to which their sides tend.

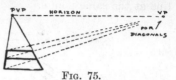

FIG. 75.

On an inclined and tilted plane.— But if that space was on a surface not only inclined upwards, but also tilted from one side to the other (A to B, Fig. 76B), then the V.P. for its diagonal would be on a line from the " uphill " V.P., and that line would run parallel to A–B. These explanations could

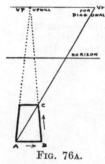

FIG. 76A.

have been expressed thus : " The V.P. for the diagonal is in the same plane as the surface the diagonal crosses," but such a concise remark might leave some readers still thinking.

The depth of a square.—It is of supreme importance in every picture that the depth of some foreshortened space should be drawn with absolute accuracy. It matters little whether it is an upright space or one on the ground, but we must have one space as a correct guide for obtaining all other depths. Suppose you have to draw a number of squares (such as the tiles of a pavement) whose sides tend to the P.V.P. If the pavement is in front of you then you can copy exactly[1] how deep one tile should be compared with its length ; but be sure you place it correctly in the floor-space or your labour is wasted.

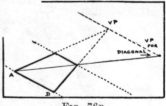

FIG. 76B.

The diagonal you draw through that tile (Fig. 77A) fixes the V.P.

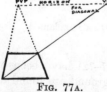

FIG. 77A.

for the diagonals of every other tile in the pavement. In other words, the receding diagonals from that V.P. determine the depth of any and every level square on the ground or above it, if one of their edges is parallel to the picture plane (usually the upright squares can be worked from this one also, as explained

[1] Measure it with your pencil held vertically at arm's length. When the length of pencil between its top and your thumb-nail covers the depth of the square exactly, rotate the pencil until it lies along the near edge of the square and see how many times the depth would go into the length.

by Fig. 61). If your picture is composed and you have no actual square in front of you, I advise you to cut out a square of cardboard, place it at the actual distance you wish it to be in the scene, and draw its proportions.

I believe this is the only way of making sure that the square form shall look as you would wish it to be, and to avoid those distorted representations that disfigure too many books on Perspective, and occasionally some pictures.

The depth of many squares.—With one square drawn and its diagonal continued to find the V.P. we can find the depth of any other square wherever we wish it to be (Fig. 77B). We do so by

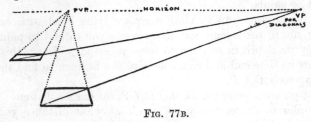

FIG. 77B.

first drawing the near-edge parallel to that of the first square. Its length we determine by using the receding lines of the first square as a scale. The sides of the new square will recede to the P.V.P. (Rule I), and we shall fix its depth at the point where the diagonal crosses one of the receding lines.

One diagonal to find depths.—By the use of one diagonal line we

FIG. 78.—Plan of any number of squares showing that the diagonal determines the length and width of each square.

FIG. 79.—The width of eight squares lying flat marked off by receding lines and intersected by a diagonal.

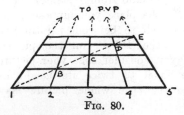

FIG. 80.

FIG. 81.

can find the depth of any number of rectangular spaces provided they are (in Nature) of equal dimensions (Figs. 78-81).

Procedure.—Draw a line (1-5,[1] Fig. 80) parallel to horizon line. On it mark off the width of the divisions required. From each division (1, 2, 3, 4, 5) draw lines meeting at P.V.P. These fix the width of each space. Draw a diagonal. At the points (B, C, D, E, etc.) where the diagonal cuts the receding lines (1, 2, 3, 4, 5) draw lines parallel to line 1-5, and so obtain the depth of each row of spaces.

The position of vanishing point for diagonals (D.V.P.) is determined by the distance the painter is from his picture or from the object he paints.

I have advised you to place a square lying level with one side facing you in the foreground of the scene you intend to paint, and to copy its depth in relation to some principal object ; this done, to draw its diagonal and continue it to the horizon to find the V.P. for diagonals D.V.P.

Most painters prefer to fix this D.V.P. for diagonals first.

In order to do so, you must decide at what distance you wish your finished picture to be seen.

If you wish the owner to examine it at close quarters, you will suppose yourself to be just that short distance as he would be from it, while you paint. If it is to be seen far away, you suppose yourself to be far off also when painting it.

The actual distance from the D.V.P. (the vanishing point for diagonals) measured along the horizon line on your picture to the P.V.P., will be the same as the measured distance along the ground from " painter " (i.e. the place you suppose yourself to be while painting) to the P.V.P. on the picture

FIG. 82.—Bird's-eye view of the painter and his picture, with the diagonal V.P. on the horizon (continued beyond the length of his picture).

(see Fig. 82). As a general rule, you consider that your picture should be viewed at a distance equal to twice its height or length—whichever is greatest—so that the whole picture may

[1] See Appendix, Note 3, for methods of dividing a line.

be seen clearly and yet without moving the head—but we will talk of this later on.

Fig. 83 represents the picture (3 ft. square) shown on the ground plan in Fig. 82. The V.P. for diagonals is 6 ft. from the P.V.P., just as the painter was 6 ft. from the picture.

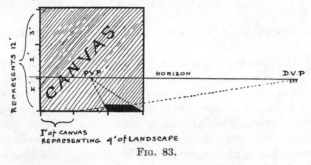

FIG. 83.

If each foot length along the bottom edge (base line) of the picture represents 4 ft. of the nearest width of the scene painted, then the actual length of the nearest foreground represented is 12 ft. The oblong drawn on the picture was 4 ft. long and 8 ft. deep, and was 2 ft. to the right of the painter's line of sight. Similarly the same scale of 4 ft. of Nature to 1 ft. of canvas shows that the painter's eye (the horizon) was 4 ft. above the ground level.

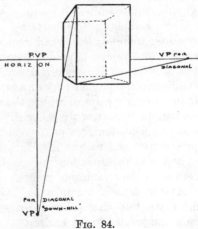

FIG. 84.

Vanishing point for diagonals can be used above or below the horizon.— As all lines which are in Nature level and at an angle of 45° with the line of sight tend to the D.V.P. on the horizon, so also lines leaning upwards or downwards tend to a D.V.P. respectively above or below the horizon, provided they make an angle of 45° with level ground surface. The "uphill" or "downhill" D.V.P. will respectively be just as far above or below the horizon as the D.V.P. on it is from the P.V.P., as in Fig. 84.

CHAPTER IV

THE USE OF PLANS IN SKETCHING FORESHORTENED SURFACES

WHEN perspective is used in a purely mechanical way—that of constructing a pictorial view from the known dimensions of some object unseen—it is necessary to employ elevations and ground plans. On these the exact dimensions of each part are drawn to scale. This process is quite unsuitable to sketching, though we sometimes employ it in pictures, mainly when architectural features are important. This scientific method is dealt with in Part II.

As an aid to drawing, even though mathematical exactness is not aimed at, a ground plan is still useful; partly because it fixes in one's mind the proportions of the object that is to be drawn foreshortened, partly because it stimulates a mental survey of the ground surface on which we propose to place forms.

For example, a foreshortened square when all the sides are receding from us, is a troublesome thing to draw if we have to employ two vanishing points, because one of them, if not both, will probably be outside the dimension of our canvas. If, however, we conjure up the ground plan of a square seen at an angle, and place it in another square of which the front is parallel to the horizon, we can on the latter fix the position of the corners of the angled square. This done, we put the square with the parallel front into perspective, and with it the four corners of the angled square, and so arrive at the direction the receding sides take without any concern as to their vanishing points.

How to draw a square when one corner is nearest you without using the vanishing points (1) when the corners on either side are on a line parallel to the horizon.

Fig. 85 is the plan of two squares, one inside the other. The drawing is only given to show how to draw the small square B, by means of the square A. Draw square A, cross it with diagonals in order to find the

Fig. 85. centre. Through the centre draw one line parallel to

the side and another parallel to the front. These will determine
the centre-point on each of the four sides. Join these four points
consecutively to make the square B.

If we draw (Fig. 86) the foreshortened square B in the same way
by means of the square A, whose receding sides and
centre line will meet at the P.V.P., then the square B
will be correctly foreshortened without the necessity of
finding the V.P.'s for its sides ; but in Fig. 87 we have
done so just to show we were right.

FIG. 86.

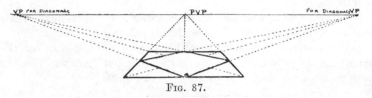

FIG. 87.

When we see a square lying flat and foreshortened in such a
position that a line parallel to the horizon would cut both its left
and right corners (Fig. 88), we know by the above figures that we
need not find its V.P.'s in order to draw it correctly, and we get to
work thus :

FIG. 88.

Practice.—Sketch lightly (they will
probably be wrong) the sides of the
square (Fig. 89), but take infinite

FIG. 89.

pains to mark its comparative length and depth. Enclose it in
a square as before and correct the sketch of its sides by repeating
the working of Fig. 86.

Application to a pavement.—Fig. 90 depicts a number of squares
forming a pavement. If square I is first drawn, square II
must be made of equal length on the line
A–B. Their depth is obtained by continuing
the back line of square 1 horizontally. A
diagonal line continued from the front row
will fix the depth of the back rows at those
points where it cuts the lines that recede to
the P.V.P., but this has already been ex-
plained in Fig. 80. If more distant pavement
has to be added one of the diagonal lines
must be continued to fix again the depth of each row, as at
C, D, E, F.

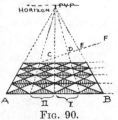

FIG. 90.

Extra squares in the foreground could be added by lengthening

towards us the lines that recede to the P.V.P., and also a diagonal to obtain the intersections marking their depth. If we know how many squares there are across the floor we can apply the easier method of Fig. 80, by taking the whole floor-space first instead of one square.

If the depth of the floor is greater than its width we can still apply the working of Fig. 80 by first making a square to represent the full width of the floor (of say twenty tiles), then we shall have twenty tiles also in depth, and we can add more, as we have seen in Fig. 90.[1]

(2) **How to draw a foreshortened square seen corner-ways, whatever its position, without using vanishing points.**

It is sometimes a great convenience not to be obliged to use the vanishing points of a square or other rectangular form when one or both points are outside our picture, as in Fig. 91.

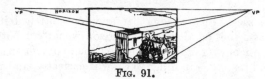

FIG. 91.

When a square is set at some other angle than that of Fig. 88 we can still, by varying our method, draw its sides that would meet at their respective V.P. without having to prolong them to it.

Fig. 92 is the plan of a square enclosing another. Whatever angle the inner square may be set at, the following procedure can be used :—

Practice.—From the corners 1 and 2 draw lines parallel to the side (A–B) of the enclosing square ; rule diagonal. From corners 3 and 4 draw horizontal lines (parallel to front of square B–C) until they meet the diagonal.

FIG. 92.

To make a foreshortened view of this :—Draw the base of a foreshortened square (Fig. 93) with the points B, 5, 2, C, ticked off upon it from the plan. From these carry lines to P.V.P. ; draw diagonal (to D.V.P. for diagonals), and where it cuts the side-line add back of square. Now place each corner of the inner square, by reversing the order in which you drew lines from them

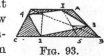

FIG. 93.

[1] Pavements are worked out in detail in Chap. XVI.

on the plan : i.e. to find corner 3, carry a horizontal line from the intersection of the line 5 with the diagonal. To find corner 4, take a horizontal from the meeting of the diagonal and the line 2. Place corner 1 at the far-end of line 5, and corner 2 at the near-end of line 2 ; join corners.

To draw the angled square without using a plan.—*Practice.*— Draw the enclosing foreshortened square as before (Fig. 94) with its diagonal. Mark on it the position of one of the corners of the inner square (say 2). Make B–5 equal to 2–C, and carry on as before. The reason for this is that corner 1 is on the plan (see Fig. 92) as far from A as corner 2 is from C, therefore the line 5 is made the same distance from B as 2 is from C. Also in the plan the corner 3 is as far removed from

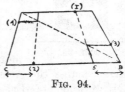

FIG. 94.

B as 4 is from D, and so horizontal lines from the intersection of the diagonal with the receding lines (5 and 2) will cut off a space 4–D equal to 3–B.

Sometimes one has to sketch a square when there is not time to consider it as a perspective problem. It is well, then, to remember that its width must be longer than its depth ; that the angle formed by its near sides will be larger than a right angle ; and that this angle becomes flatter in proportion as the square is more distant.

These rather obvious remarks are unnecessary if you will suppose yourself standing at the corner of a square, ("painter," Fig. 95). Since you would be right on top of the angle it would not be foreshortened, but would look like it is—a right angle — and its sides if continued would decide the position of the two

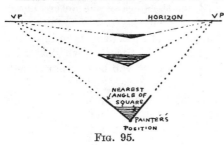

FIG. 95.

vanishing points V.P. But the next angle, if still seen from the same point, would be flatter (i.e. set at more than a right angle the one side with the other), because its sides also meet at V.P. The next angle 3 looks still more flat as it is more distant.

In Fig. 96 1 is the top of a box, 2 is its side. The pattern on its side acts as a ground plan, helping us to draw the same pattern on the top.

Practice.—First find out on what constructive lines the pattern (on the plan) was formed (they are shown in Fig. 96 by dotted lines). Draw those same lines of construction on the foreshortened

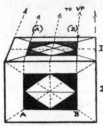

FIG. 96.

view. Remember that all receding parallel lines on the plan must, when depicted on the fore-shortened top, be made to meet at the V.P. Then shape the pattern in the foreshortened surface on these lines just as the full-face pattern was made. On the plan the constructive upright lines A and B only formed the sides of the inner oblong, they had to be carried up to the edge that divides the plan from the fore-shortened top-surface before they could be carried across the latter.

If we understand the constructive lines of the plan we need not always draw it under the foreshortened view. In Fig. 96 we can see that the corners of the diamond touch the centre of each line that forms respectively the top, bottom, and sides of the black oblong. Also that the black oblong is formed on the diagonal lines which cross the outer oblong. Therefore we can dispense with the plan and get the same result thus

Practice.—Tick off on a piece of paper the length of the inner and outer oblong and its centre Transfer these to a line that will form the base of the foreshortened oblong. From the outside dots draw lines receding to V.P. for the sides of the outer oblong. Decide on its depth to complete it. From the remaining dots (they show the length of the inner oblong and its centre) take lines also receding to V.P. Cross the foreshortened oblong with diagonals. Where they cut the lines that recede to V.P. will be the four corners and the centre of the inner oblong ; draw it.

The centre of its near and far sides is formed by a horizontal line through the crossing point of the diagonals. Draw the diamond with the corners touching the centre of each side of the small oblong.

It is just a matter of first drawing the constructive lines on the plan and then repeating them as they would look foreshortened.

The plan need not be the same length as the surface we have to draw foreshortened. If the base line of the latter is to be facing us the measurements ticked off the plan can be enlarged or reduced in the same proportion to make them the desired length.[1] If the

[1] See Appendix.

foreshortened surface is to be seen at an angle, the measurements can be transferred, as explained in Fig. 65.

A roughly drawn plan, on which we draw a diagonal and a few upright lines, will often suffice as a guide for the spacing of objects on a receding surface.

Take Fig. 97, A is the plan, B the foreshortened space. Where should the spot shown in A be placed in B ?

FIG. 97. FIG. 98.

Practice.—On plan draw diagonal (1). From spot draw the horizontal line (2) till it meets diagonal. Through that point and also through spot draw lines 3 and 4. Continue these lines down B (towards V.P. because they recede) ; and draw diagonal.

Where it crosses line 3 draw horizontal line till it meets line 4 ; there place spot. All we have to remember is that the lines we draw on A we repeat on B, but in the reverse order ; the reason being that in A where the position of spot is fixed we draw lines from it, but in B we draw the lines first to find the position of spot.

Our exercise with spot is elaborated in Fig. 98 by the addition of the little spots, but the family removal can be effected in the same way.

If we look upon these spots as figures we regard them with greater interest. The advantage of finding their position in this way needs no advertisement.

There used to be a good old-fashioned way[1] of finding standing-room for a crowd of figures. The floor-space was sectioned like a chess-board (Fig. 99) ; each square might represent 2 to 3 feet square, to allow for the shoulders. A diagonal line crossing the

[1] Since writing this I find that the custom was practised by Raphael.

receding lines determines the depth of each square, as we explained in Figs. 78 to 81.

This method applies equally well for the placing of doorways, windows, or furniture, as we see in Figs. 100 and 101.

Application to a room and the placing of figures.—Why not make a plan of a room, let us now say of the one Hans Jordaens painted (Illus. XIII), placing the chairs, pictures, tables, and figures, each at its angle, and in its proportion on the floor, and make it foreshortened by applying Figs. 97–101 ?

FIG. 99.

FIG. 100.

You will not always be able to paint subjects just as you find them.

Simple patterns can be sketched with sufficient accuracy freehand by this means (see sketches of Chap. XVI).

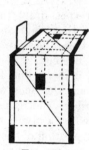

FIG. 101.

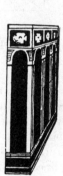

FIG. 102.

FIG. 103.

Applied to upright surfaces.—When drawing upright foreshortened surfaces we draw the plan on the near edge, just as if the pattern were on the front of a box, and we wished to draw it on one of the sides (Fig. 102).

The working is just the same, as will be seen by rotating page 58 until Fig. 96 is in an upright position.

It would be hardly necessary to draw a plan of so simple an object as a diamond pane, yet one comes across inaccurate drawings of lead lights of diamond or lozenge pattern.

The Jacobean panel sketched in Fig. 103 is much easier to draw if we use this method. It enables us with little effort to place the upper and lower mouldings in position and to give them their correct width ; and really this is not an easy thing to do without some guiding points.

This might be put to a useful purpose in sketching the carved spaces on the front of a tomb, the panelling of a room, or the tracery of a cathedral window.

Occasionally the lines of a plan interfere with those of the draw-

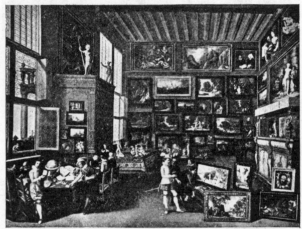

Illus. XIII. *Hans Jordaens. Photo Mansel.*
INTERIOR OF AN ART GALLERY.

ing if placed side by side, so it is better to separate them, as Fig. 105 explains.

Concentric squares.—Rectangular forms enclosed by other rectangular forms will all be of similar proportions so long as the same diagonal lines pass through their corners.

How to draw the plan of concentric squares.

Draw the outer square (Fig. 106). Cross it with diagonals. Mark off from both ends of the base the width that is to separate the inner from the outer square, such as I–II, III–IV. From these draw lines parallel to (IV–V) the sides of the square. Where they cut the diagonals will be the corners ; join them. If more squares are desired repeat the operation as from points VI and VII. Or you can simply start a square from one of the diagonal lines (say at A) and

run it parallel to the outer square A to B, B to C, C to D, D to A, since the diagonal lines will determine its corners (see Appendix).

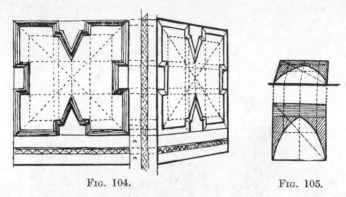

FIG. 104. FIG. 105.

The foreshortened view of concentric squares can be drawn without recourse to its plan.

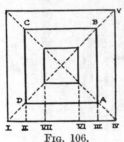

FIG. 106.

Practice.—(Fig. 107.) Draw the outer foreshortened square and add the diagonals. On base tick off desired width between squares. From these carry lines to V.P. Where these lines cut the diagonals will be the corners of

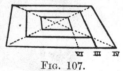

FIG. 107.

inner squares. Join them by horizontal lines.

AN APPLICATION OF FIG. 107.

Steps on four sides of a hollow square.—We sometimes have to draw a platform with a hollow centre ; in other words, steps which enclose four sides of a cavity, as in Fig. 108.

Practice.—Draw the front of the platform, carry its side lines to the P.V.P. Judge its depth in relation to its height and make the

FIG. 108.

back line (1–2). Take a line from 2 till it meets the bottom receding line (at 3) to obtain its height at the back. Draw diagonals across top. The four corners of the hollow must be on these diagonals, so fix the position of the near corner (4) and from this point carry a line to P.V.P. Where it cuts the

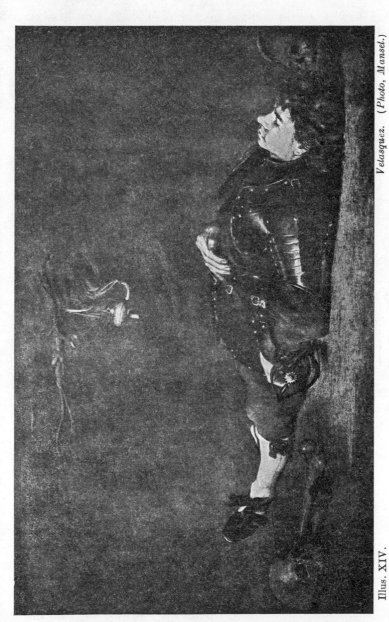

Illus. XIV.

Velasquez. (*Photo, Mansel.*)

THE DEAD WARRIOR.

other diagonal (at 5) will be another corner. Carry horizontal lines from these corners (4 and 5) till they meet the diagonals (at 6 and 7). Join 6 to 7.

FIG. 109.

Fig. 109 explains how the same method would apply if the base were seen at an angle instead of being parallel to the horizon, as in Fig. 108.

The use of a plan in figure drawing.—I once asked my old friend, the late Byam Shaw, if he found any use for perspective when drawing foreshortened figures. His reply was that he never drew one without thinking of it, and he sketched Figs. 110 and 111 in explanation. You will notice that the horizontal lines over the figure represent divisions across the back of him, so that when he is laid down these are on the ground, while the up-right lines from them give the height of the box he occupies.

FIG. 110.

FIG. 111.

The foreshortening of the division is obtained in the way explained in Chap. III.

Do not miss seeing that the last division on the chest overlaps and hides the neck. Shapes are often better explained by such contours than by the outline itself. Illus. XIV, of The Dead Warrior, of Velasquez, shows this admirably. (The study of Michelangelo's wonderful drawings will dispel any idea that drawing depends upon the representation of the outer rim alone.)

FIG. 112.

FIG. 113

Use of a plan and diagonal line when drawing animals.—The use of a diagonal line is also shown by the sketches Byam Shaw also gave me of a horse (Figs. 112–113) and a dog (Figs. 114–115), each in his box.

FIG. 114. FIG. 115.

CHAPTER V

INCLINED PLANES

THE application of Rule III to the drawing of steps.—A plank laid on a flight of steps would touch each step where the tread meets the upright. The plank in that position would be a plane inclined upwards ; its sides, therefore, when it is seen foreshortened from below, would tend towards a point immediately above that point, where they would have steered to, if the plank had been lying in a level position (i.e. the V.P. for the sides of the treads).

If the plank was as wide as the stairs, its side lines would disclose not only the steepness of the stairway, but also the position of the corners of each step on which it rested.

Bearing this in mind, we can represent the height and depth of all the steps in a flight, by using four such sloping lines—two at either end. The upper line on each side will mark the top corners of each step, the lower lines will give us those corners formed by the meeting of the back of the tread with the bottom of the rise. But we must draw one step first in its correct proportions or designed as we wish it to be.

(1) **Side view.**—If it is a side view of the steps that we have to tackle, the sloping lines can still be used. They would not then be receding from us, but would be parallel to one another (as in Fig. 116).

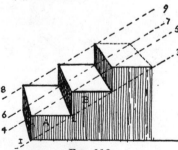

Fig. 116.

Practice.—For Fig. 116 draw step A. Take line 1–2 through corners of step seen end-on, and continue it to 3. Make line 4–5 touching edge of step and parallel to 1–3. Repeat these lines on the far side of the step, namely, 6–7 and 8–9. To form step B draw uprights one at each end between the sloping lines. These decide its height. Draw horizontal lines to fix the depth of the

66

Drawing by the Author

A Lych Gate.

Notice that the steps are worn at the edges, so that we see more of their
upper surfaces than we should if they were new.

tread. Join the near and far corners to make the front edge and the back line of the tread. These complete step B. Other steps are made in the same way.

(2) **Front view of steps.**—*Practice.*—(Fig. 117.) Draw step A, being careful to get the correct depth for the tread compared with

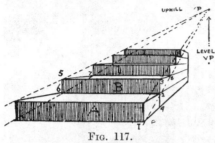

the height of the step. Across the side of the step from corner to corner draw the line 1–2, and continue it until it is above the "level" V.P. in order to find the "uphill" V.P. Run lines from the "uphill" V.P. to the other three corners on the front of the

FIG. 117.

step. Make the front of step B (2–3) the same height as the back of step A (4–2). You will then see that the height of each step can be obtained by upright lines (such as 2–3 and 6–5) drawn between the sloping lines.

Join 3–5. From the corners 5 and 3 take lines to the "level" V.P., where those cut the sloping lines (at 7 and 8) raise the uprights for the front of step. Join 7 to 8 to complete step B. Note that the depth of each step is also determined by the sloping lines that form a scale at each end. Make successive steps as you made step B.

The use of these sloping lines as a scale, to fix not only the height but also the depth of each step, is better seen in Fig. 118. The five upper steps are above the level of our eye. Their height and depth is obtained in the same way as shown by the dotted lines, so the scale also determines how much of each step is hidden by the step in front of it, and that is more than conveni- ent (Illus. XVI, XVII).

FIG. 118.

Depth of the steps found by rule.—There should be no difficulty in drawing the depth of the step in correct proportion with its height. A ruler held in a vertical position at arm's length will give the

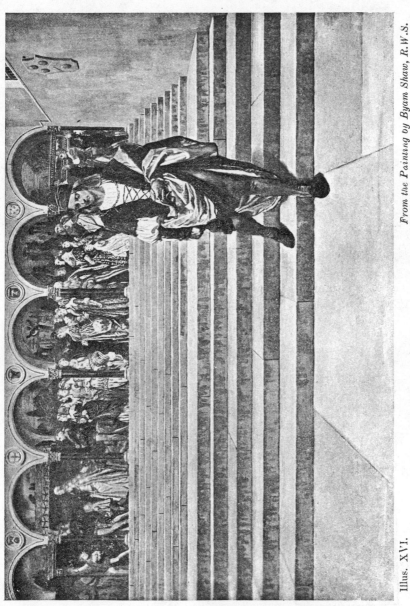

From the Painting by Byam Shaw, R.W.S.

"THIS IS THE HEART THE QUEEN LEANT ON."

Illus. XVI.

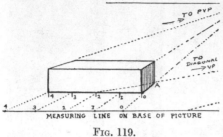

FIG. 119.

proportionate measurement; but you can draw it by perspective rules if you wish to.

Problem.—(Fig. 119.) To draw a step whose front is parallel to the horizon line 4 ft. long, 1 ft. in height, and 2 ft. in depth. Draw the front of the step, making its height one-fourth of its length. From the four corners take lines to the P.V.P. to form the sides. The length from 0 to 2 represents one-half of the length, or two feet ; therefore from the point 2 take a line to the V.P. to which the diagonals of squares run (as explained in Chap. III, Fig. 77). The depth 0 to A cut off by this line will be 2 ft., because it represents the length 0 to 2 seen foreshortened. Raise upright at A till it meets the line receding to the P.V.P. from the top corner of the step. Make the back of the step parallel to the front.

" Uphill " V.P. found by hand-rail. — A staircase that is not built between walls will have its sides protected by a balustrade or hand-rail.

If we copy the direction of the hand-rails and continue their lines (as they recede) we shall

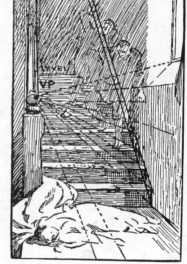

Key to Illustration XVII.

find the " uphill " V.P. at the point where they meet (Fig. 120). We then drop a vertical line from the " uphill " V.P. until it touches the horizon line and so find the " level " V.P. This is an easy way of getting round a difficulty, but it is as well also to use the receding scale as previously explained, in order to save time

FIG. 120.

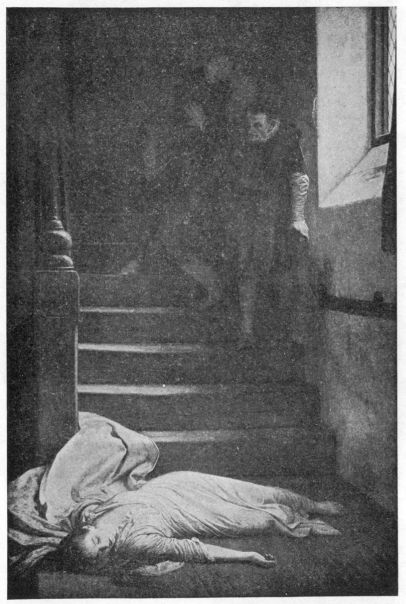

Illus. XVII. *W. F. Yeames, R.A. (Tate Gallery).* *(Photo Cassell & Co.)*
AMY ROBSART.

and to ensure accuracy in obtaining the height of each step (see Illus. XVIII).

(3) **Steps seen at an angle.**—Where steps are in such a position that you face one corner, the front and sides both recede from us. We must use two "level" V.P.'s when drawing the first step. The rest of the flight can be built by using the sloping scales and only one "level" V.P. (Illus. XXXII and Figs. 121 and 125).

Practice.—(Fig. 121.) Draw the near end of step A, and continue the top and bottom lines till they meet on the horizon (V.P. "level"). Add front of step by measuring the angle (see note, p. 38 Chap. II), and continue one line to find V.P. 2. Find "uphill" V.P. by running a diagonal (1–2) across the side of step, and continuing it till

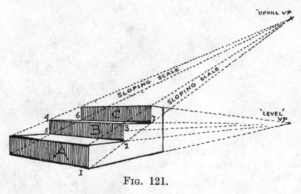

Fig. 121.

it is immediately over V.P. "level." From "uphill" V.P. carry lines to the other three corners of the front of the step to form a scale —one at either end. Flush with the back of A step, raise the front of B step, its height at each end (2–3 and 5–4) will be found between the lines of the sloping scales. From front corners (4 or 3) of B step carry lines to "level" V.P. to form the tread. Where these lines cut the lower lines of the sloping scales raise uprights for C step. Join 7 to 6 to complete step B. Form other steps in similar fashion.

(4) **A flight of steps seen from the top.**—Steps receding downhill can be drawn by the sloping scales whose use we are accustomed to, by drawing steps from below. The V.P. for the sloping scales will be at some point immediately under the "level" V.P. to which the side lines of the treads tend.

Practice for Fig. 122.—Find horizon in Nature,[1] and copy its

[1] As instructed in Chap. I.

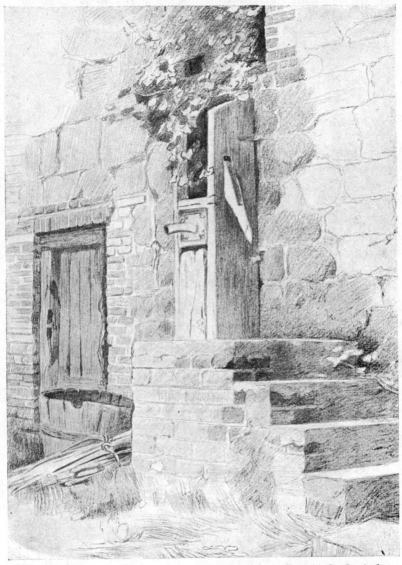

Illus. XVIII. *Drawing by the Author.*

THE MALT-HOUSE PUMP, BURPHAM.

position on picture. Draw corner of top step and the next one
(1 and 2), being careful to get their relative positions exactly, and
to record how much the top step overlaps the one below it. Con-
tinue line (1–3) of top step to horizon to find "level" V.P. Join

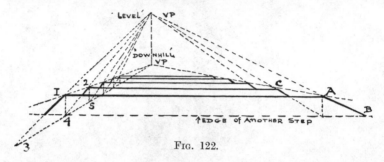

Fig. 122.

this with corner 2 and continue line till it is under corner 1. Line
(2–4) so made will be the top of step 2 (as if you could see through
the top step). Join 1 and 4 to find height of step. Draw a line
touching corners (1 and 2) of both steps, continue it till it is under
"level" V.P., in order to find "downhill" V.P. This line makes
one of the sloping lines of the scale that the top corner of each step

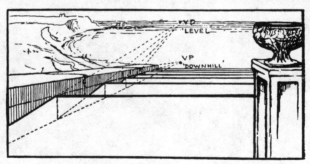

Fig. 123.

must touch. The other scale-line is made by joining the bottom
corner (4) of the top step with the "downhill" V.P. Draw height
of next step (line 2–5) between scale-lines. Join 5 to "level" V.P.
to form top of third step. Draw 1–A the width of staircase. Join
"level" V.P. with A and continue to B to complete top step. Join
corner A with "downhill" V.P. Join 2 to C. Join "level" V.P.
with C and continue to D. The rest of the flight can be quickly

drawn in the same way with the scale on the left side to find the heights, and one scale-line on the right to find the corners.

"**Downhill**" **V.P. found by skirting-board.**—If there is a skirting-board running down the stairway, its direction can be continued until it comes under the "level" V.P. to which the receding lines of the treads tend. In this way we can find the "downhill" V.P.

A stairway that is not set between walls will be provided with hand-rails or balustrades. It is a good plan to draw these first to find the "downhill" V.P. (Fig. 123).

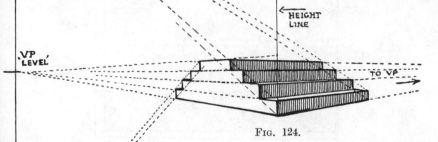

FIG. 124.

This will save time, but the operation described in Fig. 122 should be carried out. A tedious description will then be avoided in the ease of execution.

(5) **Steps on either side leading to a platform.** — In important buildings the entrance is often flanked by flights of steps on either side of the terrace or portico that ornaments its front. In this case, if we were standing near one corner we should see the ascending flight ahead of us, and at the further end the corners only of the descending steps. We could apply the methods already explained (121–122) for drawing each flight.

Fig. 124 speaks for itself, but note that the "downhill" V.P. for the far steps must be the same distance below the horizon as the "uphill" V.P. (for the near flight) is above it.

Height of steps found by measuring-staff.—Also notice that the height of each step on the far and near end is regulated by the upright on the corner of the nearest step. The upright is divided into spaces equal to the height of the nearest step ; from these divisions lines are carried to the " level " V.P. and determine the height of each course of steps. The upright line acts in the same capacity as a number of steps would, if placed one on top of another. (This method could have been applied to any of the previous examples.)

This way of measuring the height of each step will be better understood by reference to Fig. 125, though in this case we are directly facing the flight of steps.

Practice for Fig. 125.—Draw front of bottom step. Draw upright

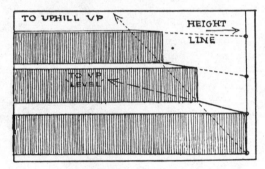

FIG. 125.

and tick off divisions equal to height of bottom step. From these divisions draw lines to "level" V.P. (to form the top of each step). From bottom corner of step draw inclined line to the bottom corner of the next, taking care to make the top of the step the correct depth for its height. Continue the inclined line. It will be seen that the meeting point of the receding lines with the inclined line, determine not only the positions of the bottom corners, but also the depth of each step. This practice is only another application of the receding scale and inclined line which has been explained in Chap. II and used in Fig. 69.

(6) Staircase with intervening landing leading to a gallery.— Begin by sketching its proportions ; then find the horizon, the "level" V.P., and the "uphill" V.P. (as in Fig. 130). Having found the height of the banister at the top of the first flight (by

means of lines running to the "uphill" V.P.), you carry lines from
the top and bottom of the newel-post and from the top of the hand-

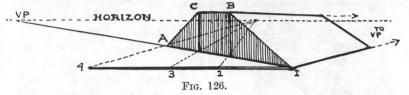

FIG. 126.

rail to the "level" V.P. in order to find the height of the banister
along the landing, and the height of the next newel-post where the
second staircase begins. Lines taken from the post (at the bottom
of the second flight) to the "uphill" V.P. determines the height of

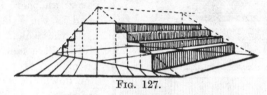

FIG. 127.

the post at the top of the second flight. The height of the banisters
and posts on the right-hand side is found by horizontal lines taken
across at each junction of stairway with landing, from the left-hand
banister and newel-posts. The stairs themselves are drawn as in
previous examples.

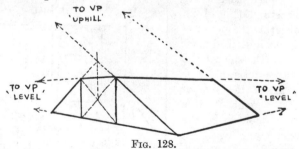

FIG. 128.

Figs. 126, 127, 128 explain three other ways of drawing the
platform shown in Fig. 124.

The height of figures on a flight of steps seen from below.—So
long as the height of each step is visible and not partly hidden by
the edge of a nearer one (as happens towards the top of the flight),
we can estimate the height of a figure in relation to the height of

the step he is to stand on, a step seven inches in height, a figure ten times as tall, and so on. Failing this we can use a receding scale

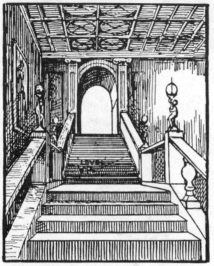

FIG. 129.

thus, Fig. 131: Along the ground on one side of the stairway carry a line to the "level" V.P. that you used for the sides of the steps; determine the height of a figure at some near point (by comparison with the height of the step or the width of the stairs), stand him on the line and carry another from his head to the V.P. to complete the scale. On other steps where figures are to be placed, drop a vertical line down the side of the stairway until it touches the ground; there the required height will be shown by the scale; make the figure the same height on the step above, and walk him along that step to the place where he is to stand (Fig. 132). Remember that the measurements as just described must be taken at the side of the flight, because the scale is directly under the side of the flight, though it does not always look so in the drawing.

This would be a cumbersome bit of work when dealing with a simple flight; it would be better to use a scale running up the edge of the steps to the "uphill" V.P., but a use will be found

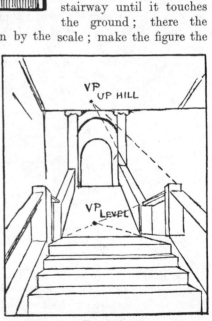

FIG. 130.

for it where successive flights lead to intervening galleries. An alternative method, in the latter case, would be the one we used for finding the heights of the newel-posts in Fig. 130.

The height of figures on a flight of steps seen from above.—The scale used in Fig. 122 for drawing the descending steps would serve equally well for fixing the height of a figure on any one of them.

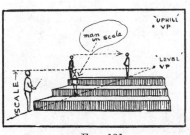

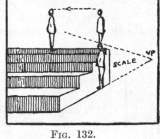

<div style="text-align:center">

FIG. 131. FIG. 132.

</div>

This would be done by marking the height of each step (as if those nearer to us were transparent), and drawing our figures their proper height in relation to the step they stand on. But it would save trouble in the end to make a scale representing the height of a man ; the bottom line of that scale would touch the end edge of each step (Fig. 134) at its centre (marked 1).

Having marked the position of the feet of our figure on the step

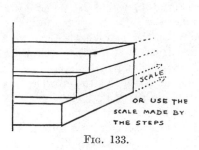

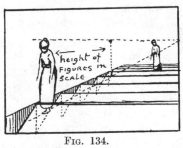

<div style="text-align:center">

FIG. 133. FIG. 134.

</div>

where he is to be, we must move his feet along the step to the scale ; having there ascertained his height we are able to make the complete man walk back to where we indicated his feet.

If the steps (Fig. 135) were so broad that we could not walk from one to another at a stride—let us call them platforms—then we should have to fix the height of a figure at the end edge of each

platform (do this by a receding scale to the "downhill" V.P.). After
that we must take a scale to the "level" V.P., in order to find the
height of the figure on any particular platform on which we intro-
duce him.

On two of the platforms I have lined up a squad of phantom-men,
just to explain the idea more clearly. The operation is really the
same as the preceding ones ; in those, however, we presumed that
the man's feet would occupy the breadth of the step ; on these
platforms we have added the scales to find the man's height as he
walks from the front to the back of the platform.

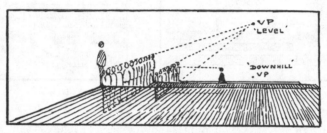

<p style="text-align:center">FIG. 135.</p>

(7) **Steps on four sides of a square.**—The base of a cross or sun-dial
is often built on platforms set on larger ones, these forming stages
of concentric steps. These can be drawn, a platform at a time, by
the method described for concentric squares (Chap. IV, Figs. 108,
109). The height of each step (Fig. 136) would be found by a
receding scale attached to the side of the lowest platform. The
width of each step could be ticked off on the near edge of the lowest
platform, as at A, D, E. The line from D (carried to the V.P.)
would, at the points where it meets the diagonal, determine the
near and far corners of one side of the smaller platform. The line
from A would also have to be carried to the V.P. Where it meets
the base of the smaller (second) platform at B it would be carried
up to the edge (to C). From C it acts for the third platform as the
line at D acted for the second platform (the top surface of the second
platform having been crossed with diagonals). Each succeeding
platform would be raised in the same way as the previous one.

The same steps (as Fig. 136) seen at an angle.—These present no
other difficulties than those of obtaining the successive depths of
the upper surface on each step and their height. Let us first draw
the lowest platform with the base of the next one marked out on it.

Practice.—Draw the lowest platform (Fig. 137) with diagonals crossing its top surface ; judge the distance between its near corner and that of the base of the second platform (1 to 2). From the near corner of the second platform (2) carry lines to V.P. 1 and

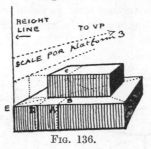

FIG. 136.

V.P. 2 ; where they cut the diagonals place two more corners ; from corner 3 take a line to V.P. 1 in order to find the fourth corner (5) ; join 5 to 4.

To find the depths on the upper surface of each succeeding platform and their height.—Repeat the working of Fig. 137 to obtain Fig. 138. Continue the side line of the second platform (1 to 2) till it meets the edge of the lower platform (at 3). Continue it down the side (3 to 4). You can now use the side as a receding scale, marked off with divisions that appear proportionately smaller

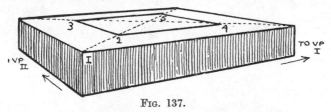

FIG. 137.

(method explained in Chap. II, Fig. 59). Each division represents the depth between one platform and the next, but before we can use it we must find the height of the second platform ; to do so take the height of the platform below the point 3 and raise it above 3, so that it stands on the edge (line 5–3). From the top and bottom of that height take lines to V.P. 1 in order to find the height of the second platform at the corner 2. Draw the second platform like the first and draw diagonals. To find the near corner of the third platform carry a line from point 6 (towards V.P. 1) across the top of the first platform, up the side of the second platform and across

its top (towards V.P. 1) till it meets the diagonals. The height of
the third platform would be found in the same way by raising the
height of the second platform at 7–8. The depth between the third
and fourth platforms would be found by a line starting from point
9 and behaving as the line from 6 which we have just detailed.
Any number of platforms could be raised likewise.

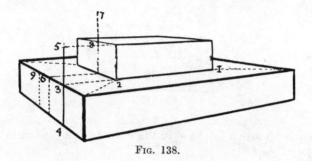

Fig. 138.

CHAPTER VI

INCLINED PLANES—*continued*

RULE II applied to the drawing of roads.—The sides and cart-ruts of a receding road on level ground tend to a V.P. on the horizon (call it "level" V.P.).

If the road runs in the same direction, but uphill, its lines tend to a V.P. immediately above the "level" V.P. (call this point

Illus. XIX. *Sketch by the Author.*

A ROAD.

"uphill" V.P.). The V.P. may be far above the horizon if the road is steep ; or only just over it if there is but a slight incline.

The road, if it has the same direction but runs downhill, will have its V.P. immediately below the "level" V.P. The steepness of the road running up or down hill determines the height above or below the horizon for the V.P. to which its sides tend.

If the road turns so that it takes a new direction, its V.P. will be more to the right or left accordingly, but it will not be higher up or lower down, unless the inclination of the road changes as well as its direction.

So it comes about that a road, unless it is perfectly straight and lies in one plane, may have many vanishing points. Each section of it that takes a new direction or inclination has its own V.P.

On hilly land a road may be seen in the foreground and again in

Illus. XX. *Drawing by R. V. C.*

A CURVED ROAD RUNNING UPHILL.

the distance, but the intermediate stretch, where it runs downhill, may be hidden owing to the steepness of the ground. Suppose we have not Nature in front of us, we can still find the width of this distant road by drawing the foreground length and adding the connecting link just as if we could see through the hill down which it runs (Fig. 139).

(1) **Road running downhill.**—Though a road runs downhill, we have to represent it running up our canvas. In order to make the illusion effective we must seize every feature that helps to give it a downward course. If its inclination is steep, the depth of the canvas occupied by its length will be slight. In this case we can

Illus. XXI.

POOLE, DORSETSHIRE.

From the Drawing by *J. W. M. Turner, R.A.*

Engraved by G. Cooke in "The Southern Coast of England," 1849.

utilise the stones and unevenness of the contours. Those near at
hand will hide parts of the roadway behind and will by their over-
lapping suggest its steepness. Quite small banks at its sides may
have their top lines running level or even downwards, and a piece
of old fencing for the same reason may be valuable. Figures are
even better for they are on the roadway itself—the head of a distant
one level perhaps with the waist of another in the foreground
explains that which the lines of the road with their upward direction
might fail to do. Roadside trees from their greater height have
more effect, the intermittent line of their tops running steeply
down the canvas.

If the road is precipitous, so that its sides if we could see them
would be running down the canvas, our troubles end. Then the
head and shoulders of a man or the shelvings of a cart and the
horse's head, with all else cut off by the nearer part of the road,

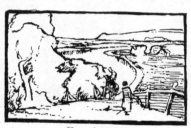

FIG. 139. FIG. 140.

arrests our attention and cannot fail to explain the situation. We
have but to introduce a figure towering over them on the top of the
hill to make the deception perfect.

With a road as precipitous as we are talking of it is advisable to
insure correctness in the size of the figures by sketching in the sides
of the road to the "downhill" V.P. Of course we cannot really
see the road, so we have to think of it as if it were the under-
surface of a plank reared up. This done, we guess or copy the height
of a figure, either at the top or bottom of the hill, and then take lines
from his head and feet to the V.P. to which the sides of the road
tend. If a figure at the bottom of the hill is chosen to give the
height for this receding scale, the lines must be continued up the
road.

Figures on roadways.—If many figures are to be introduced on a
road that turns, or changes its inclination, a figure must be placed
at each junction where the change occurs in order to carry on the

scale for measuring their height in the next section. Each receding scale will in every instance tend to the same V.P. as serves for the piece of road it runs on.

The scale[1] for the figures may be thought of as an imaginary railing, 6 ft. in height, bordering the road, conforming with it in each dip and rise, and using the same vanishing points that are necessary for the roadway.

(2) **A street on a hillside. View looking up.**—It has been said that the thing to do in drawing is to make the lines run in the right direction. Follow this terse advice by remembering that level lines of doorsteps, lintels, flat roofs, window - frames, brickwork, or masonry, run towards a V.P. on the horizon ; but carry the lines of the pavement, roadway, and a scale for anything that is upon it to the "up-hill" V.P. above the horizon and in a direct line above the "level" V.P.

If we look at a side - view of some houses of equal height (Fig. 141) we notice that each front forms as it were a step, and that lines drawn parallel to

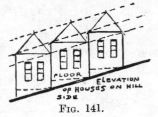

Fig. 141.

the road would touch each corner. We may not want to draw so formal a row for our view up the street, but lines to mark the corner of each house and meeting at the "uphill" V.P. would act as a receding scale to decide the height of distant houses and

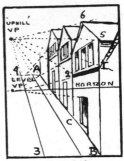

Fig. 142.

also the depth of their front walls that face the street, and these could be altered at pleasure. This is but an application of the sloping scale we used for drawing steps.

Practice.—Sketch in roughly (Fig. 142) the height of the houses compared with the width of the road, so as to place the scene nicely on the canvas. Find horizon in Nature and draw it on the canvas as if it were an actual line in Nature. Copy direction of top or some line on house that would in Nature be level (1–2), and continue it to the horizon to find the "level" V.P. Copy direction of the road B–A, and continue it till it comes immediately over "level" V.P. to find the "uphill" V.P. Copy accurately the depth of the same

[1] The receding scale for figures, etc., is fully explained in Figs. 46–49, Chap. II

house B–C. You have now drawn a foreshortened square representing the front of the house (1–2–C–B). From its near bottom and top corners (I B; 5 and 6) carry lines to the "uphill" V.P. to form scales; they will give you the heights of each house and the depth of their frontage. Touching the far side of the near

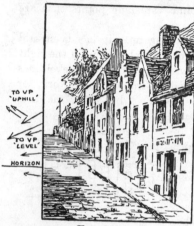

house raise the near side of the next house to the top line (1 to "uphill" V.P.) of the scale. From 5 run a line to "level" V.P. to form top of the windows. Draw the rest of the row in the same way as the first house. Carry lines (parallel to the horizon) from the bottom corners of these houses across the road until they meet the pavement line where the row facing them is to be raised. Carry lines also from the top corners. In this way you find the height and depth of the right-hand row.

FIG. 143.

To introduce figures.—Draw a doorway the correct height for the house. Place a figure in front of it so that he could walk into the doorway; take lines from his head and feet to "uphill" V.P. to form a scale and use it as already explained in Chap. II.

(3) **Street on a hillside. View looking down.**—After mastering the theory for an uphill view, you need no detailed instructions for applying it to a downhill scene.

Sketch in roughly the scene. Find "level" V.P. on horizon (Fig. 144), and "downhill" V.P. under it. Carry scale for houses to "downhill" V.P., and all the receding lines on the houses that are level in Nature to the "level" V.P.

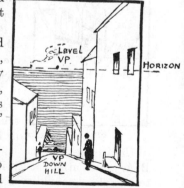

FIG. 144.

Incidents on a hillside street. Doorways.—It must be no less puzzling to the builder than to the artist to find a satisfactory solution of the difficulty occasioned by the line of the hill cutting across the level lines of

basement windows, doorsteps, and level courses of his masonry.
In cottages the ground floor is often laid at a level taken from
the end where the ground is highest. The doorway is reached by
means of a step or two from the high side leading to a stone
or brickwork platform which may be protected by a rail on
the low side and front; or the steps may lead from the low
side. If the cottage stands back from the roadway the steps
can lead directly from the front. These manœuvrings lend a pic-
turesque aspect to the village street. In towns the space-saving
basement makes an area a necessity, and front and area door are
reached by steps up and down. In poorer streets the foundations
are level with the low side, and entrance
is effected by a step sticking up at the
low end and almost submerged at the
high end—a mean device, but still one
to be considered in an uphill or downhill
drawing. Nor are basement windows,
half-hidden by the rise of the ground,
uncommon in similar surroundings. The
pavement even may be made to accom-
modate itself to the slope of the road,
as in Fig. 145.

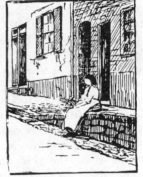

FIG. 145.

Walls.—The courses of brick walls are
sometimes laid parallel with the line of
the hill; more often they run on level
lines, though the coping-stones or top-brick courses follow the
line of the hill.

A more pleasing arrangement is
that of level courses and top-stones
built in tiers, so that the top of the
wall forms, as it were, steps leading
down the hill (Fig. 146).

FIG. 146.

The top of these walls can be
likened to the row of houses we
have just erected, and the similar
use of the receding scales will be
recognised. The scale-lines meet at
the "uphill" or "downhill" V.P. to which the sides of the road tend,
the top of each tier (because it is level) has its V.P. on the horizon.

Rule III applied to sloping land.—

(1) **Hayfields.**—The symmetry of a hayfield is charming. Lines

of swaithes, wind-rows, and foot-cocks follow one another in rise and dip over the undulations of the ground. All converge with varied regularity to some distant point. The alleys of fresh green grass receding from us expose their full width ; others, more to the side, appear as narrow bands, further still they are but threads of green until hidden from sight by the height of the hay at their margin. The T-square and plumb-line have no place here, but we must show a sympathetic appreciation of the beauty in Nature's perspective. The rule that teaches us to converge the straight lines of pavement to a point on the horizon, or to carry the clean-cut lines of the curb on a hillside road to a point above or below the horizon, come into play even with these delicate wavering edges of the new-raked hay. The height and width of hay-cocks or " hubs " are regulated by definite laws that could be demonstrated by a commonplace row of boxes, though the application were less harshly applied.

The value of a receding scale with its V.P. at that level above or below the horizon to which the ground inclines, will be appreciated when we introduce a line of men in single file " turning," or separate figures in parts of the field where we may not have seen them. We just copy a man where he happens to be, obtaining his correct height for the exact spot of ground he stands on. He serves as a gauge for the scale whose use we have already described (Chap. II, Fig. 48 *et seq*.).

(2) **Cornfields.**—At harvest-time when the stooks are set up one might almost think the farmer had it in his mind to demonstrate perspective laws. His sheaves nicely spaced stand one behind the other in even rows, and carry our eye to the fields beyond, row, gangway and row appearing to diminish in height and width on either side cover his field. Even the growing wheat seems, as it

FIG. 147. FIG. 148.

were, to carry on the game as we look over it and note towards the distance the lessening of the visible spaces of stalk between the heads of grain. This is but a beautiful rendering of the law that spaces appear less deep as they are further away. On hilly ground

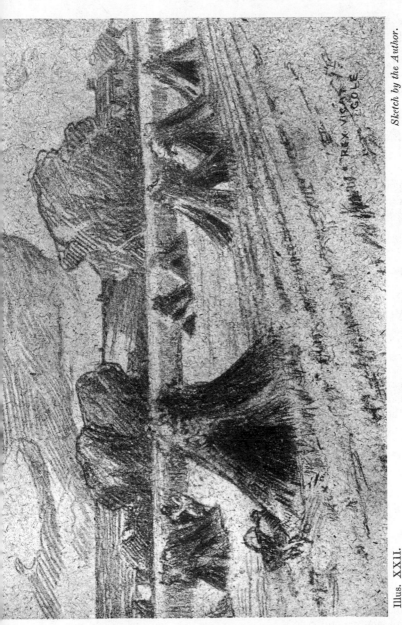

Illus. XXII. A Cornfield on Level Ground.

Sketch by the Author.

The head of the painter happened to be at the same height as were the tops of the sheaves. Therefore a sheaf drawn anywhere on the ground must be correct in height so long as the top of it touches the horizon line.

some care must be exercised in order that each block of sheaves and gangways shall show the inclination of the land (Fig. 147).

Take, for instance, a rising field that continues over the brow. Here is a rough side-view of the idea (Fig. 148), but we have to look along the lines.

FIG. 149.

Make a scale from the near sheaf (Fig. 149) and carry it to the " uphill " V.P. at that level to which the rising ground tends. Use the scale to find the height of other rows of sheaves, and carry a scale from each to the same point to give you the height of the sheaves and the width and direction of the gangways. From the sheaves that top the hill,

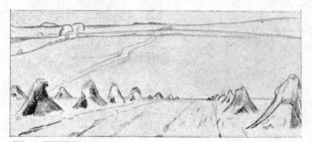

Illus. XXIII. Sketch by the Author.

carry scales to a " level " V.P. Where the hill begins to descend carry scales to the " downhill " V.P., as if you could see through the hill ; they will decide for you just how much of each sheaf in each row appears above the hill-top.

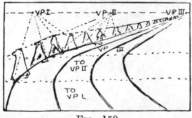

FIG. 150.

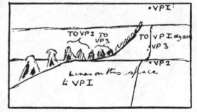

FIG. 151.

You need not do all this out of doors ; a few lines freehand based on this knowledge will give the look of reality. The training will make you quick to observe the charm in lines that is inherent to uneven ground.

If the boundary of the field is not a straight one the reaper may follow its course instead of cutting a straight "road" for the machine. The sheaves then will be set up in a curved line. The employment of two or three vanishing points affords a rough and ready way of drawing these curves, as Fig. 150 explains.

Curved lines of sheaves passing over the hill-top and coming into view again (Fig. 151 and Illus. XXIV) might be rendered in a haphazard manner that would be quite unconvincing if we had not these simple rules to guide us.

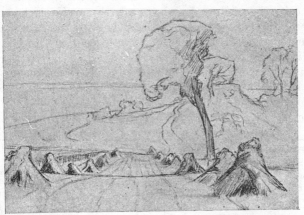

Illus. XXIV *Sketch by the Author.*

(3) **The sea-shore.**—We can see from the lines of the breakwaters just how steeply the upper stretch of sand slopes towards the sea. Each pile in a line was probably driven in to the same height, but the lower ones, partly submerged by sand, their tops nibbled down by the waves, diminish in height more rapidly than those near the shingle.

When looking across the groynes the lessening depth of sand between each row should be welcomed as an asset that helps us to convey the impression of mile after mile of shore.

In a view from the top of the sand looking towards the sea, the V.P. (below the horizon) for the sand should be found, and others also for each section of shingle or sand that is at a different inclination. The sand, where it touches each groyne, forms a line running downhill. If the groynes are in Nature parallel to one another, you can copy the direction of two such lines and continue them until

they meet ; the meeting-place will be the "downhill" V.P. for all lines in Nature parallel to the groynes on that stretch of sand, or every other that has the same tilt.[1] Other lines tending more to the right or left will have their V.P.'s correspondingly, but at the same height. The shingle sloping more steeply will have its V.P. under this one.

The V.P. for the esplanade or level top of shingle will be on the horizon slightly above the distant sea level, as is presently explained.

Figures on the shingle.—A scale for figures will be used as in previous examples. Be careful to use a V.P. at the same level as the one for the sand, and to have a fresh one for each section of sand that slopes differently. Place a bogey figure where one tilt ends and another starts, so that the scale shall be the right height where it begins to recede to a new V.P.

Figures wading.—Figures wading are often drawn the wrong size. If you have found a V.P. for the sand they stand on, and through it have drawn a horizontal line, you can note the proportion of space occupied by a figure from this line to his feet.

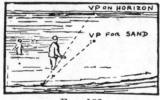

FIG. 152.

FIG. 153.

Suppose he occupies one-third of the space, then the other figures will also take up one-third of the space. In fact, you should draw the figures in the way we have learnt, just as if the sea were not hiding a portion of them. Mr. Wyllie[2] tells us how they should be partly submerged :

" Mark the position of the heel of your man ; from the margin of the sea rule a line through the heel to some point on the vanishing

[1] The height of a V.P. for the sloping land on which we stand, or shall we say the distance of its V.P. below the horizon, can be found by inserting a stick in the ground some little distance in front of you, and on it marking the actual height of your eye. The height of this mark is then indicated in your picture and a horizontal line drawn through it. The vanishing points for receding lines on the slope will be somewhere on that line. If we are standing, this line will cut through the head of every figure on that slope, or if sitting, through his waist, as explained in Chap. II.

[2] "Nature Laws and the Making of Pictures," W. L. Wyllie.

line of the plane. Exactly over this point make a dot on the horizon, and from this dot rule a line back to join the first line on the margin of the sea. This will cut the figure at his correct water-line." The " vanishing line of the plane " that he mentions is the horizontal line we draw through the " downhill " V.P. for the sand (Fig. 152).

As we look along the shore each slope of the surfaces from the upper shingle to the margin of the sea is seen as it were in profile.

To obtain the height of figures.—Make a scale that shall follow the sea margin as if it were a railing where the sea laps. Mark the spot where the figure is to be ; follow the slopes of the shore down to the scale, see how tall he would be, and walk him up to the desired spot (Fig. 153). In following the slopes of the shore one must be careful not to bring the figure nearer or further away from us than he would be in a walk straight down from the shingle.

CHAPTER VII

THE CIRCLE

WE find it less difficult to draw a foreshortened circle on a large scale if we first draw a foreshortened square and then draw a circle inside it.

The reason for this is apparent directly we look at the plan of a square enclosing a circle (Fig. 154). We see that the circle touches the square at the middle of each of its sides. This would also happen in the foreshortened view of the square, and so we should have four guiding points to shape our foreshortened circle on. Its form would be that of an ellipse (Fig. 155). (See Note X.)

The positions of these four guiding points (and others) are determined, both in the plan and

FIG. 155.

FIG. 154.

in the perspective view of the square, by diagonal lines as already detailed in Chaps. III and IV. Four other guiding points can be found in the plan (Fig. 156) at those places where the diagonals are cut by the circle and transferred to the foreshortened square (Fig. 157) by using the lines marked 1 and 2 (in the manner described in Chap. IV, Fig. 96).

In practice we do not draw the plan of either the square or the circle. We just draw a foreshortened square, and by diagonals and cross-lines fix the position of the points A, B, C, D (the centres each side line)

I II
FIG. 156.

I II
FIG. 157.

(Fig. 158). We find the other four guiding points as follows :

Mark off one-quarter of the length of the near edge of the square and using that measurement as one side, form a little square, and draw a diagonal across it. Measure the length of that diagonal and set it off on either side from the middle of the near edge (A–1, A–2).

Illus. XXV. *Drawn by the Author.*

COLUMNS IN BURPHAM CHURCH.

From 1 and 2 draw lines to V.P., in order to find those points where the circle is to cut the diagonal lines. Draw the foreshortened

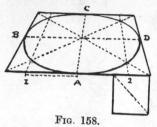

FIG. 158.

circle through these eight points. If you have not a book of reference handy and forget this measurement, you can still get these points (1 and 2) approximately, though they may not be quite correct, by making their distance from each end of the near edge equal to not quite one-sixth of its total length (Fig. 159).

Note X.—The greatest diameter of the ellipse so formed is slightly below the centre line of the square. If you cut out this circle (Fig.

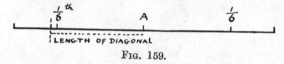

FIG. 159.

160) and crease it along the " centre of ellipse " line the two halves will fit.

The circle seen from below.—A foreshortened circle above the height of our eye can be drawn by using similar guiding points on a foreshortened square. The near edge of the square will of course be the upper one, since it would be the underside of the square that we should be looking at (Fig. 161).

FIG. 160. FIG. 161.

In a vertical position (Fig. 162) the circle presents no new difficulties, and further explanation is superfluous. In fact Fig. 158 would have stood for the drawing of a circle in four positions : (1) as seen from above ; (2) as seen from below—by rotating the book until the print came upside down ; (3) as a vertical circle on our left—by rotating the book (with the sun) until we cross the

page ; (4) as a vertical circle on our right—by rotating the page in the opposite direction.

The circle in a square seen at an angle.—It is only a little more troublesome to draw a circle enclosed by a square that is seen at an

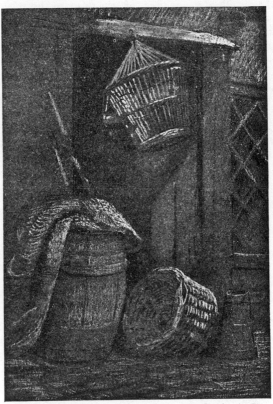

Illus. XXVI. *Drawing by the Author.*

THE WICKER CAGE.

angle. The use of the exercise comes home to us when drawing a circular column set on a square base.

Practice (Fig. 163).—Draw the angled square either by employing two V.P.'s, or in the way shown in Fig. 94, p. 57. Draw a horizontal base line from the near corner, and on it tick off the same

divisions as in Fig. 158. Divide the near edge of the square (1–2) into these proportions (in the manner explained in Chap. III, Figs. 64 and 65). From each division carry lines (to V.P. 1) down the square to fix those points where the circle is to cut the diagonal lines. Except for this way of dividing near edge of the square by means of the additional base line, the circle in an angled square is worked out just as the circle when enclosed by a square in the position of Fig. 158.

A brewing-tub tilted against the cottage wall, or the copper pans of the scullery lying at any angle may tempt one to a piece of still life painting. In each case think of the rim as if it had a square lid on it. The lid will describe the slope of the plane on which the circle has to be drawn. The old Dutchmen knew a thing or two about drawing commonplace objects

FIG. 162.

that might be incidentally noted by students to their great advantage when studying the technique of masters (Figs. 164, 165, 166).

FIG. 163.

Parallel circles.—Parallel circles occur frequently, as in the opening of a well, a fountain, or a tub of water, where the surface of the water is visible as part of a circle.

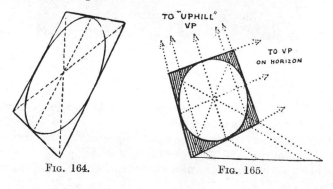

FIG. 164.

FIG. 165.

Practice (Fig. 167).—Construct the opening of the well (or rim of the tub) as before ; then form a shallow tray ; use the upper square as the top and drop lines from the corners to the bottom, to form the sides ; then draw another circle on the bottom.

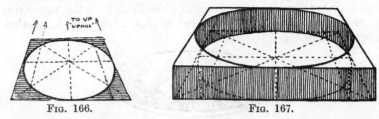

FIG. 166. FIG. 167.

Concentric circles.—The plan of a square enclosing smaller ones is given in Chap. IV, Fig. 106. If we draw circles in each square we have the plan of concentric circles (Fig. 168). The foreshortened view of concentric squares is also given in Chap. IV (Figs. 106–109). If you draw a foreshortened circle in each foreshortened square you obtain Fig. 169, and that shows how much narrower the belt

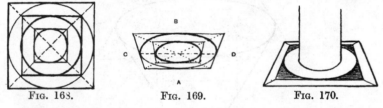

FIG. 168. FIG. 169. FIG. 170.

appears where we look across its width at the nearest and farthest points (A and B) than at the other points of contact (C and D) with the squares.

The observation of this fact is necessary in drawing the top of a well, a wheel, a font, or circular patterns on pavement (see Illus. L). It is also easier to draw such objects as a helmet, or a column

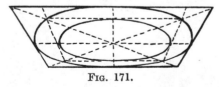

FIG. 171.

standing on a larger one, if you first sketch such a foreshortened plan and then raise the superstructure (Fig. 170).

Fig. 171 is a view of it seen from below.

There are objects—a plate for instance—where the surface of the brim does not lie on one plane, but slopes inwards and downwards. Concentric squares might still be used as a framework for the outer rim and the smaller base, but it would be necessary to form another square below the inner one, to obtain the slope from the upper rim to the smaller circle of the base below (Fig. 172). This is another application of Fig. 168.

FIG. 172.

The building lines will be more clearly seen, however, if we drop this inner square still lower so as to form a basin. The diagram (Fig. 173) suggests a useful hint for drawing parts of machinery or architecture that should not be missed.

FIG. 173.

CHAPTER VIII

THE CIRCLE—*continued*

APPLICATION of the Perspective circle to wheels.—Fig. 174 is not drawn to represent tricycle wheels of an early pattern enclosed in a crate, but to explain a method of drawing two or more foreshortened circles that would in Nature be parallel to one another.

Think of a box of any desired length, but with the two ends made of square pieces of wood, on each of which is inscribed a circle, and their centres connected by a spindle. The circle in each case is drawn as in Fig. 162.

This diagram will come in handy when a cart is to be introduced into your picture,

FIG. 174.

because it is difficult to make one wheel the right depth for the other without some method to work on.

If we take the two ends on which the circles are drawn (I mean

FIG. 175.

of Fig. 176) and put them close together, we have a diagram (Fig. 175) representing the rim of a wheel, but you must join together the top and bottom of the circles. It is the sort of wheel used on some agricultural implements. The solid spokes we have constructed out of the diagonals of the squares.

If a wheel is furnished with many spokes the points of insertion on the rim can be found, as shown in Fig. 176.

Practice.—First make a plan of half a wheel enclosed in the half of a square. Then from each point where a spoke touches the rim rule lines (parallel to the top or bottom line of the square in plan) until they meet the near edge of the foreshortened square, in which the foreshortened circle has

103

been drawn. From each point on the edge carry lines down the foreshortened square, being careful that they shall eventually

meet at the V.P. At each point where these lines touch the foreshortened circle, insert one end of a spoke, and see that their other ends meet, so that all the spokes shall radiate from a common centre fixed in the perspective middle of the circle. If indisputable accuracy is necessary in forming the hub (as in drawings of machinery), you can draw another little square for its circle (using the existing diagonal lines for the purpose), and then form the dome of the

FIG. 176.

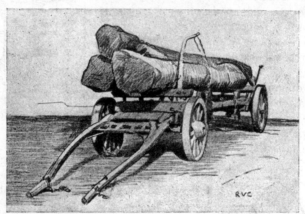

Illus. XXVII. *Drawing by the Author.*

THE WOOD-WAGGON.

hub upon it. By working in this way you will have the undoubted advantage of knowing that all the spokes are inserted correctly, both into the rim and the hub, despite certain parts being hidden from view by the projection of the hub.

The diversity of build in different types of wheels will present less difficulty in their representation if we can sketch these skeleton wheels freehand with some degree of accuracy.

Before you sketch even a cart, walk up to it and make yourself acquainted with its mechanism at close quarters (this is even more necessary with machinery). Dodges in perspective will occur with

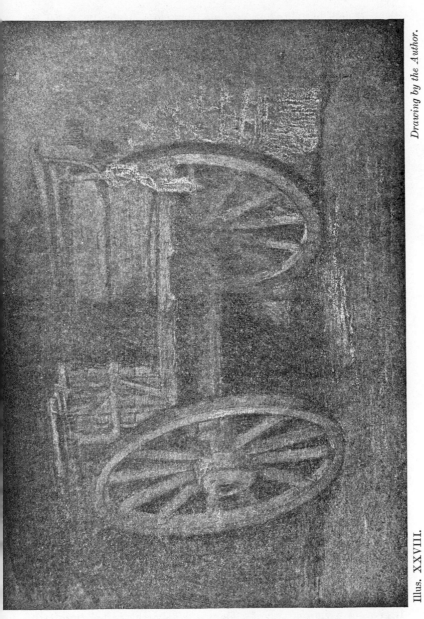

Illus. XXVIII.

THE FARM-CART.

the occasion, but note how in some farm-carts the heavy spokes are set on the hub alternately instead of on one line encircling it. Neither must one miss the " rake " of the wheels when the rims of a pair of wheels come nearer together under the body of the cart than above it, owing to the wheels not being set at a right angle with the line of the axle (see Illus. XXVIII).

The wheel of a water-mill.—If we turn again to Fig. 174 we see we can use it to make a water-wheel if we connect the rims by solid paddles instead of supplying spokes.

Circular steps.—We learnt how to draw a series of square platforms, each one standing on a larger, so that they formed steps (Figs. 136–138, Chap. V).

We now want to draw circular ones such as might be represented by a small mill-stone set on a larger, and that on a still larger one,

as in Figs. 177, 179. To do this we can draw a circle on the top and bottom surface of each square platform and connect them by uprights at the points 1 and 2, 3 and 4 (the middle of the corresponding sides of each square).

FIG. 178.

FIG. 177.

When I was drawing this I noticed how neatly the circles made a man's straw hat (Fig. 178), so I beg leave to introduce it.

FIG. 179.

Semicircular steps seen from the side.—If we cut Fig. 177 in half it gives us a view of two of a flight of semicircular steps (Fig. 180),

and we can add more steps on to it "at pleasure," as Cassayne
says. I think it might be quicker to make use of the whole square,
and to draw circles instead of semicircles, and then to cut them in
half, rather than to draw half squares. This we
have done in the next example where the steps are
seen from the front. Probably the use of this
diagram, and some others, lies in the habit it en-
courages of using bits of perspective in our sketches
as occasion demands.

FIG. 180.

Before we learn to draw semicircular steps it
would be advisable to study their plan. Fig. 181 shows concentric
circles enclosed by squares. The dark lines show the semicircles
and half-squares.

Note that on the back line the diagonals of the half-squares meet
at the middle, and that the back corners of each half-square also
mark the back corners of each semicircle (1, 2, 3, 4, 5, 6), and that

FIG. 181.

the depth of each semicircle is obtained by the
meeting of the side lines of each half-squaie with
the diagonals (A, B, C).

This same half-square seen
foreshortened is shown in Fig.
182.

FIG. 182.

A way of drawing a platform set on a larger
one was described in Chap. V (Figs. 136–138).
This will help us to understand the building up, platform by plat-
form, of semicircular steps.

The same seen from the front.—Fig. 183 represents the bottom
line of a semicircular step seen from the front.

Fig. 183. Half a foreshortened square with the guiding points
for the half-circle found in the same way as for a circle.

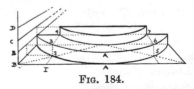

FIG. 183. FIG. 184.

Practice (Fig. 184).—Sketch in lightly from Nature the line of the
bottom step where it touches the ground. Correct this by drawing
a foreshortened half-square (as in Fig. 183). Determine the height
of step at the nearest point (A–A) ; carry that height to side of

square and form a scale there (B–B). Above B–B form as many more scales as there are steps (such as B–C–C–D). Draw the upper edge of bottom step on guiding points found by reference to scale (B–B). Join far corners to make the back of step. Where receding line 1 cuts diagonal (at 2) raise vertical to top of step (at 3). That point will be the left-hand near corner for the next half-square, and a line from 3 to P.V.P. will fix the back left corner (at 4). Find equivalent points for the right-hand corners (5, 6, 7). Join the

Illus. XXIX. *Etched by W. H. Pyne in his " Microcosm."*

A subject in which concentric circles and circles in various positions occur.

near corners (3 to 6). Complete this half-square like Fig. 183 with its guiding points. Then draw the bottom line of another step on them, find its height by reference to scale B–C. Carry on for this step as you did for the first one (two steps only are drawn to save confusion of lines).

Semicircular steps seen from the top step.—It is highly improbable that we should at any time draw a flight of steps showing their back in the way that Fig. 186 displays them ; but this is the view that makes us understand their mechanism, and it is easy not to include the unnecessary part.

Practice (Fig. 186).—Sketch the semicircular edge of the upper
step, and correct its line by enclosing it in the further half of a
foreshortened square (similar to portion A, Fig. 185). This will

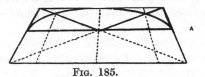

FIG. 185.

be the top surface of a rectangular platform enclosing the step, so
decide its height, and complete its sides and far end (as if it
were transparent). Draw the diagonal on the bottom of the plat-
form from the centre of the steps back through the far bottom corner,
and continue it to the horizon. Decide on width of second step.

FIG. 186.

Complete its top surface and draw the semicircular edge of the
second step in it, using the guiding points as in the first step. Repeat
the method of drawing this platform (step) for others below it.

Note that all the diagonals are here continued until they meet
at a V.P. on the horizon. This is an extra precaution to ensure
accuracy. You will remember that the depth of each platform is
governed by the meeting of these diagonals with the receding lines
of the platforms.

FIG. 187.

Columns supporting a rotunda.—In
sketching a set of columns arranged in
a circle one should begin by allotting
to each its ground space. By the
practice of previous exercises we
could draw one circle within another.

FIG. 188.

We should make the distance between the circles equal to the
diameter of a column. This is the ground plan of the arrangement,

Fig. 187, and Fig 188 give the foreshortened circles between which the columns would stand (as applied in Fig. 189).

The inside of a circular room.—Any part of a room that is built on a circular ground plan can be drawn by using the far side of semicircles enclosed in the far side of half-squares (explained Fig. 185).

Practice.—Copy first the semicircle of the floor at the base of the wall and enclose this in a foreshortened half-square (Fig. 190). If there are intricate details it will be advisable to make a plan of the circle or semicircle, and on it to mark the width and intervals between any pilasters, windows, or spaces that furnish the wall

PLAN

Fig. 189. Fig. 190.

(Fig. 190). These intervals will be carried from the plan to the drawing as previously explained ; the foundations of the pilasters being laid, they can be raised now or later on. If verticals are now raised from each corner of the foreshortened half-square we obtain a framework. On it we can quickly make any number of half-squares (by drawing a horizontal line to connect the front uprights, and side lines from these to the P.V.P., with a horizontal for back). Wherever a circular line is seen—it may be by the top or bottom of a window, or the height of a capital—draw these half-squares and set half-circles in them.

If there are regular spaces from the bottom to the top of the walls they can be measured off on the near upright (Fig. 190), or it may be more convenient to regulate them at the furthest part of the building ; then the back of the half-square can be drawn first instead of its front. The real difficulty is to accustom oneself to the appearance of the underside of the far half of the foreshortened circles that occur above the horizon line.

A niche.—A three-quarter view of a niche best explains its shape ;

merely that of a cylinder topped by a dome, the whole cut vertically
in half (Fig. 191).

Practice (Fig. 192).—Draw the cylindrical part as you would a
semicircular room. The semi-circles in

the dome are obtained thus : tick off
their distance apart on the rim (1–2).
Join each opposite point (I to 1, etc.)
to make the front edges of fore-shortened
half-squares (seen from below). Carry
their side lines towards V.P., and obtain
the depth of each half-square by means of the
D.V.P. Inscribe semicircles as before.

FIG.191.

In this, as in most examples, we rely upon a
certain proficiency in drawing. Our difficulty in
drawing unfamiliar objects is caused by our want of knowledge of
their build. Diagrams such as Fig. 193 explain the sort of lines
we should expect to find, more complicated rules would numb our
power of copying.

FIG. 192.

Bow windows.—Bow windows give us an exercise in drawing
curves that project from the face of the building. These need no
further explanation, but note Fig. 194.

Circular towers demonstrate the use of knowing how to draw
parallel circles at varying heights (Fig. 195).

FIG. 193. FIG. 194. FIG. 195.

CHAPTER IX

ARCHES

WE have now got into the habit of enclosing circles in squares and semicircles in half-squares. This custom should become an involuntary one when sketching any form of arch from Nature.

We must understand, however, the build of some of the principal types of arch if we are to draw them with vigour. Rickman describes

them thus: "Arches are round, pointed, or mixed. A *semicircular arch* has its centre in the same line with its spring" (Fig. 196).

FIG. 196.

FIG. 197.

"A *segmental arch* has its centre lower than the spring" (Fig. 197).

"*Pointed arches* are either equilateral, described from two centres, which are the whole breadth of the arch from each other, and form the arch about an equilateral triangle" (Fig. 199); or *drop arches*,

FIG. 198.

FIG. 199.

FIG. 200.

which have a radius shorter than the breadth of the arch, and are described about an obtuse-angled triangle (Fig. 198); or *lancet arches*, which have a radius longer than the breadth of the arch, and are described about an acute-angled triangle" (Fig. 200).

"All these pointed arches may be of the nature of segmental arches, and have their centres below their spring."

"*Mixed arches* are of three centres, which look nearly like elliptical arches" (Fig. 201), or of four centres, commonly called the *Tudor arch;* this is flat for its span, and has two of its centres in or near the spring and the other two far below it" (Fig. 202).

112

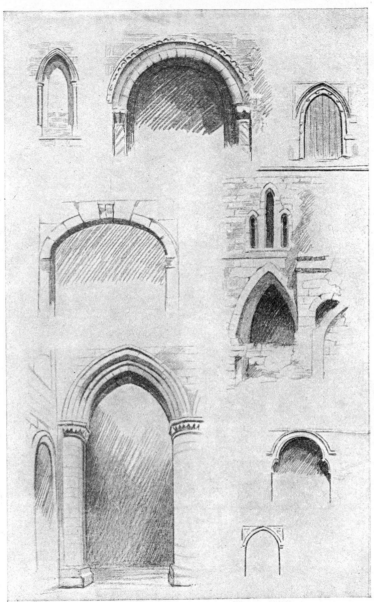

Illus. XXX. *Sketched by the Author.*

SOME TYPES OF ARCHES.

" The *ogee* or contrasted arch has four centres ; two in or near the spring and two above it and reversed " (Fig. 203).

How to draw arches.—In accordance with our custom we will first examine the plan (in this case the front elevation) of some

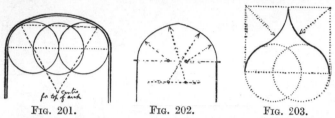

FIG. 201. FIG. 202. FIG. 203.

arches before we attempt the practice of drawing them foreshortened.

Fig. 204 gives the front elevation of a semicircular archway.

In Fig. 205 it is enclosed in a rectangle with the addition of the centre of the circle, the diagonal lines, and a line where the arch

FIG. 204. FIG. 205. FIG. 206.

springs from the column, and the guiding line that marks the points of contact between arch and diagonals.

The arch is seen foreshortened in Fig. 206.

Practice.—Sketch in the arch lightly. Copy accurately the width between the columns and the height of the arch (from its apex to the ground). Draw a receding line from the base of the near column

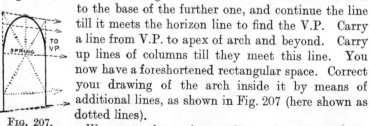

FIG. 207.

to the base of the further one, and continue the line till it meets the horizon line to find the V.P. Carry a line from V.P. to apex of arch and beyond. Carry up lines of columns till they meet this line. You now have a foreshortened rectangular space. Correct your drawing of the arch inside it by means of additional lines, as shown in Fig. 207 (here shown as dotted lines).

We must refer again to a front view (Fig. 208) to understand the course of stones that form the arch. We see their

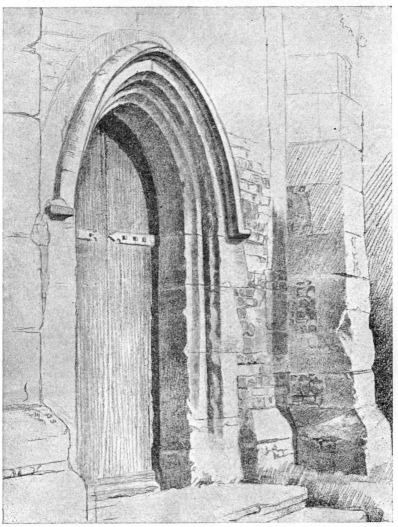

Illus. XXXI. *Drawing by the Author.*

DOORWAY, BURPHAM CHURCH.

upper semicircle enclosed in a half-square, and recognise our old
friends concentric squares and concentric circles.

Practice.—Draw the arch as in Fig. 207, decide the height of the
key-stone, carry a line from V.P. to it and beyond ; continue
the diagonals upwards till they meet this line ; from their inter-
section with it drop upright lines. You now have the space in which
to draw the upper semicircle of the stones.

We took notice in a previous diagram of the extreme narrowness

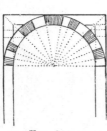 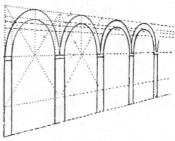

FIG. 208. FIG. 209.

of space between the circles where the space is seen the most fore-
shortened. If the appearance of truth is to be given in a drawing
of an arch, the height of the key-stone, compared with the width of
the stones at the spring, must be carefully recorded.

It appears troublesome when drawing from Nature to enclose
each of many arched lines by rectangular lines, as shown in Fig. 209 ;
but when a row of arches is in question it saves time to do so. A
few lines will give us the width and height of many spaces in each
arch, and each arch correct for its neighbours.

Referring again to Figs. 196–200 we see that a typical Norman
arch has the centre of its semicircle half-way between the spring ;
that pointed arches are formed on two circles ; each side of the
arch being described from a centre situated at, or near (according
to the type), the spring of the other side.

The joints on the face of the stones of which
the arch is built, will also radiate from these
points, and will actually do so also in the fore-
shortened view, as in Figs. 208, 210, 211.

FIG. 210.

The position of each joint at the inside edge of the arch FIG. 211.
having been obtained, their lines on the underside of the arch
will be carried to that V.P. to which a line from the front to the
back of the archway would tend.

Arches seen full-face (Fig. 212) retain their actual shape, but only appear smaller in the distance. This applies not only to a single arch with others seen beyond it, but also to those doorways that recede and are themselves composed of large and smaller arches (Illus. XXXII). This remark is necessary because if our point of

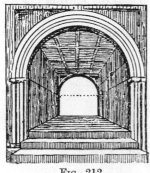

FIG. 212.

FIG. 213.

view is slightly to one side of the centre of the larger arch, the smaller ones may become partly hidden and may deceive one into thinking them different in form.

If there is any trouble about it, draw them as if enclosed in a crate ; Fig. 213 tells you all about it.

Bridges can be drawn by applying the lessons of the former Fig. 209.

Practice for Fig. 214.—Sketch the height of the nearest pier of

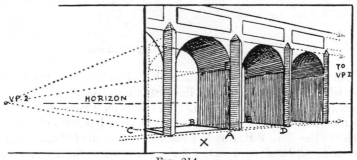

FIG. 214.

the bridge, mark off the spring of arch, the height of the balustrade, coping stone, or any courses of masonry (such as stone " strings " between brickwork), or the height of a buttress. Copy one of these

receding lines and continue it to the horizon line to find the V.P. 1.
Draw in one arch and its piers. Draw the width of other arches and
piers (by rules learnt in Chap. III). Choose one archway where the
width of the bridge is seen (x). Draw accurately a line along the
width of the bridge where the pier touches the ground or water
(A–B). Continue the line till it meets the horizon line and so find
V.P. 2.

From V.P. 1 draw a line to the bottom of the arch on the far side

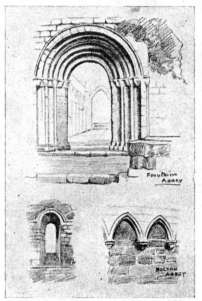

Illus. XXXII. *Sketch by the Author.*

of the bridge (to B), and continue it (V.P. 1 to C). This line decides
the width of the bridge. All lines running across the bridge will
meet (at V.P. 2) on the horizon. The line from A running to V.P. 2
marks where it cuts the line C, V.P. 1. Thus a line from D to V.P. 2
cuts the line C to V.P. 1 at E, deciding how much of the pier under
the arch will be seen; again, a line from F where the arch springs,
if taken to V.P. 2, will decide where the spring of the arch on the
far side of the bridge is to be, and consequently how much of the
underside of the bridge will be shown in our drawing.

If the piece of the arch on the far side of the bridge does not seem

Illus. XXXIII.

Drawing by the Author.

to be in drawing, it may be expedient to draw a rectangular framework for the arches on the far side, as if the bridge were transparent (Fig. 213) as we did on the near side. On guiding lines so formed, complete arches can be drawn, and any inaccuracy in the piece that is actually visible will be detected. Recourse can even be had to an elevation, but this would be an encumbrance rather than a help, except for some complex arch such as the *ogee*.

Five guiding points for drawing the foreshortened view of the arch can, however, be easily ascertained by an elevation in the way we are familiar with (Fig. 207), or we can find still more guiding points by crossing subdivisions of the rectangular form with other

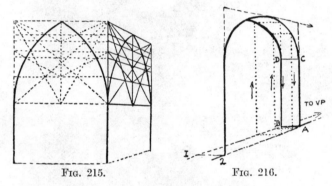

FIG. 215. FIG. 216.

diagonals (as in Fig. 215). This application of diagonals will be recognised if Chaps. III and IV were understood.

The thickness of a bridge where it is seen on the underside of the archway—or to put it another way—the drawing of the arch on the far side of the bridge can be gauged by means of a receding scale (Fig. 216). The operation has this drawback that it can only be used with advantage when the lines of the bridge recede to the principal vanishing point ; even so it would require great neatness in execution to apply it to a drawing on a small scale.

Practice for Fig. 216.—Draw the arch on the near side of the bridge as before. Decide the width of the bridge where the piers touch the ground, and draw the lines 1 and 2 to the V.P. ; they will form the scale. Draw a horizontal line to represent the inside bottom line of the pier (A to B), and another where the arch springs (C to D). From any point on the arch drop a vertical line till it meets the scale, carry a horizontal line across the scale, find the width, then carry the line vertically as high as the starting-point

and make a dot at its end. Now do this again from several points
on the arch and you have a series of dots to draw the far arch on.

Details of archways.—Opportunities for the use of perspective
are almost inexhaustible. Rules cannot be laid down that shall cover
each contingency ; they must, as they occur, be met by the exercise
of some ingenuity. For example, the overlapping of projecting
mouldings enriched with ornament, such as a number of fluted
columns set with ball flowers, can more easily be placed in position
if we draw their foreshortened ground plan where they take their
rise.[1] Or again, the curves of arches following one another may
become deceptive by the projection of the dripstone above (Illus.
XXXI), and in this case a separate rectangular form may be drawn
in perspective in front of the arch and on it
guiding points found for the curves of the
dripstone. Sometimes the joints of the stones
themselves when visible can be brought to
our assistance. If each stone carries its orna-
ment, a key to the spacing of the latter is provided by the fore-
shortening between each joint. We see this in the " axe "

FIG. 217.

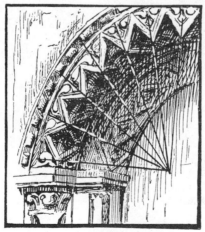

FIG. 218.

decoration (Fig. 217), when the pattern is formed in diagonals
crossing each stone of the arch.

[1] When harassed for time it is not amiss to supplement a quick sketch
with an actual ground plan which can be rapidly made by measurement of
each moulding.

The enrichment of a Norman doorway might puzzle the best draughtsmen, but each point of the zigzag ornament may perhaps coincide with the lie of the stones and so afford him solace (Fig. 218).

It may be noticed that the rectangular guiding lines enclosing a pointed arch give us directly the construction of a doorway of the perpendicular period. A few lines in addition to the diagonals used for the arch will be serviceable in mapping out the ornament of the spandrels.

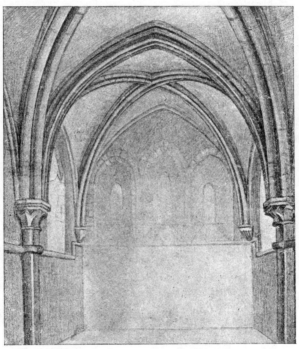

Illus. XXXIV. *Drawing by the Author.*

GROINED ROOF IN BURPHAM CHURCH.

Groined roof (or vault).—Groined roofs exhibit so many intricacies that here we can only state the general principles that influence our method of drawing them.

For this purpose we will consider that the roof is held up in a simple way by six arches ; two of them spanning the width ; two

others the depth ; and two more that span the space diagonally, and so cross one another at the centre (Fig. 219) ; all these springing from four piers. This arrangement being repeated as often as necessary for the length of the space to be covered.

Practice for Fig. 220.—Begin by placing the piers with their capitals (or the vaulting shafts and corbels if these are present) so as to obtain a footing for the ribs, cross-springers, and side arches. Draw all the arches except the diagonal ones, as previously explained, by means of

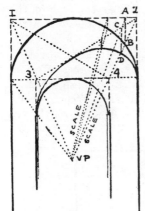

rectangular shapes. Think of the space 1, 2, 3, 4 in Fig. 220 as a flat ceiling held up by the arches, now cross it with diagonals (1–4, 2–3), and let their intersection be also that of the arches you will build diagonally from the near left-hand pier to the next right-hand pier and vice versa. I think these diagonal arches are best drawn freehand with only the diagonal lines to guide one, but authorities give additional points on which to draw the arch, so I will repeat their instruction. At a likely place on the full-face arch mark off the distance from the guiding line above it (A–B). Take lines from the top and bottom of that line

Fig. 220.

Fig. 219.

(from A and B) to the V.P., and so form a receding scale. The upper line of the scale (from A) will pass through the top of the diagonal guiding line that starts from 2.

Where it does this (at C) drop a line (C–D), then the diagonal arch should touch the point D. An equivalent point for other diagonal arches on the same side can be found by this one scale. Make another scale on the other side of the full-face arch, and it will be the means of finding equivalent points on that side. Use as many scales as you like on both sides.

Fig. 221.

CHAPTER X

HOW TO DRAW CURVES BY STRAIGHT LINES

W E will now consider curves in another way. Look at Illus. XXXV and XXXVI. The former shows how the curves of the bridge and railing would look; the latter the curves of a causeway.

These drawings suggest that a foreshortened curve might in Nature be made up of a number of short straight lengths. If this were so, then in the foreshortened view each length would recede towards a new V.P. We only have

FIG. 222.

to remember our practice with roads inclining up or downhill (see Chap. VI) to be able to correct a faulty drawing by a few lines (as in Fig. 222) drawn freehand. In the same way curves on a horizontal plane, such as a winding river seen from a height,

FIG. 223.

124

Illus. XXXV.

The Wooden Bridge.

or the track of a road across the valley, might be sketched by short lengths ; each length successively tending to a V.P. further away on the horizon line (Fig. 223).

Illus. XXXVI. *Sketch by George Cole.*

THIRLMERE BRIDGE, CUMBERLAND.

Perspective of a head.—I hesitate before applying hard and fast rules to the drawing of those exquisite curves seen on the human figure. To attempt to describe how perspective steps in would but end in a boring wordiness. But I insist that the curves and contours will be better understood, and so better rendered, by the train of thought that follows a knowledge of perspective.

For example, we know that it is less difficult to place the features on a head correctly if we sketch them as lying on lines encircling it from side to side. The tilt of the head upwards or downwards will be expressed by the fullness of curves made by these lines—we think of them as parts of circles seen from below, or from above, respectively. It is easy to understand then that if the length of the nose and the ears lie between two such parallel lines, their position in regard to one another is automatically regulated in many positions of the head by the curvature of those lines. Another line taken up the face from the centre of the chin to the central parting of the hair becomes, in any other view except that of a full face, a part of a circular line seen from one side, and consequently denotes the foreshortening of the head and face (Figs. 224–226, Illus. XXXVII *et seq.*).

Drawing by Rubens.

Illus. XXXVII.

Fig. 224.

Outlines to explain the perspective curves of a head.

FIG. 225. FIG. 226.

Outlines to explain the perspective curves of a head.—*continued.*

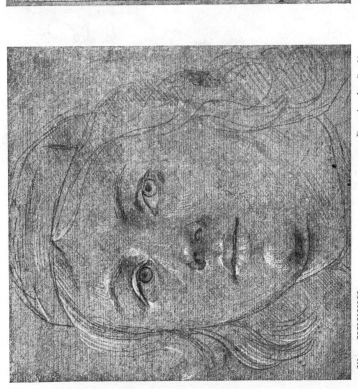

Illus. XXXVIII. *Drawing by Credi.* Illus. XXXIX. *Drawing by Maratti.*

These as well as Illus. XXXVII are reproduced from the drawings in the library of Christ Church, Oxford, by the courtesy of the Governors, from prints supplied by the Clarendon Press.

Contours on a figure.—In a foreshortened view of a limb or the trunk, the contours that overlap or even hide the forms behind them are often more valuable for expressing the action and structure of the figure than the outline itself. The nicety of these foreshortened curves will not be overlooked if we know the appearance of a circle in any position.

Contours on animals.—There is a nicety in the line of a foreshortened circle, whether it is on a figure, a cloud, or an animal, that is so expressive and yet elusive. It may be missed from not being recognised as just the line that would show which way a form is tilted. It is good sometimes to draw forms without a model, so that each plane has to be thought of and then built up to another.

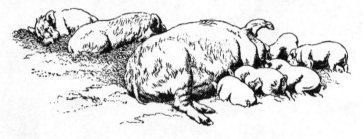

FIG. 227. THE SOW AND HER LITTER.

Etched and published by R. Hills, 1814.

The habit breaks one of making unintelligent copies, and quickens one's wits in detecting a useful line. In Hills' etching (Fig. 227) every line has its use.

The circle of a flower.—In the majority of flowers the circle is the basis for their design (Figs. 228, 229, 230). In some it may do service not as an actual circle, but to set a boundary for each petal.

FIG. 228. FIG. 229. FIG. 230.

In others, it has a lavish use—pistil, stamens, petals, and sepals all regulated by concentric circles; each part radiating from the centre of its circle; the whole beautiful in its symmetry, varied repetition, and exactness.

The plant itself displays each floret bravely. Circles in full-face,

circles nodding, tilted sideways, upwards and down, this way and that. All the facts we studied in cart-wheels and pots and pans, are in every flower a commonplace beauty ready for our appreciation.

In foliage.—Leaves of certain trees and shrubs are nearly circular in outline. The hazel, apple, alder, and some leaves of the aspen may be cited. Their foliage studied at close quarters displays the infinite variety in the forms of a circle when seen in different positions. The poplar holds its leaves well apart, each with its individual tilt, so that we cannot overlook the charm of line in a foreshortened circle. The great leaves of the burdock have often figured in the

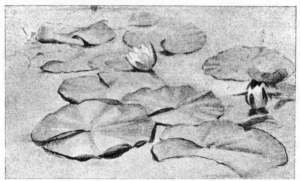

Illus. XL. *Pencil Drawing by Vicat Cole, R.A.*

WATER-LILIES.

landscape painter's foreground, and its approximate circle been made good use of in the composition. The circular leaves of celandine, buttercup, marsh marigold, and some ivies, and many others of oval form, however slightly indicated, might be given their true character if the circle and its ways are understood. Water-lily leaves give flatness to the surface of the water. They float, pointing this way and that—almost appearing as a true circle by your boat-side; reduced to the thickness of a line in the distance (Illus. XL).

Layers of foliage (notice it on the beech and hornbeam) are subject to those severe perspective rules we have been at pains to study. Subtle curves in the bending of a bough, or the composition of its foliage outline, may lose their inherent grace by a clumsy rendering, and this through neglect that passes over their governing lines unrecognised.

Circles on the limbs of a tree.—The peeling rings of bark on a birch trunk help to show its roundness. At the level of our eye a ring would appear as a horizontal line, higher and yet higher the greater fullness of the ring is seen, and so, on a picture, the height of the stem can be made the more convincing.

Foreshortened boughs might be better drawn if the student were to sketch a great gun seen from its breech, and then from its muzzle. He would understand how each contour on a limb may overlap the next stretch, and he would not overlook the direction of the curves at the junction of trunk and bough, bough and branch, branch and twig. They may seem so slight a matter, but no aid can be neglected if the bough is to stretch away from the trunk, or head towards us, for many yards ; yards that occupy but an inch or so of our canvas.

A field of flowers often suggests the use of circular lines. Daisies in rings stud the meadows, each ring becoming flatter and flatter as it is more distant, so that the spaces of grass between the dancing heads are seen less and less. The meadow, green and white in the foreground, becomes further away a white one, and the children run to the far end to pick flowers where they seem to grow more thickly, till looking back again they doubt but they left the richer spoils behind.

The forms of water.—As you watch those swirling eddies flowing from the mill-race, and see them break and pivot you have the circle at its best. Little circles revolve, and cast off others of bigger girth, these in turn lose their circumference, and become semicircles. Where the weight of water pushes forward, bows are formed that leave the more sluggish ends to lag behind. All these show the direction of the current, its strength, its forward course, or backwash, its meeting with others, and its whirlpool.

The river flowing from us gives lovely renderings of the far line (Fig. 231) of a foreshortened circle.

If we look upstream we find the bow reversed, its bellying curve nearer than its slower travelling ends (Fig. 232). Beyond these, higher up the stream, the curves appear less full, and those furthest off are so foreshortened as to seem to be straight lines. Looking across the river from bank to bank we recognise the direction and force of the stream in the groups of concentric half-circles (Fig. 233).

FIG. 231.

FIG. 232.

The relative foreshortening of each group explains the flatness of

the water surface. Sometimes great half-circular bows seem to stretch across the river's width ; an appearance that might in a vulgar way be likened to the sagging in the centre of floating ropes if their ends were fastened to the bank on either side.

Note.—You know the story of some one who deplored Turner's idleness, saying he had spent the morning watching the circles made by the stones he threw into the river ? Well, learn your perspective as he did, by studying every law of nature, after mastering what books can teach you by the winter fireside. We know he also did not despise his Malton ("A Complete Treatise on Perspective in Theory and Practice," folio 1776, Thomas Malton).

FIG. 233.

CHAPTER XI

ARCHITECTURE OF THE VILLAGE

A S this book deals only with Perspective, a description of cottage architecture would be out of bounds. Some outstanding features of cottages may, however, without straying from our subject, be illustrated, as they afford instances for the practical

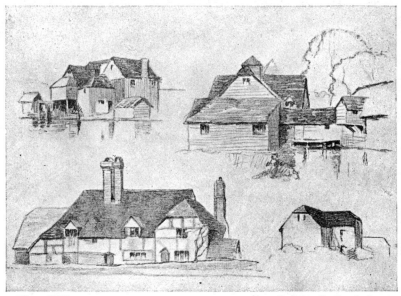

Illus. XLI. *Drawing by the Author.*
GROUPS OF ROOFS.

application of Perspective rules. My drawings incidentally present buildings that are typical of some Surrey and Sussex villages. We cannot do better than take their construction piecemeal.

Roofs.—The recurrence and accidental grouping of a few prevailing shapes, themselves simple in form, bring about an infinite variety in the sky-line of a Sussex homestead. The farm or cottage

is commonly a two-storied one ; half-timbered, and set on a low foundation wall of rough stone. It is oblong in plan, and covered lengthways by a high-pitched roof of tiles or stone slabs, or by a still steeper one of thatch. One or both ends of the main roof may be hipped, with the apex of the hip-roof surmounted by a little gable. In many buildings the hip-roof is continued downwards from the height of the eaves by a lean-to forming the roof of the wood-shed. At the back of the cottage the main roof may be continued to within four or five feet (sometimes less) of the ground. This arrangement is often beautiful in its proportions. The break in the outline caused by the hip-roof and the little gable that tops it, when seen from different points of view, present much variety in shape, suggestive of more elaborate design (Illus. XLI).

The gable roof.—Nothing could be easier to draw than the gable, but one must be careful not to let its ends inadvertently lean forward or backwards. We have but to draw two gables and join them by a roof.

Practice for the end view (Fig. 234).—Draw the end of the building on which the roof is to rest, cross it by diagonals, and raise an upright where they meet. Decide on the pitch of the roof and mark it by a dot on the upright, join that dot to the top corners of the end wall, and continue the roof sufficiently to form the eaves (Fig. 234).

Fig. 234.

Building seen foreshortened.—When we look towards one corner of the building, the side and end walls become foreshortened, but we still build the gable over one end in the same way as over the end when seen full-face (in Fig. 234). To make this quite clear we will suppose the walls to be of glass (Fig. 235).

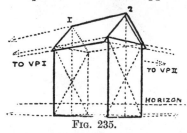

Fig. 235.

The walls built, we raise an upright through the middle of both the end walls. On the upright at the near end of the building we mark the height of the roof (2), and join that mark to that V.P. to which the sides of the building tend. The line joining the tops of two uprights (1 to 2) will now form the ridge-pole, and the skeleton of the roof will be completed by rafters leaning from the top corners of the walls to the

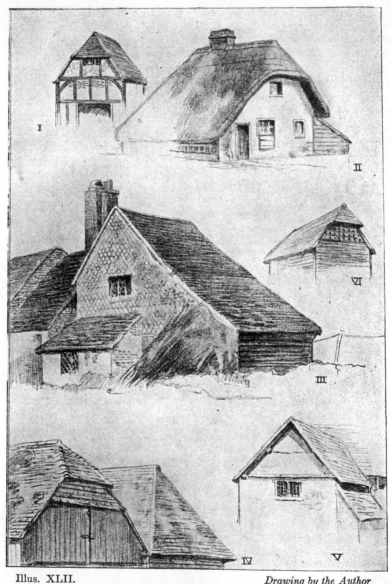

Illus. XLII. *Drawing by the Author*

SOME TYPES OF HIPPED AND GABLED ROOFS.

ends of the ridge-pole respectively. This skeleton house explains the way we should make a drawing of it. If you now continue the lines of the near side of the roof in their upward direction, you will find they meet at a point immediately over the V.P. for the end walls of the building. Also if you continue the lines at the far side of the roof in their downward direction, they will meet at a point immediately below the V.P. for the end walls (this was explained in Chap. II, Fig. 40B). But the foregoing was only demonstrative.

FIG. 236.

Practice for Fig. 236.—Draw the cottage walls. Cross the near end wall with diagonals, raise an upright at its middle. Decide on the slope of the roof, and join the top corners of the near end wall to a point on the upright to complete the gable. Rule the line of the ridge to the V.P. Continue the near slope of the roof to find "uphill" V.P., and from it rule a line to the near corner of the far end wall ("uphill" V.P. to A). (With a little practice the direction of this last line can be guessed so long as we remember it runs to the same "uphill" V.P. as the other end of the roof.)

The hipped gable.—The end elevation of a gable (with the top line of the wall supporting it) forms a triangle (Fig. 234). The triangle and the wall stand in one plane. In a hipped gable the apex of the triangle is not fastened to the end of the ridge-pole, but to a point at a little distance from its end, so that the triangle slopes back from the end wall (Fig. 237).

Practice.—Sketch lightly the gable as in the previous figure. Copy the direction of one slope on the hip (say 1–2). From the point (2) where the slope meets the ridge draw the other slope of the hip (2–3). If the roof projects beyond the wall to form eaves—then continue one of the slopes downwards (Fig. 238) as far as necessary (3–4); from its end carry a line to the V.P. The other slope is continued till it meets this line (at 5).

Roof hipped at both ends.—If both ends of the roof are formed by a hip, it will be necessary to apply the working of Fig. 237 at both ends of the building. This means that we first sketch a gable roof, and then find the points on the ridge to which the end roofs are hipped back to (Illus. XLVI).

FIG. 237.

Practice.—Sketch lightly the roof as if it were a gable. For

Fig. 239 copy the slope of the hip at whichever end it shows best (say A to B). Note the length of ridge-pole left from where the hip meets it, to its end where the apex of the gable came (B–C). From the other end of the ridge mark off an equivalent length F–D to that already cut off. (The way to do this was explained in Chap. III, but Fig. 240 may refresh your memory.) Fit in the absent rafter D–E. The ridge may be so short between the hipped

Illus. XLIII. *Sketch by the Author.*

THE PUMP-HOUSE (ROOF HIPPED AT BOTH ENDS).

ends as to give the building the appearance of having a pyramid roof (Illus. XLVI).

Gable hipped at its apex.—Often it is only the upper part of the roof that is hipped so that for some height above the supporting wall it is a gable. The effect is charming in its quaintness, and is constantly met with (Illus. XLVI).

Practice for Fig. 241.—Draw the gabled cottage as before, and a line (to V.P.) where the hip-roof joins the gable. From its near point (1) carry a line along the roof (to V.P.) to find where the other hip and gable join. Then build the hip-roof as before.

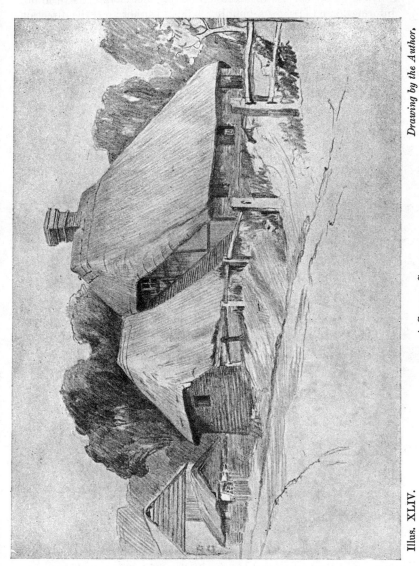

Drawing by the Author.

Illus. XLIV. A SUSSEX COTTAGE.

Note.—The real use of the diagrams in this chapter is to afford information on (1) how a building is put together ; (2) the direction its constructional lines take in perspective. If both of these points

FIG. 238.

FIG. 239.

are in one's mind's-eye when sketching, one will grasp the essential features and be able to draw them freehand with sufficient accuracy, but one may test a debatable feature—for some lines are very deceptive—by applying bits of these diagrams when in doubt.

FIG. 240.

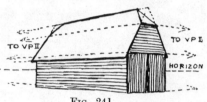

FIG. 241.

A curb or mansard roof.—This is a gabled roof that has the upper part of the slopes hipped, so that each side runs at two angles (instead of forming one continuous line from the ridge to the wall plate, Fig. 242).

Practice for Fig. 243.—Copy the slope of the lower part of the roof and con-

FIG. 242.

FIG. 243.

tinue its direction until it forms one side of a gabled roof. Complete the gable roof as previously directed. Draw a line (receding to V.P.) across the next gable to mark where the roof

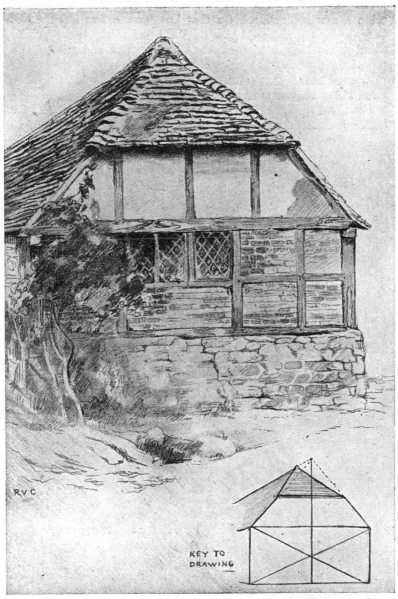

RVC

KEY TO
DRAWING

Illus. XLV. *Sketch by the Author.*

THE HIPPED GABLE OF A COTTAGE ROOF.

takes a new inclination. On that line form a less steep gable. Carry a line (B) along the tiles (to V.P.) to find the corresponding point on the far gable. Complete the new gable and rub out the top of the perspective.

Pyramid roof.—This consists of four sloping sides meeting at a point above the centre of the building.

Practice for Fig. 244.—Find by diagonals the centre of the building, either on the ground or on the top of the walls, which-

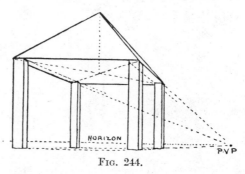

FIG. 244.

ever suits you best. Raise a vertical from the centre, copy the inclination of one side of the roof till it meets the vertical line. Make the other lines of the roof meet this vertical at the same point.

In the drawing of a brick-kiln (Illus. XLVII) we see the underside of the roof ; this we should draw first and find its centre, then set up a central pole, and on it mark the apex of the roof (Fig. 244).

Another way of finding the centre. It is not always convenient to find the centre of a roof in the manner just described. Let us reason out another way. Suppose yourself in a rectangular room, and that an X was stood upright diagonally across it so that the ends of the upper arms touched two ceiling corners and the lower ones two floor corners. Cross-lines placed thus would decide the centre of the floor (by dropping an upright from their intersection) quite as well as would diagonals laid on it. To apply this (Fig. 246) when drawing the outside of a building we first mark off the height between an imaginary floor (4, 6) and ceiling (1, 3) where they would touch the angles

FIG. 245.

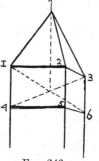

FIG. 246.

Farm Buildings.

Drawing by the Author.

of the walls (Fig. 246), and draw the diagonals as if we could see through to the walls.

Lean-to roof.—A plane sloping roof usually rectangular and attached at the top to a wall. It would be an insult to the intelligence of the reader if I described how he should draw this, but he might without offence be reminded of Rule III, Chap. II, so I add Fig. 247.

DETAILS

Gables.—On larger houses that afford more scope for architectural design, the gable becomes a prominent feature. A beautiful set of three gables is illustrated here (Illus. L). The brick courses projecting from the stone and the carved lines of the coping make up a simple but rich frontage.

FIG. 247.

When drawing an elaborate design it may be an advantage to enclose it in a triangle. Some, if not all, the projecting forms will touch the triangle. A sketch plan, as advised in Chap. IV, might be used. Of course if the gables are of equal height a line from the apex of the near one receding to the V.P. will fix the height of any others, while similar lines will give the height and direction of stone courses, brick strings, etc.

Barge-boards.—Our diagram (Fig. 248) will supply the key for drawing those beautiful barge-boards on the wooden porches and

FIG. 248.

house gables which one sees in Herefordshire, Cheshire, and elsewhere. Remember that the projection of the tiles beyond the face of the barge-boards may partly hide one side of the board in a fore-

Illus. XLVII.

A Sussex Brick-Kiln (Pyramid Roof).

shortened view ; so it is best to sketch in the complete barge-board first, and then partly hide it by the projecting tiles.

Dormer windows.—The dormer window, as regards its front and roof, repeats in miniature the structure of a gabled cottage end. The gable may be high-pitched or stunted, upright or hipped. The ridge will be long or short by consequence of the window's position in the roof or the inclination of the latter (Illus. LI).

Illus. XLVIII.　　　　　　　　*Sketch by the Author.*

This group of buildings is interesting for its many types,
including composite forms of the Pyramid and Pavilion.

Practice (Fig. 249).—Draw all the dormer except the meeting of its lines with those of the roof as you would a gable end. Copy the slope of the roof where it touches the side of the dormer (2–1). (If the slope of the roof has already been drawn, take a line from 1 to the "uphill" V.P. of the roof to find the slope of the line 1–2.) From the middle of the sill take another up the slope of the roof until it meets the dormer ridge (at 4) ; join 4 to 2.

Illus. XLIX. *Drawing by the Author.*

A SUSSEX HOVEL.

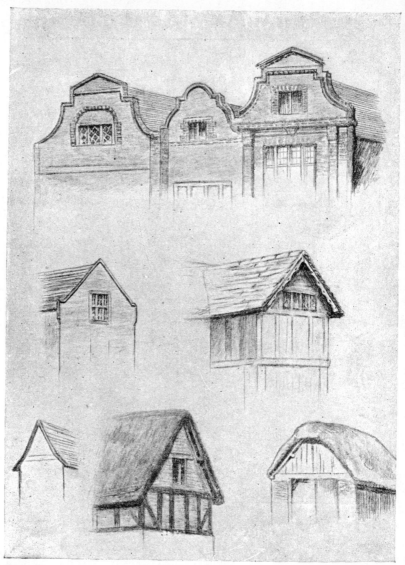

Illus. L.

Sketch by the Author.

SOME TYPES OF GABLES.

The hipped dormer can be explained by a diagram (Fig. 250)

FIG. 249. FIG. 250.

without wasting words. If the sides of the windows are weatherboarded, see that their lines run to the V.P. used for the bottom

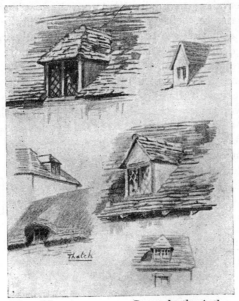

Illus. LI. *Drawn by the Author.*

DORMER WINDOWS.

edge of the tiles on the dormer roof. The cart entrance to a barn must also be mentioned here, as the same recipe will without jugglery do for both.

N.B.—It would be superfluous to detail the build of a barn; it closely follows that of a farm-house.

Chimneys.—The chimneys of a Surrey or Sussex cottage are so remarkable in their proportions and features that they cannot be overlooked. New rules need not be called into play, but the old ones must be observed, and some close observation must be brought to bear (Illus. LII). This applies equally well to the more pretentious chimney stacks on fine buildings throughout the country. These cannot be drawn in a convincing manner unless their ground plan or horizontal section is understood ; so I should advise their being studied from different points of view, and a sketch made of their plan before a drawing is begun.

To return to our Sussex cottage. The most common form is an outside chimney with a base of huge dimensions to provide the " down " hearth and ingle nooks. The massive base is reduced in width at intervals ; the gradient between the base and the smaller one it gives rise to, being weather-proofed by tiles. The edge of the tiles are sometimes hidden by an ornamental parapet. Occasionally the depth of the base, as well as the width, shares this reduction after the fashion of a buttress. But more often the face of the base and the shaft are in one vertical plane.

Chimneys carried through the roof, as well as these outside ones, are often given an appearance of slimness in their shafts by the cunning way they are set on the base. In some cases several shafts

Fig. 251.

may be semi-detached ; others are set at an angle with the base (Fig. 251), star-shaped ; or several, though square with the base, may not be in line (Fig. 252), so that unusual rectangles are left between them. The shaft-heads widen out by

Fig. 252.

successive courses of projection of bricks (Illus. LII). In outside chimneys, the angles between the back of the shaft and the roof is often spanned by a little gabled roof to avoid a gutter where the roof would join the chimney.

Towers.—A tower, square in plan, and crowned by a low-pitched pyramid spire, is a form commonly met with. The position of the windows, whether they are in pairs or centrally placed, will be found by diagonal lines, crossing each face of the tower. We have already acquired facilities in drawing the tower itself, with its groups of level receding lines meeting to right and left at V.P.'s on the horizon line, or at a single P.V.P., according to our point of view. Neither shall we neglect to carry guiding lines across one face of a wall, or to make these recede with others of its group in order to find the

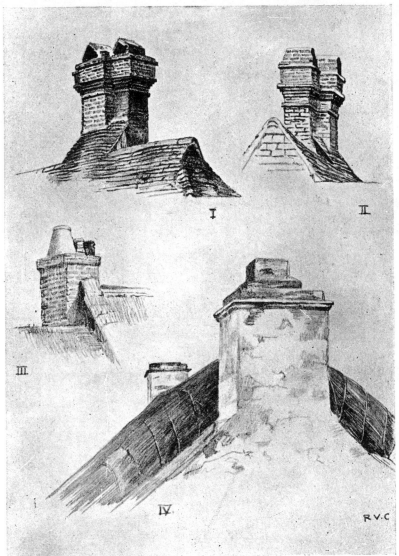

I

II

III

IV

R.V.C

Illus. LII. *Sketch by the Author.*

CHIMNEYS ON GABLED ROOFS.

height of windows equivalently placed on another side (Fig. 253).

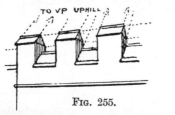

We should also do this for the "long and short" work of the corner stones if they happen to be placed with symmetry ; or we may go to this trouble merely to judge their height on a far angle.

Fig. 253.

Battlements.—The character of the parapet or battlement may call up some exercise of craft, in particular when the battlement has a capping or moulding continuous with its outline. The spacing of a certain number of

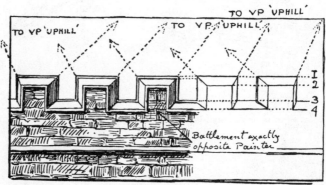

Fig. 254.

battlements with their intervals will be gauged by one of the methods explained in Chap. III. This will be worked out on the face of the wall, and then receding lines will be taken at each interval through the thickness of the wall (or up the slope of the cap moulding) to determine the back line of the battlements. In this way the upright width of each interval will be obtained (Figs. 254 and 255).

Fig. 255.　　　　　　Fig. 256.

Buttresses.—For our purpose we may consider the ground plan of a buttress as a half-square (Fig. 256), or rather as two concentric half-squares, the inner being that of the shaft. The base diminishes

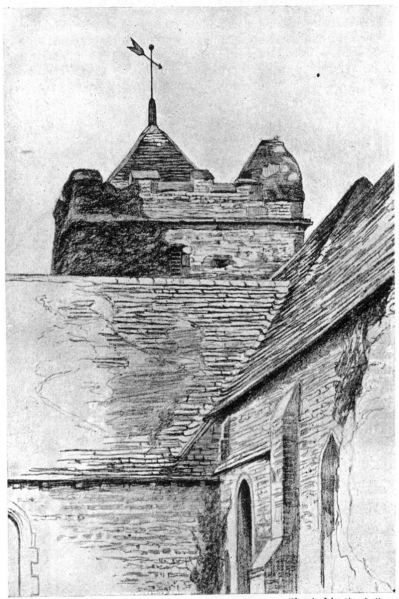

Illus. LIII. *Sketched by the Author.*

BURPHAM CHURCH.

to the shaft by a sloping " set-off." There may also be mouldings or strings from the main building carried round the buttress.

Practice.—Draw the base. Find the middle of its top line at the back and from it raise an upright. Copy the slope at one corner of the " set-off," continue its direction until it meets the upright at the

FIG. 257.

back of the base. To this junction join each corner of the base (Fig. 257). Plant the shaft on the reduced top of the base now ready for it. Repeat the operation for any similar reduction in the girth of the shaft above.

The steeple.—A pyramid steeple may be set directly on the tower walls with the lower course of tiles forming eaves, or it may rise from inside a parapet or battlements. In either case we find the centre of the tower (explained in Fig. 246), raise an upright there ;

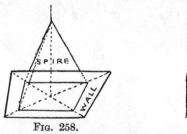

FIG. 258. FIG. 259.

decide on the pitch of the steeple ; make its apex on the upright, and complete the spire (already explained in Fig. 244).

When the base of the steeple is hidden by a parapet (Illus. LIV)

Illus. LIV. *Sketch by the Author*.

SOME LOW PITCHED STEEPLES.

we draw the underside of two foreshortened concentric squares (Fig. 258). The space between them will represent the width of the tower walls, and the steeple will stand on the inner square. These squares will be drawn at that height where the walls meet the parapet (Fig. 259).

Composite pyramid.—A pleasing variation of the pyramid steeple is shown in Fig. 260. It consists of a pyramid with a spreading base. This base is really the lower part of a more lowly-pitched steeple.

Practice.—Copy the inclination of the tower pyramid till it meets the upright that we always draw in the middle of the tower. Over this pyramid fit, at the correct height, the higher-pitched steeple.

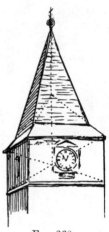

Fig. 260.

CHAPTER XII

CONCERNING DOMES, TURRETS, AND STEEPLES OTHER THAN THOSE DESCRIBED IN CHAPTER XI

AN octagonal steeple on a square tower.—An octagon has eight sides of equal length (Fig. 261). If enclosed in a square, four of its sides would lie on the middle portion of the sides of the square, the other four sides would cut across the corners. If then we find the length of one of its sides, we can construct the others by means of the square. In Fig. 261 the point A is at the end of a (dotted) line which cuts the diagonals at the same points as a circle would if inscribed in the square (explained fully in Chap. VII). The point C is the same distance from A as A is from B. The point D is the same distance from B as C is, and it is found by drawing the line C–E, and at its intersection with the diagonal the line F–D. The other corners of the octagon are found in the same way.

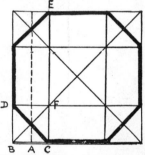

FIG. 261.—Plan of an octagon.

To draw a foreshortened octagon.— *Practice.*—Draw a foreshortened square, find the point A, then the point C (by making C–A equal to B–A), then use the line C–E as in similar circumstances described in Chap. VII.

The octagonal steeple.—Draw the foreshortened under side of a flat roof on top of the tower; on it construct the foreshortened octagon; from each corner raise sides that meet a central vertical pole at the appropriate height (Fig. 262).

An octagonal tower and steeple.—*Practice.*—Draw its octagonal roof and steeple as in the last example. From each corner seen drop uprights to form its sides. Continue the roof sides to horizon to find the V.P.'s for each side; use these for all

157

sets of parallel lines such as where the tower touches the ground, window-sills, and drip-stones, courses of masonry, and strings (Fig. 263).

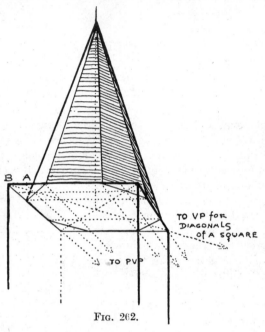

FIG. 262.

Fig. 264 represents an octagonal dome and turret surmounting a square tower.

Composite octagon spire (Fig. 265).—An octagon spire not rising directly from the tower—which is of larger dimension than the base of the octagon—but joined to it by another roof.

Practice.—Draw a foreshortened square to represent the underside of a flat roof to the tower. Inside this (see " concentric squares ") form a smaller one ; raise the latter and form an octagon on it. Join the corner of the octagon with the tower corners, and allow for eaves.

Any exercise with the octagon can be simplified by remembering that if four of

FIG. 263.

FIG. 264.

its sides lie on a square, the remaining four sides lie at an
angle of 45 degrees with the sides of the square. We should
apply this in a front view of a tower by taking the near sides of the
octagon that cut across the corners to the V.P.
for diagonals ; one to the left, one to the right.
If by chance the far sides should be visible,
remember they use the same V.P.'s as the near
sides (i.e. the far side on the right is parallel to
the near side on the left, and so it uses the
"diagonal" V.P. on the left, etc. (Fig. 266).

Details of the same.—An octagonal spire is
often set on a square tower with merely a tablet
in place of a parapet. Examples of this are
given in Figs. 267, 268, 269. Then the triangle
left between the face of the spire where it cuts
across the tower corner is filled by two sloping
sides that taper and meet on the centre of the
spire-face. These are the visible parts of the
"squinches" or small arches which cross the
tower corners and support the octagonal spire.
There may be gabled lights on the faces of the

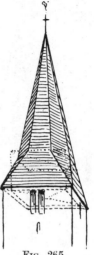

FIG. 265.

spire, as are shown in Fig. 268. They present no new problems,
being similar to a gabled roof-window.

Practice (Fig. 267).—Draw ceiling of tower and on it an octagon.
Raise central upright. Form pyramid roof A, B, C. Cut off at

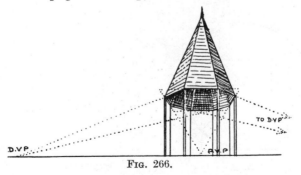

FIG. 266.

D, E. Raise spire from corners of octagon. Join " E " the centre
of one face of the spire with 2 and 3 its base. It is already joined
to the corner of the tower F.

An octagonal spire on a round tower.—We see from the plan

(Fig. 270) that if a circle is inscribed in an octagon, it touches it at the middle of each of its sides. We know how to find these points

FIG. 267. FIG. 268. FIG. 269.

(1 and 2) from our familiarity with the circle (Chap. VII). We also recognise that the corner B is found by the intersection of the line from C with the diagonal (Chap. IV).

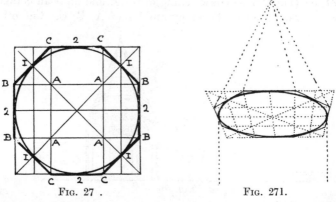

FIG. 27 . FIG. 271.

Practice (Fig. 271).—Tick off from the plan, Fig. 270, the points X in order to locate B by means of intersection of diagonal at A. Refer to Figures 261, 262 and explanation if you find this one insufficient.

A dome (Fig. 273).—*Practice.*—Make a plan of half a circle (A) ;
on it mark off divisions required. Draw outline of dome, and
across (the middle of) its base the line 1, on this transfer divi-
sions from line 2 of plan. From P.V.P. carry lines to extremities

Illus. LV. *Sketch by the Author.*

COMPOSITE OCTAGON SPIRE.

of line 1 and continue them to form sides of a foreshortened square,
on which the dome rests. From P.V.P. carry lines through each
division of line 1 ; construct circle. Mark where lines radiating
from P.V.P. cut circle, and from each division on the circle draw,
freehand, the lines from base to apex of dome ; carry these (divi-
sions on the circle) vertically downwards also if columns are present.

The depths of the perspective square is found by a line (2) from its centre (the intersection of the central vertical, with the horizontal middle line) to D.V.P.

A door as it is opened travels on the circumference of a circle.

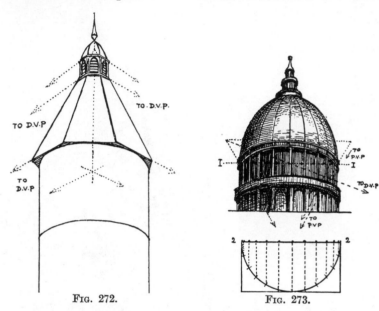

FIG. 272. FIG. 273.

Any projection on the bottom of the door would scrape a portion of a circle on the floor ; another from its top might mark a circle on the ceiling. Remembering this we could, but we do not, draw one circle above another by imitating the motion of the door.

Practice (Fig. 274).—First draw a foreshortened circle ; find its centre, and on it raise an upright for the door to swing on (1). From the centre of the circle rule a line to the circumference (to make the bottom edge of the door), and continue it to the horizon to find the V.P. ; join the V.P. with the upright pivot to make the top edge of door. Join the bottom edge where it touches the circumference to the top edge. Repeat this operation to represent the door at various angles. Use all the outer top corners as guiding

FIG. 274.

FIG. 275.

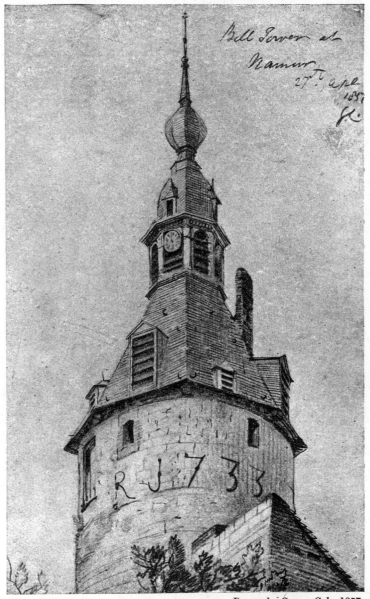

*Bell Tower at
Namur,
27ᵗʰ apl
1857
fc*

Illus. LVI. *Drawn by George Cole, 1857.*

THE BELL TOWER AT NAMUR.

points for the circle, and it will be correct in perspective in relation to the other circle below.

If the outer top corner had been rounded the door would have resembled half a dome (Fig. 275). If such a door were opened at equal intervals, each representation of it would give the exact curve of the lines that run from the apex of a dome to its base.

Practice (Fig. 276).—Draw the outline of the dome and the fore-

FIG. 276.

shortened circle it stands on. Divide the near side of the circle into spaces that on the plan would be equal. On the centre of the circle swing a rectangular flap 1, 2, 3, 4 ; draw a diagonal across it (3–1), and where the diagonal touches the dome draw a horizontal line A, B. Now construct a foreshortened flap by first joining one of the divisions on the circular base with the centre of the circle C–1. Continue this line to the horizon to find V.P., join V.P. with the top of the pivot (4), and continue it to D, join D to C.

FIG. 277.—Half plan of circle.

CHAPTER XIII

PERSPECTIVE OF THE SKY AND SEA

PERSPECTIVE of the Sky.—The wonder and delight we experience in looking at the sky need not be less, or its forms appear in a matter-of-fact light, by reason of our enquiring into the laws that govern its exquisite embellishment.

Cumuli.—We cannot look at the massed cumuli of thunder-forms without feeling their power and dignity, but we gain facility in drawing them, if the foreshortening of their serried ranks is familiar to us. The regular lessening in the width and depth of receding shapes ; the overlapping of nearer contours ; the reduction in size of more distant forms ; have all been the subject of former exercises. These should not be overlooked, because the scenery of the sky has so many other powers of attraction.

Cirrus clouds.—In wisps of the upper sky ruled by the winds we find every form that fantasy can suggest. On one day drawn-out lines span the whole vault overhead, each line steering to a meeting-point straight ahead of us. If we " about turn " we see the phenomenon repeated, for the other end of the lines meet again at another point opposite the first. Stand in the centre of a long building and look along the roof—its lengthways timbers steer to a V.P. at one end ; turn your back on it, and the timbers tend to a V.P. at the other end. It is the same rule for the mechanical boards as for these delicate strands of vapour. This statement must not be taken quite literally because the V.P. for the receding lines of the building would be on the horizon. The V.P. for the lines of clouds would be far below the horizon because the clouds are, as it were, the underside of a semicircular ceiling.

On another day curved wisps are arranged in groups ; each wisp in a group radiating from the vanishing point for that group. It often happens that in the upper group the wisps radiate upwards from a vanishing point below. Another group to one side and lower, carries its wisps more horizontally, so that they radiate from a vanishing point under that of the upper group. A third and still

lower group takes a more horizontal position. In this manner the radiating ends of all the groups are arranged on a curved line. Another day finds the wisps in horizontal rows ; each more distant row seeming to be narrower in regular sequence. Each wisp in the row filled, as it were, by the wind and bellying from it ; its tail recurved by a current from the opposite quarter. This double curve, beautiful in itself, is subject to those changes that our view of it affords. In the upper row overhead—almost an S in shape—it

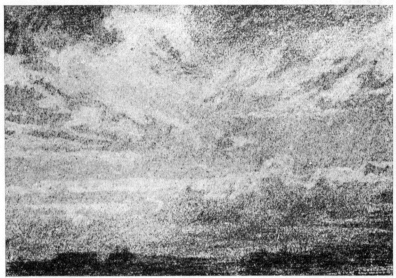

Illus. LVII. *Drawing by the Author.*

CLOUDS.

becomes flatter in each receding row, till nearing the horizon it hardly differs from a horizontal line. Away on either side the curves become more and more lengthened.

Cirro-stratus.—Dappled cloud patterns of a more fleecy character than the " mare's tails " present somewhat similar effects. The curved wisps we mentioned may be thought of as imaginary side edgings for numberless detached or semi-detached fleeces lying between them at right angles. The group arrangement holds good, and sometimes becomes more intricately beautiful from the crossing of groups brought into position by cross-currents.

The countryman, always ready to find a telling and often pleasing name for Nature's subjects, has dubbed some forms of mottled skies with the nicknames " mackerel-back," " Mother Carey's chickens," " hen-scratted."

Ruskin aptly likens them to sea-sand ribbed by the tide ; the scientist coldly labels them cirro-stratus.

Whatever you call them, remember they are made up on a system, not haphazard ; that curved lines varied by our perspective view

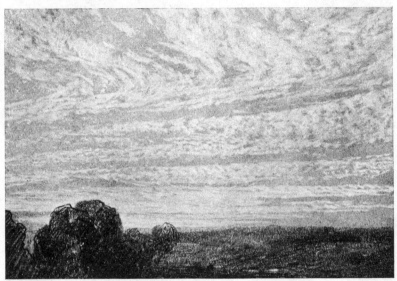

Illus. LVIII. *Drawing by the Author.*
CURVED WISPS OF CIRRO-STRATUS.

underlie their arrangement ; and that in their component parts, and as a whole, they tell which way the wind blows.

Stratus.—The perspective of the lower region is of the simplest kind and may be likened to a boarded ceiling ; our view being across the boards. As, however, these long horizontal stretches of cloud are impressive by the repetition of their lines, one must render the full extent of their receding surface by the gradual reduction in their depth. Near the horizon the closeness of their dividing edges must be carefully observed. In painting a corresponding perspective of the brush strokes may assist the impression of distance.

Other clouds less regular in order—more cross-bred in character—make fine groupings. Here again the foreshortening of surfaces and spaces between is all-important. Their massing in the horizon and detachment overhead—the breaking away of units from collective groups—their tendency to radiate from certain points—are matters all concerned with simple perspective laws that cannot be neglected.

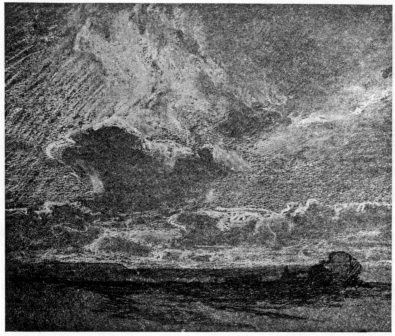

Illus. LIX. *Drawing by the Author.*

CLOUDS.

The perspective of smoke.—It is worth notice that lines of smoke (say from a row of chimneys or a line of ships) though really travelling with the wind in parallel lines appear to tend to a distant point. That is only an example of our first rule. But one has met people disturbed by this apparent incongruity when they looked out to sea instead of overhead to find which way the wind lay.

Curvature of the earth.—Looking down from the hill-top on to

the land below, the nearer fields appear to slope upwards as if we should have a slight incline to traverse before we reached the distant plain. The middle distance appears to lie more level—the far distance quite so. In pictures we represent all this as one level plain stretching to the horizon.[1] We do so because this is how people think of it, and it adds nothing to the beauty of Nature to make it otherwise. If we were recorders of facts and science only, we should use horizontal lines on which to place our vanishing points for each surface, one line for the foreground, another for the distance, and a third for the far distance, and by this means could convey the impression of the rotundity of the earth.

In painting the sea we cannot neglect this curvature, for has not even the tripper to Clacton learnt to say " hull down " when speaking of a ship sailing behind the visible horizon ? We have to reckon with this " dip " of the sea ; for its most distant visible surface is below our horizon line, and ships in our picture if continued to it would rest on a cushion of air instead of floating on the sea.

In Nature we see the hull of a ship appearing to rise more and more out of the water as she nears the horizon. It sits as it were on the edge of the water silhouetted against the sky. After this the hull sinks and sinks behind the sea-line till only a mast-head or line of smoke betrays her existence. Standing on a cliff we can clearly observe this surface curve from the shore to the open sea. In practice, then, we use a horizon line above the sea surface for the V.P.'s of our foreground sea, the sea-level as an horizon for the most distant strip, and if necessary a lower horizon for all that lies beyond. Above all we remember we are drawing a surface that might vulgarly be likened to the outside of a huge cylinder. If instead of a cylinder I had said "convex surface" I might have implied that the curvature from left to right had also to be considered, but this (as explained in the introductory chapter) is not the case.

A six-foot man standing on the sea-level cannot see its surface beyond three miles away, and he would have to be twenty feet above sea-level before he could see five miles.

Visibility of distant objects.—In a nautical almanac I find this table (abbreviated) of the distances of objects seen at sea. In using it, you first reckon the distance visible according to the height

[1] Not quite. We ought to take our foreground to a V.P. a bit above the visible horizon, and to flatten the far distance as if its plane ended at a line below the horizon.

of your eye above sea-level ; then the distance that would be visible from the height of the object ; then add the two together. I add a diagram to complete the explanation.

Height Feet					Distance of horizon Naut. miles
1	1·15
6	2·81
10	3·63
15	4·46
20	5·15
40	7·27
80	10·28
150	14·98
400	23·00
1000	36·36

Example.—A man 5 ft. above sea-level can see only for 2·57 miles. At 100 ft. above sea-level he would see 11·50 miles. There-fore the actual distance of the object 100 ft. high that he can see is 14·07 nautical miles from him. The curve of the sea is also appre-

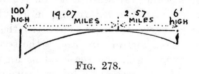

FIG. 278.

ciable when looking along the shore rim ; the lines of the breakers —unless our view is a very low one—tend to a V.P. well above its distant surface.

Foreshortened surfaces.—One would be but dull-witted to miss the chance of foreshortening waves by means of the lines, curves, and circles of the spume. It explains the flatness or upheaval of a plane just as the decoration on a jar helps to explain its roundness, or the pattern of a dress the shape of a figure. Men who have painted the sea and impressed us with the feeling of its restless heave, and weight of water, have done this, not by their intimate knowledge of its form alone, but by an understanding of that subtle perspective we call foreshortening ; Turner, Henry Moore, Julius Olsson, each in his own way, show us its grandeur. We cannot take their pictures line by line to show how each had its meaning, but it must be looked for in pictures and in Nature. The truth that dis-

tinguishes all good art is attained only by the hand working under two forces simultaneously—the observation of natural laws and beauty, and the almost unconscious reasoning that selects the right forms ; and so the mind of the artist is added to that which he paints.

CHAPTER XIV

REFLECTIONS in water.—Perspective of colour has not been considered in this book. Moreover, it is impossible here to make an exhaustive study of those amazing effects in reflection caused by movement in water. All this has been searchingly inquired into and lucidly explained in that beautiful book, "Light and Water," by Sir Montague Pollock. That work should be read to supplement the bald facts that every painter must know.

Reflections in smooth water.—*Theory.*—Rule : "The angle of reflection is equal to the angle of incidence" (Fig. 279). Let us take one point of an object to be reflected, and call it the "object."

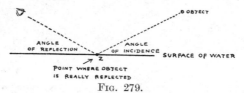

FIG. 279.

But the reflection of the object does not really appear to be at Z, as shown in Fig. 279, but at X (Fig. 280).

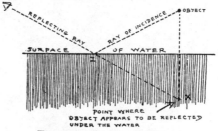

FIG. 280.—Section of Water.

It will be seen that X is on a continuation of the reflecting ray, and that it is the same depth *below* the surface of the water as the object is high above the water.

Practice.—Rule A. Find the surface of the water immediately

172

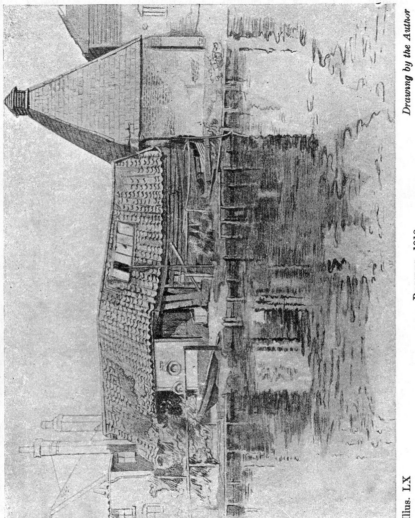

Drawing by the Author

Illus. LX

BECCLES, 1918.
Notice the reflections.

under each point to be reflected. Rule B. The reflection of each point will be on a vertical line dropped from that point. Rule C. The reflection of each point appears to be as far below the surface of the water (directly under it) as each point to be reflected is above the surface of the water (Figs. 279 and 280). Rule D. The image in water of an object is found by reflecting each of its essential points one at a time, and then joining them in the image as they are joined on the object.

Example of Rules A, B, C, D (Fig. 281).—An upright stick standing out of a sheet of water.

Practice.—First mark where the surface of the water touches the stick (1). Measure the height from that water surface to the top

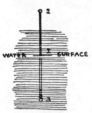

FIG. 281.

of the stick (2), and repeat that measurement below the water surface on a vertical line dropped from the top of the stick. The point 3 is now the reflection of the top of the stick. Join 3 to 1 to complete image.

Another example (Fig. 282). An upright post standing out of a sheet of water.

FIG. 282.

Practice.—Mark where the water surface touches the near side of post (at 1). Drop verticals from every point to be reflected. Measure the height from the water surface to top of post, repeat same measurement below the surface (1–3) on the vertical lines, and so obtain the two edges of the near side of post ; join them to make the reflection of the top line. Now mark the surface of the water where it touches the far side of post (at 4). Measure height of post (4 to 5) above surface at this point and transfer it to below surface (4 to 6). Join the corners (6 to 3) of the post.

If we repeat Fig. 282 by Fig. 283 and continue the receding lines of the reflection we find they tend to the same V.P. as the lines they are the image of ; and this is always the case when the lines are in Nature level lines, so we can add Rule E.

Rule E. **Reflected lines.**—The reflection of a line that is in Nature level, tends to the same V.P. as the line it reflects. Much labour in measuring can be saved by remembering this. For instance, in Fig. 283 a receding line from V.P. to corner 3 would decide the length of line 4–6.

Rules A to D apply equally well to lines that are not level.

Fig. 284 represents a post leaning to one side of us.

Practice.—Find surface of water when it touches post (at 1). Draw vertical from top of post. Find surface of water beneath top (at 2). Measure distance from top of post to water surface 3–2. Transfer that length below surface 2–4. Join reflected top of post (4) to where post rises from water (5).

Fig. 285 represents a post leaning towards us. In this case, in order to find where the surface of the water would be under the top of post, we must guess where a pebble dropped from its top would splash (say line 1) then carry on as before.

In Fig. 286 the post leans to the side and from us. Guess the splash as before (same rules).

A stick leaning to the right and projecting from a mound affords another example (Fig. 287).

FIG. 283.

FIG. 284.

Practice.—Find where surface of water would be under bottom of stick (1). Drop verticals from any point to be reflected. Measure their height above surface (2–3, for example), and repeat them (on verticals) below surface (2–4).

Try the same rules for a curly stick (Fig. 288).

When you first sketch from Nature you may think I mislead you in these

FIG. 285. FIG. 286. FIG. 287.

rules, because the view you get of an object is often so entirely different from the view the water gets (excuse the expression) of the object, and this will account for apparent discrepancies that your wits alone must account for.

Reflection of inclined planes.—We saw that the reflection of lines which are in Nature level tend to the same V.P. (Fig. 283) as the

originals. It is interesting and possibly useful to notice that the reflection of an inclined plane tends to a V.P. of a plane lying in the reverse direction (provided both are at the same angle). Thus the "uphill" V.P. of a gable roof serves for one side of the roof itself and for the reflection of the other side; while the "downhill" V.P. acts in the same way (Fig. 289).

FIG. 288.

The reflection of objects distant from the water.—
We have said that the image of each point to be reflected, is as far below the surface of the water directly under it as the point itself is above the water surface.

When objects do not rise out of the water but are distant from it, we must imagine the water to be continued till it is at their

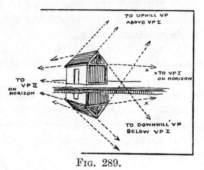

FIG. 289.

foundations, or the foundations of the ground they rest on; this done, we proceed as before.

Fig. 290 shows a post set back on the embankment. The height of the embankment is repeated in the reflection, but only a part of the post is reflected.

The tip of the distant tower is reflected, its body and the hill are not. The reason being that land occupies the surface where the reflection would come.

There will be sufficient accuracy in a composition done without reference to Nature by this habit of imagining water to replace

FIG. 290.

the land surface. With Nature before one it will prevent the occurrence of absurd mistakes. The punts in Fig. 291 and Illus. LXI are useful illustrations of the rules taught by the less interesting Figs. 286 and 287.

Illus. LXI. *Drawing by the Author.*

Notice the reflection of the underside of the punt and the angle of the paddle.
Also that the eel-basket is not reflected.

Our delight in watching still water is often due to the tricks its surface seems to play on us. In it appears, perhaps, the underside

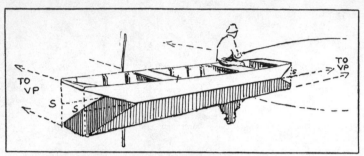

FIG. 291.—Notice the reflection of the invisible underside of punt, and the reflection of half the fisherman.

of a footbridge we look down upon, or the dark lower surface of overhanging leaves instead of their sunlit tops. The water sketches, as it were, an important bank outlined dark and sharp against a clear sky as the reflected picture of an insignificant river-edge and

FIG. 292.

miles of flat country. Objects that are in Nature hidden from view by others intervening, appear in the water side by side with distant and near ones, and yet nothing is haphazard, but all conform to the everlasting laws of Nature.

Reflections of an archway or bridge. —The same rules apply to the reflection of arches.

Practice.—Draw the bridge (Fig. 293) and a line along the surface of the water where it touches the near side of the bridge 1–2, and a corresponding one on the far side 3–4.

These lines will be under the face of the arch on the near side and the far side of the bridge respectively, and consequently will mark the surface of the water beneath each.

We can now drop verticals (line A–B, Fig. 294) from any point to the surface to find how far below the surface (line B–C) the reflected point will come.

If there are projecting buttresses remember to draw additional similar lines where they touch the water surface.

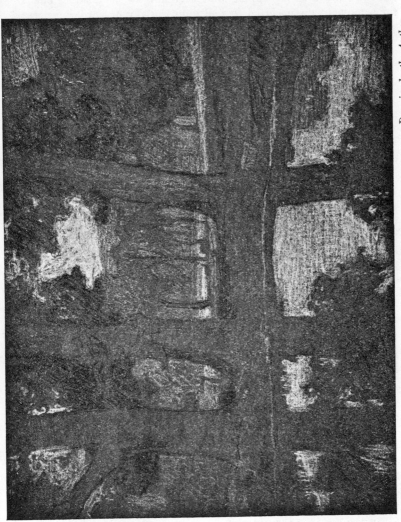

Illus. LXII.

Drawing by the Author.

THE HILL-TOP POND.

Notice that the distant trees and hill are not reflected and read explanation.

Reflections in a raised canal or pond on a hill-top.—Standing by a hill-top pond with the sloping land stretching to the distance one is for a moment disconcerted to find only the sky or bordering trees reflected. The reason for this is clear enough when we recall our

Fig. 293.

Fig. 294.

rules. If in Illus. LXII, for instance, we continue the surface of the water we see that it could never come directly under the distant trees, in fact it would be above the level of their tops, and so they cannot be reflected. This does not apply to the tops of the trees higher up the slope, and we see their reflection.

Reflection on a sloping surface.—When a sloping surface such as wet sand gives a reflection the image will not be under the object,

Fig. 295.

as is the case in still water, but it will be inclined to one side (Fig. 295). Its divergence from the vertical position will be slight if the sand is nearly level, and more pronounced on a steeper slope.

Reflections in rippled water.—Our notes on the angle of incidence and reflection still hold good.

The law that a reflected point is somewhere on a vertical line under the point itself also may stand.

The law as to the relative height of an object and its reflection must be modified.

The chief differences between still and slightly rippled water are : (1) the image instead of repeating the height of an object may be elongated ; (2) the image is incomplete or interlined with the reflection of another object, or by different parts of the same object ; (3) in the distance the object is often more closely resembled than in the nearer reflection ; (4) vertical objects are seen in the reflection, when narrow horizontal ones are not repeated.

(1) Lengthening of the image. Let Fig. 296 represent the length of the reflection of the tree as seen by the painter. Let Fig. 297

also show this, but with a ripple in the painter's foreground. He will see a portion of the ripple turned partly away from him, and in this new plane the reflection of the tree. This accounts for the reflection appearing longer, as in Fig. 299.

FIG. 296.

FIG. 297.

(2) We account for the image being broken or incomplete by Fig. 298. The ripples in it have several planes, and each of these planes reflects at a different angle. The reflection from two planes of the ripples only are shown to save confusion. One sees that tree and sky might be reflected alternately. His picture therefore would be like Fig. 299, the closeness of the reflection lines in the distance being partly due to their foreshortening. In part also to the fact that the near sides of the distant ripples might catch the reflection of the tree (from the angle they are seen at), instead of reflecting the sky as the near ones would do.

FIG. 298.

(3) This also supplies a reason for the closer repetition of the image far away, though another common cause is that the edges of the river or lake are less ruffled than the outlying surface.

FIG. 299.

FIG. 300.

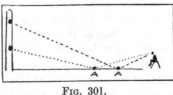

FIG. 301.

(4) Horizontal and vertical lines. Horizontal lines being missed in the reflection, though vertical ones are shown. Perhaps this is the most characteristic quality of rippled water. In Fig. 301 let us suppose an upright post or wall and the dots to be horizontal bars. The reflections of these bars could only appear a certain distance (A). If a ripple occurs at these points it destroys the reflection of a bar, but one of the many planes on the ripple is sure to catch some

part of the wall. The part it catches might be higher up or lower down than that part reflected in still water. It is an everyday experience to see the upright posts of a railing reflected but the image of the rails missing.

The lengthening of an image vertically is often due to the same spot being reflected in various planes of successive ripples, and so at night we get those beautiful lines of height stretching towards us from the harbour lights.

Reflection of the moon.—These pathways of light are roughly the same width that the object throwing them appears to be. One notices this fact in the lengthening reflection from the moon on slightly rippled water. On rougher water the reflection will be

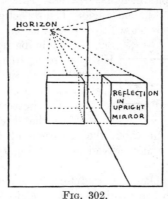

FIG. 302.

caught by the sides of waves outside the regular path, and so extended horizontally to a wider and less sharply defined streak. It is a mistake to think of this streak of light literally as a silver path on the surface of the water ; if it were so, its sides would converge towards the horizon. The width of the streak varies as the moon is high or low, and it may be deflected to one side by waves running that follow the line of the horizon.

Note.—Though we said that reflections are always vertically under the objects, I have noticed one is apt unconsciously to represent the reflection of vertical lines as very slightly inclined towards the spot we stand on, and I have seen them so painted, and I think rightly so, by artists of repute.

In the harbour when the water heaves with a gentle swell, we see effects that seem to contradict every rule of still-water reflections. Wonderful loops, half-circles, and zig-zags as the reflections of an

upright mast or even bits of images not upside down but as the object, the latter phenomenon being accounted for by the curves in the water acting as a convex mirror would.

Reflections in a mirror.—The same rules by which we copy an image in still water have to be used (A) when the reflection is given by a mirror with its surface in the same plane as water (i.e. level). Therefore we need not repeat the instructions when the mirror lies in a level position below us. (B) If the mirror stands in a vertical position (Fig. 302) on one side of us, we carry horizontal lines across from each point to be reflected, till they touch the mirror's surface and continue them the same distance beyond, to fix the reflection of the point. When each point is reflected and joined, it will be seen that the receding lines in Nature and their reflection have the same vanishing points.[1]

(C) The reflection in a mirror lying level above the height of our eye is subject to the same rules as one lying below the height of our eye. The chief difficulty is getting used to carrying lines up to the mirror's surface instead of downwards.

In the case of A, B, C, if the mirror is a small one or nearer to you than the object you must continue its surface until it is (for A) under, (for B) opposite, or (for C) over the object, as the case may be, just as you continue the surface of water until it is under the object.

Refraction.—We see the most perfect reflections when our head is near the level of the water ; the reason being that our eye receives the greater number of rays that are reflected from the water surface, and it does not perceive the colour of the water or stones at the bottom, which become visible by refracted rays.

Some rays of light as they strike the surface of water are reflected, the remainder refracted ; that is, they enter the water and continue their course still by straight lines, but at an angle in a more vertical direction towards the bottom. It follows that if we retrace the

[1] A man of science explained this to me most admirably. "Think of a room furnished and arranged exactly the same at one end as at the other ; let it be divided through the centre by a sheet of glass. The half of the room you see through the glass may be considered as the actual reflection of the other half, and can be drawn by perspective rules just as if it were the room itself."

In a plane mirror the image is a fixed one, and will appear different to us as we get a new view of it. This is not the case in convex and concave mirrors. As regards the latter, I was cautioned not to come to the conclusion that the laws as taught in books on science could be applied direct to the laws of appearance.

course of a refracted[1] ray from a stone on the river-bed, that it reaches the water's surface by a straight line, and leaves it by another that is less vertical, and so reaches our eye. When we look at the water we do not reason out this angle in the rays' journey, but we think we see the stone on a continuation of the straight line from our eye ; and are deceived into thinking the stone to be nearer the surface than it actually is.

The reason for reflections appearing more perfect as we approach the level of the water is that more of an oblique ray is reflected, and less refracted, than of one that strikes the water in a more vertical position. The lines of foreground rocks, water plants, and objects partly submerged constantly show the refraction. They are often beautiful and should be studied, and a beginning might be made by looking at Millais' " Ophelia," and by observing such common-place effects as a slanting stick with its submerged end appearing to be tilted upwards.

[1] The laws of reflection and refraction as given in text-books on science, must be accepted with reserve, for the reason that the alteration in the appearance of lines from perspective is not considered. Often more can be learnt by a stick, a pail of water, and a looking-glass, than by books which are not written for artists.

CHAPTER XV

PERSPECTIVE OF SHADOWS

THERE is a good reason for understanding the principle of shadows ; though it is not always realised by students. You may have thought of a fine subject, and yet miss valuable features that would have been suggested by perspective, as the subject unravels itself from the first hazy idea. For instance, a dramatic subject might be a shrine lit by a single light and approached by steps ; on them a figure, seen from behind, in a supplicating attitude. The light throwing radiating shadows down the steps would just add the mystery and bigness necessary for the subject.

Out of doors we see somewhat similar radiating shadows from tree trunks between us and the setting sun.

We ought at least to know the bare rules governing these two types of shadows.

The shape of a shadow will at times convey our meaning better than the object itself. Have we not seen pictures of cloaked and hatted conspirators round a table, their guttering rushlight throwing fantastic shadows on the wall that were more expressive of their evil machinations than the plotters themselves ?

Again a shadow may be thrown from things hidden from view and thus explain their shape. Or a shadow from some trifling object may bring out the good points, or least explain the form or surface of the plane it is cast on.

The rules usually given for drawing shadows are many and complicated.

Looking at numerous examples under varying conditions is a pastime apt to deter one from learning the underlying principles. Therefore I tried to confine myself to the most simple object—the side of a wall—for each example, in order to show how the shadow would be obtained under some of the more usual conditions of lighting. The monotony of that reiterated blank wall forced me to add other diagrams to demonstrate the practical use of the rule.

Shadows from the Sun

(1) **Sun on one side of the subject.**—Suppose the sun on our left ; the ground level, an upright wall receding from us.

If the sun is not in front, or behind us, its rays will travel in parallel lines. These lines of light, since they cannot pass through the wall, travel over the top. Where they strike the ground the shadow from the wall ceases.

Practice for Fig. 303.—Draw the wall. Draw horizontal lines on the ground from its nearest and farthest base (1–2, 3–4), or from any other points such as 5–6. From each point marked (where the

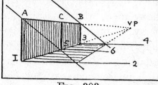

FIG. 303.

wall touches the ground) raise uprights to the top of the wall (A, C, B). Decide on the slope of the sun's rays and carry them in parallel lines over the wall at each point marked. Where they meet the ground join them, to give the extent of the wall shadow. It is obvious that the rays from the sun when high in the heavens will be more vertically inclined, and the shadow consequently narrower, than when the sun is low and throws more horizontally-inclined rays.

If you doubt rays from the sun being parallel when it is on one side of you, go out one misty autumn morning and observe those

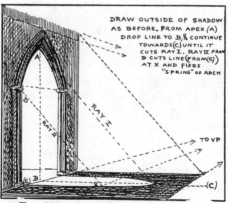

FIG. 304.—An application of Fig. 303.

lovely lines of light that pass over the hedge and light the sparkling dew or melting hoar-frost. The shadow looking cold and blue with the rime is clearly defined.

Illus. LXIII. *Drawn by the Author* (*Brinkwells*, 1913).

A study of sunlight shadows thrown by the sieve and tub on to the uneven
surface of the weather-boards.

(2) **Ground sloping from the object that throws the shadow.**—
Using our same wall, let us make the ground slope evenly (and
always at the same inclination) from the wall. The rays of light
must be continued until they meet the ground—the only difference
between Figs. 303 and 305 is in the greater length of the shadow.

Practice (Fig. 305).—Draw the wall and the inclination of the

sun's rays as before. Represent the
slope of the ground by lines carried
from certain points at the base of
the wall, mark these certain points,
and above each over the top of the
wall take a sun's ray until it meets
the ground.

FIG. 305.

Example.—The shadow of a chimney on a sloping roof.

(3) **Shadow from an object meeting an upright surface.**

Practice (Fig. 306).—Same as for Fig. 303, but the shadow instead
of being continued on the ground is caught up
by the vertical surface, its top being determined
by the direction of the sun's rays. The foregoing
examples of the sun on one side make it clear that
common sense and a few guiding lines are the only
necessary equipment.

This leaves the mind free to appreciate and
render the fine outlines of shadow that unevenness
of the ground or the shape of the object make
manifest.

This is more especially the case when single
objects or detached groups cast their shadows.

FIG. 306.

Each shadow dips into a hollow and rises over each
contour ; becomes foreshortened on the far edge of a slope, or
hidden by a projection that catches the sun.

Mathematical accuracy is not required so long as general truth is
observed and the beauty to be found in lines is given full play.

SUN IN FRONT OF US

(1) **Sun throwing shadows towards us.**—On level ground when
the sun is in front of us, or rather in any position except behind us,
or to the side of our subject ; then its rays are no longer to be drawn
parallel. They must radiate from the sun, or if you prefer it, must
have the sun for their vanishing point.

Practice for Fig. 307.—Draw the object. Mark the position of
the sun. From it take lines over the top of the object to represent
the sun's rays. Mark the ground under each spot where
the rays touch the top of the object. The vanishing point
for the shadows will be immediately under the sun on the
horizon line. From the "shadow"
V.P. take lines to the marks on the
ground, and continue them till they
meet the ray above each mark.
Join each point so found in the
same order as the original points of
the object are joined.

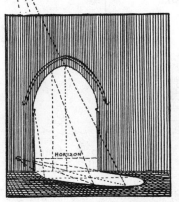

(2) **Shadow on ground sloping to-
wards us.**—The V.P. for the shadows
will (as in the last case) be directly
beneath the sun, but instead of
being at the height of the horizon,
will be at the same height (not
necessarily in the same place) as the
V.P. for the ground.

FIG. 307.—Application of Fig. 309.

Practice for Fig. 308.—Draw the
object, the ground, the sun, and a vertical dropped from it. Find
the "uphill" V.P. for the ground; at the same height mark the

FIG. 308.—Application of Fig. 310.

V.P. for shadows on the vertical (i.e. under the sun). Draw rays.
Under the top points of the object touched by rays mark ground.
From "shadow" V.P. draw lines to ground marks and continue.
Join meeting points of rays and ground as in last case.

(3) **Shadows on vertical planes.**—In former cases we found that the " shadow " V.P. lies in the same plane as the surface the shadow is thrown on. Thus on level surfaces the " shadow " V.P. is on the

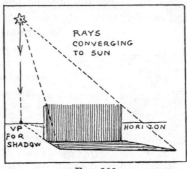

FIG. 309.

horizon. Again, when the surface was sloping up we found the " shadow " V.P. at the same height as the " uphill " V.P. of the sloping surface. In both cases the " shadow " V.P. was directly under the sun. The " shadow " V.P. for shadows cast on upright planes is found to be at the height of the sun and immediately above

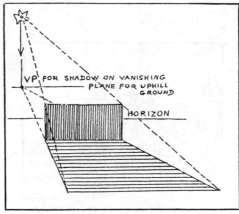

FIG. 310.

the V.P. to which level lines on that plane recede. And so the " shadow " V.P. still retains its custom of being in the same plane as the surface on which the shadow is cast.

Practice for Fig. 311.—To draw a shadow on a vertical receding

plane cast by a horizontal projecting surface. Draw the object, its V.P., the horizon, and the sun. Take a ray from the sun to a

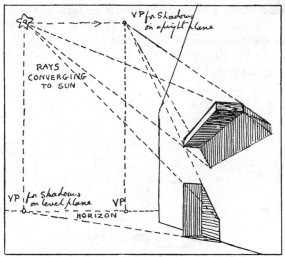

Fig. 311.

corner of any surface projecting from the upright. From the " shadow " V.P. carry a line to the junction of the upright surface with the projecting surface, continue the line till it meets the sun's ray. This determines the length of the shadow at that spot. Repeat the operation at each corner. The method need not be varied for vertical projections.

Sun Behind the Painter

It is evident that the sun being unseen behind us, we can no longer draw rays from it—as in the last example—to obtain

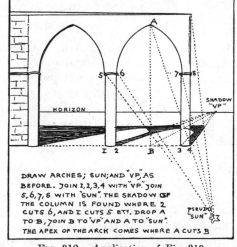

DRAW ARCHES; SUN; AND VP. AS BEFORE. JOIN 1,2,3,4 WITH VP. JOIN 5,6,7,8 WITH "SUN". THE SHADOW OF THE COLUMN IS FOUND WHERE 2 CUTS 6, AND 1 CUTS 5 ET?. DROP A TO B, JOIN B TO VP AND A TO "SUN". THE APEX OF THE ARCH COMES WHERE A CUTS B

Fig. 312.—Application of Fig. 313.

the length of the shadows. To get over the difficulty we suppose the sun to be at the other end of a ray just so far below the horizon as the sun itself is above it.

(A) **Shadow from a vertical object cast on level ground.**

Subject.—A wall rather to one side, facing us, and lit by the sun so that we see its shadow on the ground behind it.

Practice for Fig. 313.—Copy (Fig. 312) the direction of one side of the receding shadow (1–2) and continue it till it meets the horizon.

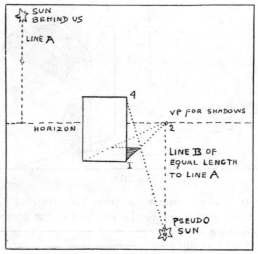

FIG. 313.

This will be the "shadow" V.P. Immediately under it and at the same distance below the horizon as the sun is above it, mark the

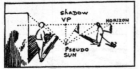

FIG. 314.

pseudo-sun. From it carry a ray to the top of the upright (to 4) whose shadow has been drawn. The ray will cut off the shadow and determine its correct length. Connect other ground points with the "shadow" V.P., and cut them off by rays from pseudo-sun to top of uprights above them.

(B) **Shadow thrown on an inclined plane.**—When we drew the diagram of a wall on an uphill slope and the sun ahead of us we found the "shadow" V.P. to be immediately below the sun and on a level with the V.P. for the sloping ground (i.e. in the same plane with it). With the sun behind us we transpose it as in the last

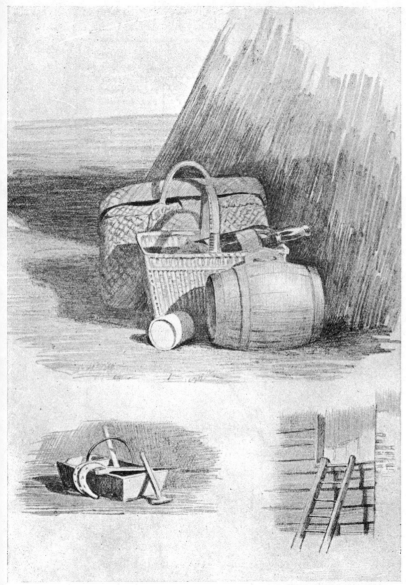

Illus. LXIV. *Drawing by the Author.*

Notice the shadow of the beer-keg on the mug.

figure ; fix the "shadow" V.P. on a level with the "uphill" V.P. (as before), and place it immediately above the transposed sun.

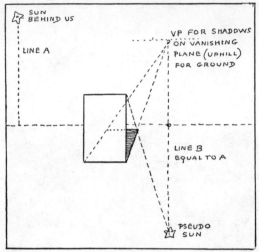

FIG. 315.

Practice (Fig. 315).—Draw the object, the sloping ground, the transposed sun, and the edge of one shadow. Continue the line of

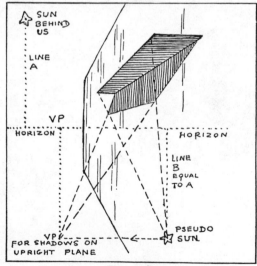

FIG. 316.

the shadow until it reaches a point immediately above the pseudo-sun, and at the height of the V.P. for the sloping ground. That point is now the V.P. for shadows. Find their direction by lines to

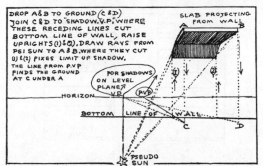

FIG. 317.—Shadow from a horizontal projection thrown on to a vertical surface that faces us.

the "shadow" V.P., and their length by rays from the pseudo-sun as in former exercises.

(C) **The shadow of a projection from a receding upright.**

Practice for Fig. 316.—Copy the direction of one line of shadow and continue it (1–2) to a point immediately under "level" V.P. to make "shadow" V.P. Carry the ray from the transposed sun to the end of projection throwing the shadow (3–4), the intersection of line and ray fixes length of shadow downwards. Carry on as before.

EXAMPLES.—Shadows cast on steps.

(1) **Sun on one side.**

Practice for Fig. 318.—Follow out Fig. 306 by drawing the wall, the sun's rays, and the shadow until it meets the step, carry the shadow up the "rise" of the step along the tread. Repeat the operation until the limit of the shadow at both ends is obtained. Join end of shadows.

FIG. 318.

(2) **Sun behind painter** (Fig. 319).—The length of the shadow is determined by the rays from pseudo-sun (see Fig. 313 if diagram does not explain itself).

(3) **Sun in front of painter.**—The shadow on the tread of each step is found as in Fig. 307. When the shadow reaches the edge of the step it is taken vertically down the "rise" and continued over the next tread again as in Fig. 320.

Shadow cast by a leaning object.

Sun on one side (Fig. 319).—Draw the rays touching the far corners. Drop verticals from the same points, and find out where

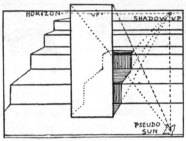

FIG. 319.

they touch the ground by connecting near corners of slope with "level" V.P. Draw horizontal where verticals touch the ground. The junction of the sun's rays with horizontal line determines the

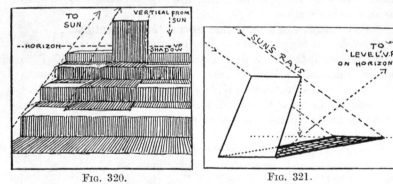

FIG. 320. FIG. 321.

length and width of the far end of the cast shadow ; join it to the near end of the slope.

ARTIFICIAL LIGHT AND DAYLIGHT

The light and shade of objects under artificial light resembles that of sunlight in the sparkling intensity of the lights and the defined forms of the shadows. It differs from it in the greater distortion in the forms of shadows. The one will never be confused with the other by reason of the even luminosity of far and near objects under sunlight, as opposed to the rapid fading in the brightness of objects that are more distant from the source of artificial illumination.

Joseph Wright, in his picture of the air-pump, made judicious use of variety of lighting from a simple candle to accentuate the expression of the faces.

Rembrandt delighted in the mystery of candlelight. His painting of the " Nativity," apart from its emotional side of the subject, but just looked at as an ordinary interior of a stable lit by a lanthorn, shows how much mystery and greatness he saw in everyday effects.

Shadows from Artificial Light

Compared with daylight shadows.—We found that sun shadows cast on level ground point towards the horizon owing to the vast distance that separates us from the sun.

Shadows from artificial light when thrown on top of a level surface differ from those cast by the sun in having their V.P. under the light itself (Fig. 323).

For instance, some objects on a table might be lit by the sun in front of us. Their shadows on the table would all point towards a V.P. on the far away horizon and under the sun.

Fig. 322.—Daylight.
Sun at side. Rays parallel to one another (as in Fig. 321).

The same objects on the table when lit by a candle would have their shadows pointing towards a V.P. on the table itself, exactly under the candle-flame.

Consequently, with shadows under artificial lighting there is a

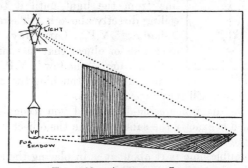

Fig. 323.—Artificial Light.
Lamp at side. Rays radiating from it, shadows pointing towards foot of light.

violent distortion of the form of the object that does not occur under the illumination of the sun.

(1) **Shadows from objects under artificial light on level surfaces.**
Practice for Fig. 323.—Draw the horizon line and the lamp. From light draw rays over far and near end of wall top. Mark where the lamp-standard meets the ground, and from that mark take lines to far and near end of base of wall and continue them. These lines decide the width of the shadow. The length of the shadow is determined at these points (1–2) where each ray meets the shadow-line under it. Join such points to complete the shadow.

It stands to reason that objects will cast their shadows away from the light ; those that are situated behind the light will have shadows receding from us, while others between us and the light will cast shadows towards us.

As the same recipe is used for all shadows thrown from objects that stand on level ground we need not detail each circumstance. Remember to carry a vertical down from the light until it meets the surface the shadows will be on. The "shadow" V.P. is the junction of that vertical with the level plane.

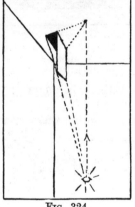

(2) **Shadow thrown by an object projecting from the ceiling.**—The "shadow" V.P. for objects projecting from a ceiling will be that point on the ceiling that is directly above the light.

Practice for Fig. 324.—Draw the object, the ceiling, the light. Raise a vertical line from the light until it touches the ceiling directly above it. There place the "shadow" V.P. Carry rays from light over ends of object that juts out from the ceiling. Join "shadow" V.P. with each corner of object touching the ceiling, and continue these lines till they meet the rays.

FIG. 324.

Now turn the diagram upside-down, and you recognise that the work performed is exactly the same as when the object stood on the ground and the light was from above.

The only troublesome part about it is in placing the spot on the ceiling directly above the light. This may be manœuvred by carrying a line along the floor, up the wall, along the ceiling till it meets the vertical from the light (see arrow-marked line in diagram).

But other dodges equally effective can be thought of.

(3) **Shadow on a vertical plane.**—When drawing a shadow on the wall (Fig. 325), first find the "shadow" V.P., which must be on the wall, at the same height, and exactly opposite, the light. In other respects there is no difference between the working of this problem and the previous ones.

Here again we have only to rotate Fig. 325 one-quarter of a circle to recognise our old friend in a new position.

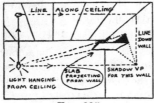

Fig. 325.

CHAPTER XVI

PAVEMENTS

SQUARE tiles.—For Fig. 327 of chequer tiles tick off equal divisions I, II, III, IV, etc., all along front of floor. Rule

FIG. 326.

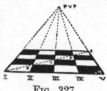

FIG. 327.

lines from each division to D.V.P. Carry a diagonal to D.V.P., and where it cuts receding lines I, II, III, etc. (at A, B, C, etc.), rule (either by parallel rulers or by using a T-square; horizontal lines along the whole length of the floor.

A pavement of ornamental tiles.—For one such as Fig. 328 make a plan of the pattern which repeated many times will cover the floor-space. Many designs are formed on one or more squares and

FIG. 328.

FIG. 329.

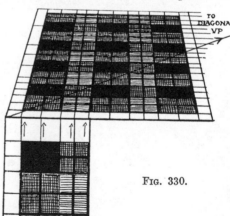

FIG. 330.

diagonals, as these are. Make a foreshortened square from the plan (explained in Chap. IV), and continue the diagonals across the floor and the horizontals along it, as is made clear by Fig. 330.

Fig. 331, and many other rectangular patterns, need only the one diagonal line to determine their depth and that of the borders surrounding them.

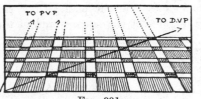

FIG. 331. FIG. 332.

Herring-boned.—Fig. 332 is the plan of a herring-boned wood floor, and the drawing (Fig. 333) explains itself. The wavy appearance of the floor is not wholly untrue to nature, it is sometimes quite

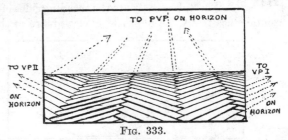

FIG. 333.

disconcerting on a highly polished parquet where the grain of the wood as well as the direction of the blocks help the illusion.

Roman pattern.—Fig. 334. The plan and perspective of a Roman pavement is given to demonstrate how a pattern that is in appear-

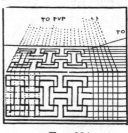

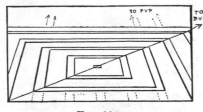

FIG. 334. FIG. 335.

ance complicated can be easily drawn when its proportions are mastered.

Concentric squares.—Parquet floors and some pavements have

bordering lines, or lines forming concentric squares or oblongs that cover the floor. The diagonal gives the spacing of each line.

Octagonal pavements.—For Fig. 336 mark off the width of squares 1, 2, 3, etc., and the points C from the plan. Draw the receding lines 1, 2, 3, etc., of the sides of the squares and of the

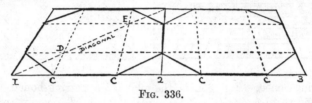

FIG. 336.

corners of the octagons C. From near corner of square 1 draw diagonal to D.V.P. Where diagonal cuts the receding sides of squares draw horizontal lines to fix the depth of every square in that row.

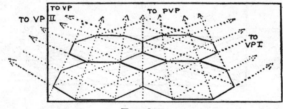

FIG. 337.

Where diagonal cuts lines from C draw horizontals to fix position of D and E, the "side" corners of every octagon in the row. The

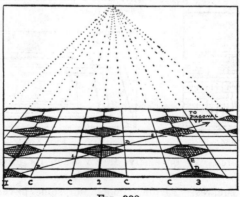

FIG. 338.

lines from C cutting the back of each square mark the remaining corners. Join the corners.

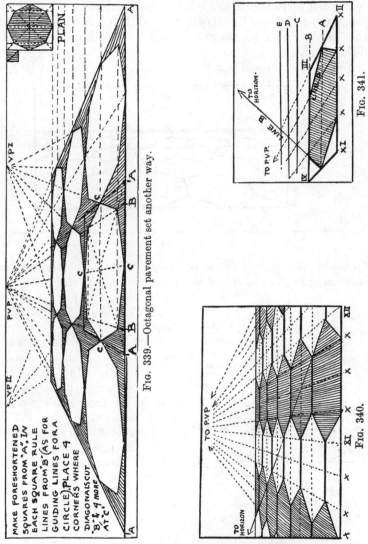

FIG. 339.—Octagonal pavement set another way.

FIG. 341.

FIG. 340.

MAKE FORESHORTENED SQUARES FROM "A". IN EACH SQUARE RULE LINES FROM "B" (AS FOR GUIDING LINES FOR A CIRCLE). PLACE 4 CORNERS WHERE DIAGONALS CUT "B" & 4 MORE AT "C".

The above method is easy; an alternative way is to use the two V.P.'s as shown in Fig. 339, though the long-distance V.P.'s may be inconvenient.

Pavement of hexagons.—For Fig. 341 tick off along the base equal divisions X to X, etc., and join each one to P.V.P. Divide (using diagonals) the depth II–III in half by the line A. Complete the hexagon. Where line B cuts the lines X rule lines B, C, D, etc., the full length of pavement. Complete pavement as shown by diagram (Fig. 340).

For Fig. 342, in addition to the P.V.P., two V.P.'s can be used

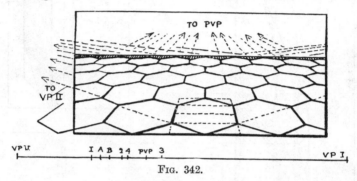

FIG. 342.

for the chevron ends of all the hexagons. These V.P.'s are found by continuing two foreshortened sides (dotted lines) to the horizon.

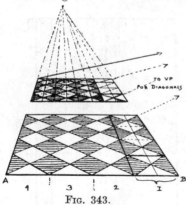

FIG. 343.

Fig. 343. **The lozenge or diamond tiles** (already explained in Chap. IV).

Squares inscribed with circles.—Draw the foreshortened squares as just directed. Inscribe a circle in one of them (as shown in Chap. VII). From guiding points on it carry lines to P.V.P., and horizontally across the pavement to serve for all other squares. Remember not to take too wide an angle of vision, so as to avoid absurdities.

THOUGH a man must be something of a sailor to draw a ship as she should be drawn, that is not to say that we landsmen must grant him an exclusive monopoly. It is just here that perspective comes in to save us from drawing a boat that could neither float nor sail.

FIG. 344.—Plan for Fig. 345.

Taking a punt as the most primitive of boats we find her little more than a shallow box, undercut at bow and stern. Nothing here to stop you making a perfect drawing by perspective rule alone. (Punts drawn in Figs. 291 and 292 and Illus. LXI.)

Guiding points for drawing her curves can be found by means of a box.—To make a toy-boat from an oblong chunk of wood you mark the stern post at the middle of one end, and the bow at the other, and connect these by a line for the keel. Then taper her sides from beam to bow, and to the width of her stern. Undercut her from water-line to keel and you have a rough boat, all but the lengthways curve of her gunwale. It is a help when drawing a boat to get to work in something of the same way, and as there is no difficulty in drawing the box at any tilt or angle, you keep by its means the essential parts of your boat correctly placed one for the other.

205

With such guiding lines it is best to draw her curves by eye, though they could with infinite patience be drawn by rule, which might be a necessity, if instead of a boat one had only her plans to work from, but of this presently (see Part II, Chap. XXIII). Meanwhile, by Fig. 345 we see how to find guiding points for the line of her gunwale, which curves both horizontally and vertically.

The use of a sketch plan when drawing a boat.—Fig. 346 might stand for the shape of a ship's bow.

In Fig. 347 we have taken the heights (O–D), the lengths (1–4), and the width (O–B) from Fig. 346 and transferred them to our

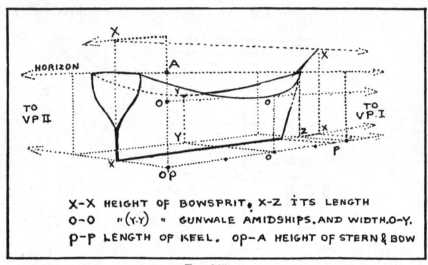

X-X HEIGHT OF BOWSPRIT. X-Z ITS LENGTH
O-O " (Y.Y) " GUNWALE AMIDSHIPS. AND WIDTH.O-Y.
P-P LENGTH OF KEEL. OP—A HEIGHT OF STERN & BOW

FIG. 345.

perspective drawing (Fig. 347). The diagram itself explains how these (or any other) points are moved to their correct position.

In Fig. 348 I have worked out a few more guiding points in the same way and run a line through them. If the boat is to be represented only a little to one side of you, the ends of the box will not be foreshortened. In this case you need not take the measurements on both edges of the near end, as we did in Fig. 345.

We can go one step further without mechanically drawing our boat from plans. Suppose you know what the curves of her body plan would be like (in section) at (say) three-quarters of her length ; you can sketch that curve on the box end (Fig. 349), and from it

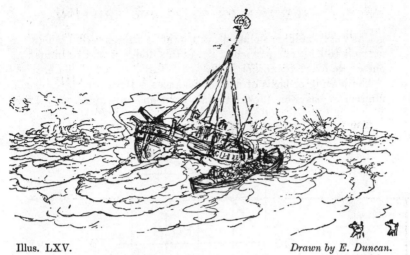

LIGHTSHIP AND LIFE-BOAT.

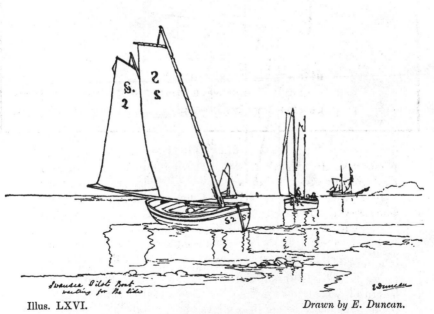

Swansea Pilot Boat
waiting for the tide

SWANSEA PILOT-BOAT.

get as many guiding points as you want in the partition where the curve is to be. The particular use of this dodge would be in making one curve overlap another nicely at the furthest end of the box.

The placing of boats at correct distances.—If you have to place a number of boats or ships in certain positions on water you will find

FIG. 346.

it admissible to cover its surface with foreshortened squares just as we advised for groups of figures. Each square might be the length of a boat to save trouble. Be careful to fix your distance-point judiciously before drawing the horizontal lines. The way to do all this has been thoroughly explained already.

TO FIND Z — FROM ELEVATION TICK OFF a—d. THE
MEETING OF LINES FROM 4 AND d FIXES POINT Z.
TO FIND X — FROM PLAN TICK OFF O-B & RAISE B—a. FROM
ELEVATION GET a-b. FROM b AND B TAKE LINES TO VP. WHERE
LINE FROM B CUTS LINE FROM I (AT H) RAISE UPRIGHT TILL IT
CUTS LINE FROM b. THERE PUT X. OTHER POINTS SIMILARLY.

FIG. 347.

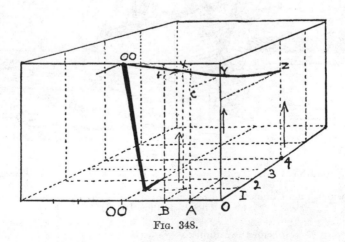

FIG. 348.

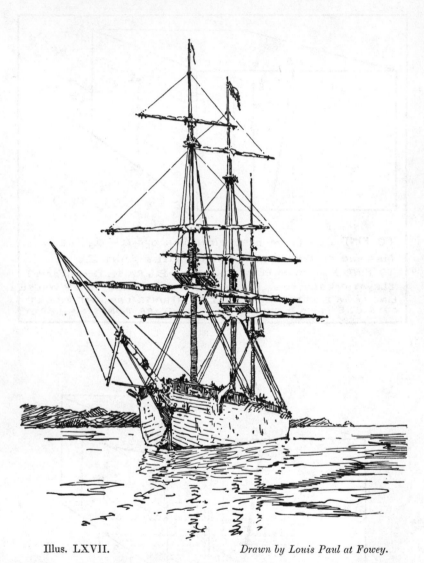

Illus. LXVII. *Drawn by Louis Paul at Fowey.*

How much more dramatic and personal a ship looks close at hand than when
at a distance, as in Illus. LXVIII.

Illus. LXVIII.

Another drawing by L. Paul of the same boat as she would appear further away. Notice that the masts show their actual relative heights better. Also note the position of the yards and the diminishing in the length of the bowsprit.

Effect of distance on foreshortening.—A common mistake is to introduce at a certain distance a study of a ship that was drawn from a different distance. The rapid foreshortening in a boat seen close by, compared with one seen far off, is so unmistakable that it makes the error unpardonable. Compare Illus. LXVII with Illus. LXVIII.

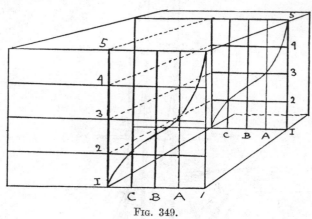

FIG. 349.

In "Nature's Laws and the Making of Pictures," by W. L. Wyllie, R.A., you will find much instruction regarding ships that I am unable to give you (see also Chap. XXIII for drawing ships from her plans).

Note.—An article in "Yachting Monthly" (May, 1916) explains to those who are well versed in Perspective how a yacht can be correctly drawn from her designer's plans.

CHAPTER XVIII

PERSPECTIVE FROM UNUSUAL POINTS OF VIEW

THE great painters of old were content to take a quite usual view of a subject, relying on their mastery of composition, colour and tone, for the making of a work of art. Such pictures by their sense of beauty and dignity command respect.

Modern unrestfulness and changed conditions call for novelty; the jaded taste of the public must be excited by freak drawings and amused by eccentricity. Some one or other obligingly lies on his back and depicts a steeplejack at his work, and shows the sides of the cathedral towers receding to a point in the heavens above; so he is reckoned a very smart fellow.

Another may sketch our country as seen from aircraft with houses wider at their roofs than at their base, and side walls tapering to their foundations.

Authors of such as these are mistaken in hanging their productions on a vertical wall. The picture of a tower seen from the sky must, to look correct, lie on the floor; while the steeplejack picture should be pasted to the ceiling.

Quite apart from art, there is a use for drawings made from the earth looking skyward, and for a view of the sky; nor is there difficulty in making them except for their exercise in gymnastics, for the old rules of perspective still hold good, and we require no new ones.

(1) **Looking down from a bridge.**—If your fancy leads you to sketch the Thames as seen through a chink in the footpath of the Tower Bridge, you have but to shed a tear, and where it splashes a hundred feet below you, will be your point of sight and consequent P.V.P. on your paper. The mast of the ship below (if vertical) will tend towards the P.V.P., and will be subject to the usual rules of foreshortening; the rim of the steamer's funnel will hide its base, or if it is a little to one side of you, the funnels will taper to the deck. The eddies on the water will appear as unforeshortened curves or circles, just as their ground plan would be drawn.

213

(2) **From an airship.**—Can you dream that you are in front of a huge wall and some houses are sticking out from it, in such a way that the wall is where the inhabitants' floor should be, and you yourself are facing the roof ? If you then drew those houses using exactly the old rules of perspective, your drawing would seem to have been taken from an airship.

(3) **At the sky.**—If you lie on your back to sketch (Fig. 350), the P.V.P. will be amongst the stars directly over your head and all upright lines will recede to it. The only thing to cause trouble is the novelty of the point of view. You must, however, remember

that you cannot include the ground or the base of the building ; also that to see your finished drawing you should hold it over your head. Incidentally we may add that in ceiling paintings the point of sight is placed overhead among the floating figures.

Fig. 350.

Again, pictures with a very high horizon should be hung low down on a wall, and, if practicable, with their base tilted out, so that the spectator may be looking down on the subject as the painter was. It follows that those with a low horizon can be placed higher so that we also may look up to the scene.

When scenery has to be viewed from different points of view, as in a theatre, dodges must be resorted to, in order to make them appear naturalistic ; again, the circular representation of the panorama had its use.

The position of the painter in regard to his subject and that of the spectator to the picture has

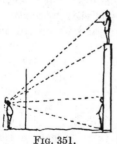

already been alluded to. It is one of the theoretical canons of painting that only so much of the subject shall be included as can be seen without moving the head. In practice this is not literally adhered to. By understanding perspective one can give the ap-

Fig. 351.

Fig. 352.

pearance of the rule having been observed.

If, therefore, we wish to paint a figure standing on a height (Fig. 351)—say a tower—and another at its base, we should take up a

position far enough away to include both without having to look up and down, and the figures would appear to be the same height, or our composition might include only the upper part of the tower, in which case (Fig. 352) it could be studied near at hand.

In mural paintings the figures or other objects high up on the wall will have to be progressively larger than those at the level of our eye, if they both are to appear in the same proportion ; more particularly so when, from insufficient floor space, a near view becomes a necessity. If you draw a small single object, say an upright cup, you could represent its circumference as being more circular in shape than if you painted many cups ; the reason being that you can look down on one cup close at hand, but to see many you would have to go further away and their rims would become more oval. If you represent a cup with a circular rim and yet include the room beyond it, you suppose your eye capable of taking in a larger angle than is natural and your drawing looks distorted, or the rim of the cup appears to be tilted towards you.

We may conjecture that if you revel in elaborate detail you can use a rather wide angle of vision, because your picture will be examined at close quarters ; while the beauty of the detail would be missed if your work, to seem correct, has to be looked at from across the room. In fact, if you had chosen a long-distance view, you would be ill-advised in introducing detail at all ; it would look unnatural and lessen the grand qualities that blank spaces of fine tone and colour possess. The surface of the paint itself should automatically register the distance the painter was from his subject ; rough paint, unintelligible (except to an artist) if closely examined, compels the owner of the picture to stand back until he can focus the whole canvas, then the blotches and smears resolve themselves into beautiful drawing and the owner desists from again attempting to see the work from a wrong point of view.

Perhaps little pictures should have a short D.V.P., and big pictures one far away—but I won't be led on to dogmatise ; and when painting is concerned I hate a controversy.

PART II

PERSPECTIVE AS PRACTISED BY OTHER NATIONS AND AT OTHER TIMES

CHAPTER XIX

PERSPECTIVE IN GREEK AND ROMAN AND OTHER PAINTINGS

IF we attempt to resurrect those early days when perspective was first recognised we should have to probe into the archives of antiquity. For it seems that Vitruvius (who wrote his treatise on architecture about 46 B.C.) casually mentions that perspective was well understood at a very early date ! He tells us that a certain Agatharchus, a painter in Athens, " was the first who contrived scenery upon which subject he left a treatise." Agatharchus was in fact employed by Æschylus (born 525 B.C.) to paint scenes for his plays that he produced late in life ; moreover his scenery laid out by the principles of perspective was, at the time, a distinct novelty.

The treatise that Agatharchus wrote, or perhaps it was the scenery itself, excited Anaxagoras to take up the pen in explanation of how " in drawing the lines ought to be made to correspond, according to a natural proportion, to the figure which would be traced out on an imaginary intervening plane by a pencil of rays proceeding from the eye, as a fixed point of sight, to the several points of the object viewed." [1]

Fuseli, speaking of the great painter of the same period as Agatharchus, says, " The first great name of that epoch . . . is that of Polygnotus of Thasos who painted the pœcile at Athens, and the public hall at Delphi. Of these works Pausanias gives a minute and circumstantial detail, by which we are led to surmise that what is now called composition was totally wanting in them as a whole ; it appears as plain that they had no perspective, the series of figures on the second or middle ground being described as

[1] "Dictionary of Greek and Roman Mythology."

placed above those on the foreground, as the figures in the distance above the whole ; the honest method, too, which the painter chose of annexing to many of his figures their names in writing, savours much of the infancy of painting. We should, however, be cautious to impute solely to ignorance or imbecility what might rest on the firm base of permanent principle. . . . If we consider the variety of powers that distinguished many of the parts, we must incline to ascribe the primitive arrangement of the whole rather to the artist's choice and lofty simplicity than want of comprehension ; Nature had endowed him with that rectitude of taste which in the individual discovers the stamen of the genus, hence his style of design was essential with glimpses of grandeur and ideal beauty."

Perspective with its realism would have been antagonistic to the aims of the painters of that period, a reason that also holds good for its exclusion in the art of the Egyptians.

A century later we find the school of Pamphilus—which was founded by Eupomus—with very different aims and execution. The decorative work of Polygnotus, big in conception, had meanwhile been changed by Apollodorus, Parrhasius, and Zeuxis, to a more imitative style, by the addition of light and shade, gradation of multiplied tints, and elegance of proportion.

Pamphilus, with a knowledge of geometry and an extreme love of accuracy, taught that science and art must go hand in hand.

Apelles, Melanthus, Protogenes, and Euphranor all came under his influence. Numerous stories are told of the accuracy of eye and precision of hand practised by them.

Those painters whose works were acknowledged, acclaimed, and extolled as masterpieces lived when Greek architecture and sculpture flourished at its best. Among their critics and commentators were cultivated men whose writings still afford examples of consummate art. In their day drawing was practised as an indispensable part of the education of the upper classes. Their schools of painting had definite aims and traditions, their national characteristic was the close following of Nature's forms.

With such a training it is impossible to believe that perspective could have been overlooked, misunderstood, or despised ; it was essential to their aims of realism ; it would follow naturally in their zeal for, and practice in, exactness ; and would have been acquired as an adjunct of art in their self-imposed education.

Sir Joshua Reynolds has said, speaking of their pictures, " I have no doubt that we should find their figures correctly drawn as the

Laocoon, and probably coloured like a Titian." Let us add that Canaletto would not have rivalled their perspective and we may not be missing the mark, though it is but a reasonable conjecture.

Perspective in Roman paintings.—I cannot understand why the credit of discovering perspective should often be given to the early Italians, while existing evidence of its recognition by the Romans can be seen on the walls of Pompeii (Illus. LXIX). It is evident that in simple parallel perspective (the Italians till quite a late period did not understand angular perspective) they were very well versed though without the accuracy we now expect.

The perspective of these wall decorations is of the standard shown in the rest of the work. If this was the work of slaves and " some bow-backed artificer or other, who can paint many faces in a short time," as Juvenal calls them, the work of the better artists must have been very accomplished and their perspective, as far as it essayed to go, irreproachable.

The foreshortening of the horses and men in the battle of Alexander, though a Greek work, is sufficient evidence of a sureness in workmanship, and observation of Nature, totally lacking in the beautiful early attempts of the Italians.

THE EARLY ITALIANS, A.D. 1200–1400

In the thirteenth century, by the genius of the Florentines, Cimabue (1240–1308) and his pupil Giotto, and the Sienese Duccio, painting was given fresh life, and the era began in which Nature and beauty had its resurrection.

The new aim of realism grew in strength and seems to have been readily recognised by the nickname, " the ape of Nature," given to Stefano (b. 1301).

The work of Fra Angelico (1387–1455) is so reverent and full of a child-like simplicity that it would seem like sacrilege to subject his visions to the cold light of reasoning. Without doing so, we can give instances where his ability lagged behind his conception. As in his " Martyrdom of St. Mark," in which he signally failed to make the Saint lie flat on the ground ; nor did he realise that the parallel faces of buildings would recede to one and the same vanishing point. His constant observance of the spacing in receding rows of columns, no less than his study of a carpet in the " Madonna of San Marco," make it a matter of wonder that he should have blundered so completely in the placing of the figure of Christ in the

Illus. LXIX. (*Photo. Alinari.*)

Painting on the walls of Pompeii. Parts of it are so illusive as to appear
as an actual framework.

" First Eucharist " (San Marco, Florence). The Saviour is repre-
sented placing the wafer in St. John's mouth, though his hand is at
least seven feet away from the Apostle's mouth.

Paolo Uccello (1397–1475), a contemporary of Angelico, appears
to have been the first scientific exponent of perspective.

How admirably he put his deductions into practice is seen in his
battle picture, now in our National Gallery (" Rout of San Romano,"
Illus. LXX). The foreshortening of the fallen figure, the lances,
the spacing of the ground, and the beautiful drawing of armour,
show the strides he had made in his study.

Vasari tells us how " Paolo Uccello employed himself perpetually,
and without any intermission whatever, in the consideration of the
most difficult questions connected with art, insomuch that he brought
the method of preparing the plans and elevations of buildings, by
the study of perspective, to perfection. From the ground plan to
the cornices, and summit of the roof, he reduced all to strict rules,
by the convergence of intersecting lines, which he diminished towards
the centre, after having fixed the point of view higher or lower, as
seemed good to him : he laboured, in short, so earnestly in these
difficult matters that he found means, and fixed rules, for making
his figures really to seem standing on the plane whereon they were
placed, not only showing how, in order manifestly to draw back or
retire, they must gradually be diminished, but also giving the
precise manner and degree required for this, which had previously
been done by chance, or effected at the discretion of the artist, as
he best could. To pore over all these matters, Paolo would remain
alone, seeing scarcely anyone, and remaining almost like a hermit
for weeks and months in his house, without suffering himself to be
approached."

The early Florentines produced inimitable works which fortun-
ately for us were visions of their subject rather than the reality they
strove for. Bit by bit the result of observation crept into their
work. One after another added a law of nature as he recognised it,
or as he acquired the power of recording it. Among them were men
who called science to help, and talked and wrote of their new
perspective. There can never be another Cimabue, Angelico, Lippi,
or Botticelli. We can delight in their sweet conceptions whole-
heartedly without the taint of analysis or criticism.

From Masaccio to Leonardo da Vinci.—With few exceptions up
to the time of Masaccio (1401–1443) figures of no individual likeness
sat irresponsibly under little arcades, or tiptoed with dolls' houses

Illus. LXX.　　　　　　　　　　　　　　　*Paolo Uccello.*　(*Photo. Mansel.*)

ROUT OF SAN ROMANO.

"He shut himself up, devoting himself wholly to the study of perspective, which kept him in poverty and depression
to the day of his death."—VASARI.

set about them in a charming land of their own. They had no connection with the world of pleasure and pain, and they took the thoughts of those who watched them far away from it, as was their mission.

Masaccio brought real figures into his designs. They were modelled in relief ; capable of casting shadows ; they formed groups and walked firmly heel down on level ground.

The laws discovered by Uccello were recognised by him in Nature and copied with surprising mastery.

His portrait of an old man (now in the Uffizi Gallery) was taken at close quarters, as we see by the depth of the foreshortened surface.

The same study if painted far away from the sitter would have lost much of its realism. In later days the Dutch school made great use of this notion of the spectator being among the objects painted, or let us say at arm's length from them. And it is then that acquaintance with perspective becomes invaluable, for the distortion of near receding surfaces may easily become disagreeable while the introduction of an object outside the field of vision may make the picture incongruous.

Vasari wrote his biography in fifteen hundred and something, and we gather from his descriptions of pictures that the perspective of rather simple forms still in his day presented difficulties, so that the men who overcame them were given praise quite disproportionate to that merited by their artistic conception. Thus, speaking of a picture by Piero, "Above these figures is a most beautiful Annunciation, with an angel which seems in truth to have descended from Heaven ; and what is more, a range of columns diminishing in Perspective which is indeed beautiful."

It would seem that a range of columns and an angel from Heaven were artistically on a footing !

These were early days for tackling the intricacies of a vaulted roof, but Andrea dal Castagno (1410–1457) introduced into a fresco a loggia with cross-vaulting and ribs diminishing in perspective which gained the approval of his contemporaries.

We find constant reference made to drawing of objects, such as the octangular table that Cosimo Rosselli (1439–1506) painted, and the accuracy of eye displayed by Domenico Ghirlandaio (1449–1494), who could draw an amphitheatre or an obelisk correctly without measurement.

The rise of perspective (let us say the revival of it) belongs particularly to these early painters of Florence, but we must not forget

Jan Van Eyck of the Netherlands (1385–1441) with his wonderful portrait interior (No. 186, National Gallery). He stood close in front of the man and his wife with their little dog and painted them and the room just as he saw them at close quarters, and made his receding surfaces as accurate as they need be.

Nor will it do to omit Andrea Mantegna (of Padua, 1431–1506) who carried the foreshortening of figures a step further.

There is a picture in the National Gallery by Beccafumi (Sienese, 1486–1551). It is characteristic of the uncertain use made of perspective at that time. He carries his receding lines with care to a vanishing point, but when introducing some of the buildings of Rome incongruously draws them as they would be seen from another level.

Filippino Lippi (1457–1504), with his power of composition, seems generally to have overcome the difficulties of foreshortening. His architecture, in the " Triumph of St. Thomas Aquinas," is drawn just as surely as his " Music " (in S. Maria Novella, Florence) with its very low horizon.

The early painters aimed at making their figures look real. Their study of architectural perspective led them in this respect into a theatrical extravagance in order to obtain the illusion of nature. This they did by continuing in their painting an imitation of the adjacent architecture, so that one can hardly tell where one leaves off and the other begins. Giovanni Bellini used perspective in this way on his altar-piece at San Zaccaria, in Venice. Even Leonardo da Vinci and Michelangelo did not despise the device.

From Leonardo to Veronese.—Leonardo da Vinci (1452–1519), with his enlightened genius for art, mathematics, science, and mechanics, gave finish to the new ideals which Masaccio began.

He ushered in the great period when genius, no longer the monopoly of one school, brought painting to perfection.

Perspective was no longer a mystery to be studied and used tentatively. It had become an essential tool of the workman. The difficulty was no longer in copying Nature, but in choosing the best way in which she should be represented.

Giorgione and Titian discovered the beauty of space and unity between the land and sky, trees were given their fullness and land its level plains. Dürer, engrossed in studying line, learnt all he could of the laws of perspective, and even went to the trouble of tracing objects on an upright glass in order to perfect the accuracy of his eye, and has left us some of his principles in his book on Geometry.

In the Christ Church Collection at Oxford there is a sketch by

Raphael of figures (Illus. LXXI) standing in groups, the floor being divided into a number of receding squares. Beneath this drawing is the plan of the floor correspondingly divided into squares with the position of the figures on them. It is of interest to note that he should have taken the pains first to draw a plan of the surface on which he was to place his figures. This method, a common one among latter-day painters, has already been described. Vasari says, " Among other artists, Raphael formed a close intimacy with Fra Bartolommeo di San Marco, during his abode in Florence, the manner of that master pleasing him greatly, wherefore he took no small pains to imitate his colouring, teaching that good father on his part the rules of perspective."

A curious use was made of the knowledge of perspective in Venice during this period. In the words of Lanzi, " It became an attribute of the art to feign colonnades, galleries, and rich cornices, for those halls in which real architecture would not admit of them. In this, Cristoforo and Stefano Rosa more particularly distinguished themselves. They were from Brescia, very intimate with Titian, and merited the honour of being employed by him, in his architectural ornaments for several of his subjects " : those painted illusions were referred to as " Perspective Pieces," and appear to have been very popular.

How fond Veronese was of figures placed high up with a low horizon. We see how dignity is added to his picture " Respect " by his choice in placing the horizon low down. In his " Family of Darius at the feet of Alexander " our eye is on a line with the feet of the foreground figures. In the tall upright, " The Vision of St. Helena," the horizon is just about the bottom of the picture.

From Veronese to Rembrandt.—It was just after the period of Veronese that painting came to the front in other countries besides Italy, Germany, and the Netherlands.

National art had its rise in France, England, and Spain ; while numerous Flemish and Dutch schools were established.

The giants of those days gave a new purpose to perspective.

Claude carried it into the sky and the sea, Rembrandt into the mystery of night and artificial lighting. Frans Hals discovered perspective in the paint itself, by his brush-strokes. With its aid Rubens built up the staging for his scenes.

The subject-painters Ostade, Terborch, and others obtained by it a just proportion between figures and surroundings. The painters of still-life must have had perspective at their finger-tips when

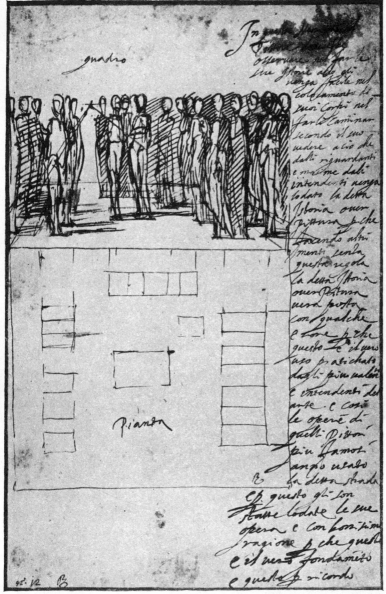

Illus. LXXI. *Clarendon Press, Oxford.*

A Drawing by Raphael at Christ Church, Oxford. Reproduced by courtesy
of the Governors.

drawing the ellipses of their shining copper pans and placing the high lights on their transparent glass.

Ruskin covered pages with invective on Claude's art and sneered, without cause as far as I can see, at his perspective. Here is a sample : " The eye of this artist, with all his study, had not acquired the power of taking cognizance of the apparent form even of a simple parallelepiped." Perhaps Ruskin was right, but then I don't know what a parallelopiped is. Anyhow, it is a small matter in a picture (" Queen of Sheba embarking," now in the National Gallery) that shows Claude as a master of perspective in things that really matter.

With knowledge and more tolerance he criticizes another picture in which Claude had painted a band of light—the reflection of the sun—crossing the sea obliquely instead of vertically. " Taking his impression instinctively from Nature, Claude usually did what is right and put his reflection vertically under the sun ; probably, however, he had read in some treatise on optics that every point in this reflection was in a vertical plane between the sun and spectator ; or he might have noticed, walking on the shore, that the reflection came straight from the sun to his feet, and intending to indicate the position of the spectator, drew in his next picture the reflection sloping to this supposed point, the error being excusable enough, and plausible enough, to have been lately revived and systematized. . . . Every picture is the representation of a vertical plate of glass, with what might be seen through it drawn on its surface. Let a vertical plate of glass be taken and wherever it be placed, whether the sun be at its side or at its centre, the reflection will always be found in a vertical line under the sun, parallel with the side of the glass." When Ruskin finishes a page of abuse (concerning Claude's foregrounds)[1] with the words, " owing to his total ignorance of the laws of perspective," etc., he was writing piffle, as he sometimes did when not engaged in expressing beautiful and helpful thoughts in beautiful and thoughtful language.

The biographer and artist Baldinucci, who was a contemporary of Claude, tells us something of Claude's methods :[2] " He placed his eye where it seemed good, but he was wont to divide the height of his picture into five parts, of which two were inferior to the horizontal line, or I should say that of the visual rays. Then placing the eye on this line, he took a thread and placing one end at the eye, he

[1] Pt. II, Sc. IV, Chap. IV, " Modern Painters."
[2] Quoted from Edward Dillon's " Life of Claude."

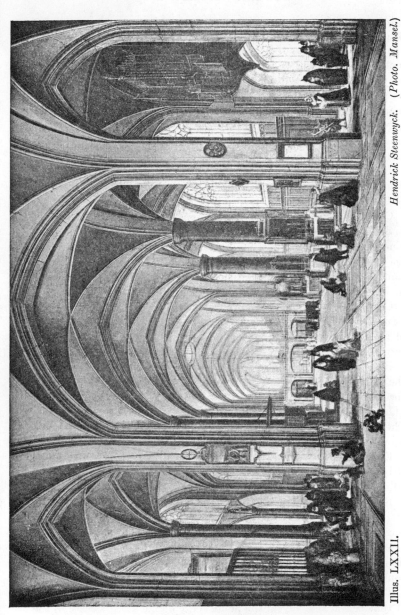

Illus. LXXII.

INTERIOR OF A CHURCH.

Hendrick Steenwyck. (Photo. Mansel.)

rotated it in a circle upon the picture, including in this circle the whole of the said picture. Then he placed his distance upon that spot where the line traversed the circle. He adopted the same method in drawing views from Nature, and the line in question played so an important a part in his works, that with the Flemmings he got the name of " Orrizonte." In other words, Claude usually made the horizon two-fifths of the height of the canvas : selected a good position for P.V.P. on the horizon ; measured the distance from his eye to the P.V.P., and marked off that distance on either side of the P.V.P. to find D.V.P.'s.

It is interesting to find that in both the pictures, " Temple of Apollo at Delos " (Rome), " Embarkation of St. Ursula " (National Gallery), the horizon is as mentioned, two-fifths up the canvas.

Claude learnt his perspective from Agostino Tassi, who had studied under Paul Bril. We learn of Tassi that he imitated Bril in his landscapes, " and was also distinguished as a painter of architecture and perspective, in which he had considerable employment, till for some offence he was sent to the galleys. During his confinement he amused himself by painting marine subjects."[1]

Caravaggio (1569–1609), in his picture " Christ carried to the Tomb," placed his horizon on the ground, consequently no space of it is visible between the feet of the standing figures, the feet coming all on a line.

Rubens often used a low horizon. In his half-length portrait of the Archduchess Isabella (Brussels Museum) the horizon is below the picture, for we can see the underside of the balcony rail, which, quite low down, is used to hide the excessive corpulence of Isabella. The horizon in " The Emperor Theodosius repulsed by St. Ambrose " is on a level with their ankles.

Early in the book we gave instances of a low horizon used by Ribera and Velasquez, and reproduced the latter's " Dead Warrior " (Illus. XIV, Chap. IV) when speaking of foreshortened figures.

Rembrandt made great use of the massive shapes of shadows by artificial light, and their habits of searching out the forms of surfaces they fall on. The radiating bands of light and shadows, from a lantern could, in his hands, be one of the central points of a great composition. Understanding the simple laws that govern such light he could use it at will in his mastery over what is mysterious and grand.

The " Anatomy Lecture " is one of many among the great works of that period that reveal the acute sense of the artist's taste in the

[1] Pilkington's " Dictionary of Painters," 1829.

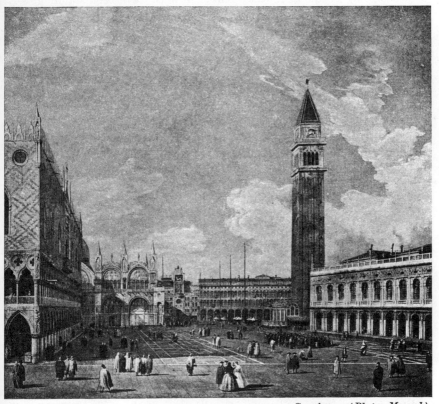

Illus. LXXIII. *Canaletto.* (*Photo. Mansel.*)

St. Mark's.

matter of choosing a not too large or small angle of vision, and in avoiding surfaces that would disclose what the angle of vision actually was. Their pictures in consequence have that appearance we envy, of looking well, both at a distance and near by. The "Anatomy Lecture" looks correct when seen far off by reason of the heads being so similar in size. The men must have been standing with distance between them. If, therefore, Rembrandt had painted close up to the group he would have made the nearest heads much larger than those behind, and the picture seen from a distance would have looked wrong. His "Syndics of the Cloth Hall" is another instance of a low horizon giving dignity to the subject.

One also comes across examples of a mistaken use of a very low horizon. Nicholas Berchem, for instance, in his etchings made capital out of the perspective of hilly ground, by placing his spirited figures and animals partly hidden by rising land, or to give life to odd corners. But when, as I remember, he drew a sheep standing on a vast plain with the horizon just above its feet, he must have sketched lying on his stomach. It is not this I object to, but to the comic dignity of that immense sheep. We see sheep on a hill-top outlined against the sky, but that is another story.

The foreshortening of a floor immediately reveals the distance the painter was from the scene. If he was close to it, and his angle a wide one, his picture might look distorted unless seen from a few feet away. If he were a long way from the scene his figures might look too similar in size to be forcible, and his picture would look incorrect unless one saw it only from a distance. We see in the masterpieces of this period instances of figure groups in which the feet are hidden, as by the space they occupy they would immediately explain the distance.

The painters of architecture, Hendrick Steenwyck, his son of same name, and Pieter Neefs, display an amazing ability in rendering by perspective lines alone the idea of space. One could pick out a little mistake here and there in the direction of their lines and the course of their curves if one were not fully occupied in wondering at their patient skill as they copied each column and arch. I think they must have set out the floor by perspective rule, to enable them to fit the objects on it, each in its place (Illus. LXXII).

Emanuel de Witte did not rely on perspective so entirely, but introduced spaces of light and shade.

The elaborate painting in detail in the "Interior of an Art Gallery," by Hans Jordaens (Illus. XIII), in the National Gallery, is amazing.

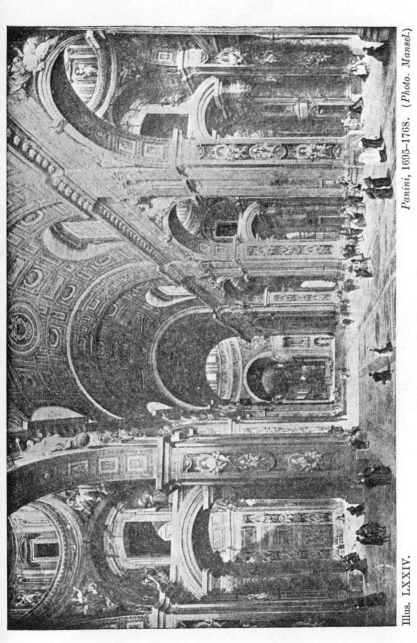

Illus. LXXIV.

Panini, 1695–1768. (Photo. Mansel.)

INTERIOR OF ST. PIERRE, ROME.

Only the simplest of perspective rules are required for such a subject, but for exactness of hand it borders the limit of human performance.

There is no need to call attention individually to the uniform correctness in the perspective of the Dutch Genre painters : De Hooch's interiors and courtyards can be taken to illustrate the laws of parallel perspective, as might Hobbema's delightful " Avenue, Middleharnis," in the National Gallery.

One notices the low horizon sometimes employed by Paul Potter, and the dignity it gave to his cattle seen against the sky.

The still-life painters might employ a high horizon with success, and a wide angle of vision, since a bowl of fruit or a bouquet can be seen and drawn when close up to you. The almost miraculous painting in some of the still-life must be closely examined or the daintiest of human work be wasted. All this detail would be lost, all the elaboration a defect, and the angles appear horribly distorted if the picture can only be seen from a long distance. For this reason I think such subjects or any other with a wide angle of vision should preferably be on a very small scale, suitable for little crowded rooms where they can be enjoyed nose to frame.

The picture that towers grandly in the gallery is the one of big blank surfaces of sumptuous colour and atmospheric tone ; the low horizon, and the piled-up composition of a Venetian master.

Canaletto (1697–1678) (Illus. LXXIII) and his nephew Bellotto, with their pupils Marieschi and Vicentini, formed a small school that relied implicitly on perspective for their composition. They chose a good architectural subject—copied it precisely—and understanding the effect of receding lines, realised the impression of immense space and flatness of ground on their canvas. You see what I mean by looking at Canaletto's " Piazzetta," in the National Gallery. It interests you first by the deception of space, secondly by his colour, and thirdly by the purity of the air that enables him to record the intricacies of architectural detail.

Francesco Guardi (1712–1793), more exuberant and without the exactness or restraint of Canaletto, his master, shows us that rich detail of multiplied ornament, can, by free handling, suggest the sumptuousness of an interior. He showed considerable skill in crowding the floor with figures that were, by comparison with the height of the walls, quite tiny, and yet not insignificant.

CHAPTER XX

PERSPECTIVE IN SOME FRENCH AND ENGLISH PAINTINGS

IT would be futile to attempt a detailed description of the more modern pictures with the use their authors have made of perspective. We have spoken of Claude, and we know that Nicholas Poussin, with all his natural gifts, still made it his business to understand the principles of architecture, anatomy, and perspective, in addition to his knowledge of poetry, the classics, and mythology.

François Millet wrote of Watteau : " The idea of marionettes always came back to my mind when I looked at his pictures, and I used to say to myself that all this little troupe would go back to their box when the spectacle was over, and lament their cruel destiny."

Millet's simile of the marionettes makes me wonder if he was in particular thinking of those subjects in which small figures are scattered in woodlands, such as " Les Amusements Champêtres," in the Wallace Collection. In some of these, Watteau's choice of a long-distance point gives one the feeling of figures on the stage when seen from the back of the house. In another of his pictures where there is more difference in their size they become more intimate, they are nearer to us, and we no longer feel ourselves such outsiders. Probably Watteau knew all about perspective, but I think he was careless in the comparative size of his figures in this instance, but this has no bearing on the discussion.

Millet in his out-of-doors subjects was fond of placing his horizon on about the height of the chest so that the heads and shoulders of his peasants were seen against the sky, as in " Les Lavandières " and " The Angelus."

Modern French painters often set their horizon at the top of or even above their canvas, and one recalls single figures so arranged by Degas and Manet.

William Hogarth with his acute knowledge of form would, as a matter of course, appreciate the possibilities for good or bad in perspective, and we see how good a use he made of it in his pictures

233

now in the National Gallery. Don't miss the humour in his frontispiece for Kirby's Perspective (Illus. LXXV). The sign-post hung from one house with a strut supporting it from another—the " give me a light " episode, and the fisherman's float.

Kirby was born in 1716 and we learn was " bred a house-painter " —he lectured on perspective by invitation of the Society of Arts in 1754, and published the " Dr. Brook Taylor's Method of Perspective Made Easy." In 1761 he published his " Perspective of Architecture." Gainsborough, as well as Hogarth, etched a print for Kirby's book, painted the portrait of him that is now in South Kensington, and directed that he should be buried in Kew churchyard, near his friend.

Sir Joshua Reynolds, head of the English school, began his art education at the age of eight when he mastered the rules of " The Jesuits' Perspective," and proved them by a drawing of his father's school at Plympton (Devon). One of his notes on Du Fresnoy's poem explains concisely the purpose of perspective : " The translator has softened, if not changed the text, which boldly pronounces that perspective cannot be depended on as a certain rule. Fresnoy was not aware that he was arguing from the abuse of the Art of Perspective, the business of which is to represent objects as they appear to the eye or as they are delineated on a transparent plane placed between the spectator and the object. The rules of perspective, as well as all other rules, may be injudiciously applied ; and it must be acknowledged that a misapplication of them is but too frequently found even in the works of the most considerable artists. It is not uncommon to see a figure on the foreground represented near twice the size of another which is supposed to be removed but a few feet behind it ; this, though true according to rule, will appear monstrous. This error proceeds from placing the point of distance too near the point of sight, by which means the diminution of objects is so sudden as to appear unnatural, unless you stand so near the picture as the point of distance requires, which would be too near for the eye to comprehend the whole picture ; whereas, if the point of distance is removed so far as the spectator may be supposed to stand in order to see commodiously, and take within his view the whole, the figures behind would then suffer under no such violent diminution."

No man ever carried the practice of perspective so far as J. W. M. Turner, R.A. It mattered not whether he painted the sky, the sea, the hills, or the plains, his peculiar and intimate knowledge of Nature's laws is there, combined with the theory of perspective.

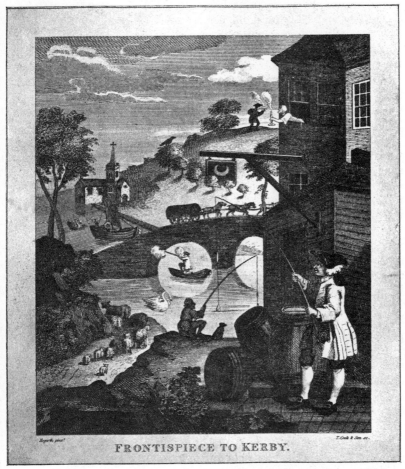

FRONTISPIECE TO KERBY.

Hogarth pinxt *T. Cook & Son sc.*

Illus. LXXV. *Kirby.*

HOGARTH'S PRINT FOR PERSPECTIVE.

I have heard ignorant people doubt his knowledge of its theory ; but why ?

As a lad he worked under Thomas Malton, the topographical draughtsman who a few years before (in 1776) had written one of the largest and best works on perspective (" A Complete Treatise on Perspective in Theory and Practice on the Principles of Dr Brook Taylor "). Is it likely that Turner, who thought of nothing but his art, would miss so easy an opportunity of learning all that could be taught by that book or its author ? Neither is it likely that later in life he would have accepted the post of lecturer on per- spective at the Royal Academy if he was ignorant of the science. The proof that he was not so, lies in his works.

James Holland made perspective lines beautiful by filling them with great masses of light and shade. And Joseph Nash has left us a legacy in his accurate and interesting drawings of the old mansions of England. Of others, too recent to need mention, unless it were to call attention to the use Alma Tadema made of perspective in the different levels of terraces, where figures were partly hidden. In this way he gave interest to odd corners. I sometimes wonder whether the working out of the perspective itself did not suggest some of his composition. I would advise you on some slack day to make a drawing of a written description of an incident entirely by perspective rules. In doing this, first place yourself where the writer describes (or imagines) himself to have been. This fixes the horizon and D.V.P. ; this done, the objects will drop into their place automatically.

The rise of the open-air school, and of the " Impressionists," is still fresh in our minds. Though the latter I believe are already old-fashioned. Theirs was an effort to record the perspective of the air, and being an honest innovation, gave impetus to the art of the day.

H. H. La Thangue, I believe, was one of the first who in England put the horizon at the top of, or above, his picture. I remember one of a girl sitting by a stream, with the water continuing up the whole height of the canvas. Such an arrangement adds enormously to the attainment of realism ; provided the painter has, as in his case, the artistry to avoid the errors and unfeelingness of the snap- shot photo.

A painter's dream.—I should be tedious if I dragged on my notes about British artists *seriatim*, but the other night groups of them presented themselves to me in a dream. Will it bore you to hear it ?

In my dream the painters were standing, each before a sheet of glass—their perspective glasses—placed at a convenient angle, and through these they looked. Behind the glasses was Nature displaying herself in every beautiful phase.

One set his glass so that he had a vista of blue lake between mountains. He painted the serene water and the perspective of the land in sunlight and shadow, and this he did so sweetly, and with reverence, that I knew him for Richard Wilson.

Through another glass I saw the head and bosom of a beautiful girl. In his picture she seemed more lovable than I had at first guessed. Her face and breast where in shadow, faded into the rich red stuffs that were behind her, and these were set off with deep warm blues and creamy whites. He seemed troubled because his pencil did not catch her proportions just as they were. It mattered not that his perspective was not quite accurate, for he made her so natural and womanly that she did not even appear undressed. He signed his name Etty.

A group of young men had placed themselves where there was but a small outlook. In fact a wild rose bush overhanging a little pool occupied one of them for weeks together. He copied each flower and the water, and even the fish and the stones they swam over. He knew he must paint each one beautifully, because they were all God's work and he loved them so. Later on he peeped over his glass and saw the moorlands with their moving shadows, but he could only represent with vigour their outer likeness. He marked the corner of his picture M.

Another caught the dew of the morning and the glitter on the grand old elms and set them in natural groups to remind us of our country. As the wind got up he worked again furiously, so that the white clouds raced across the dark blue of his sky and the water of the mill-race flashed back its light. He seemed to be friendly with another, in more old-fashioned dress, who also painted great trees—not any particular ones—but just living things that tower above one and spread out over the pool where cattle came to drink. I could not find out which piece he was copying, but when he had finished his labours I felt that the summer air was in them. They told me his name was Gainsborough, and he called his young friend Constable.

I recognised Cotman at work because the trees seen through his glass reminded me of the dignity of architecture, and he only looked when Nature was feeling reticent. Sometimes he would walk away

to the castles and copy one very faithfully, so that it looked big and grand.

In this corner where the buildings were, I found pictures wonderfully life-like, but most of these were signed Sam Prout or David Roberts.

The men I had seen were sitting in the front, quite close to Nature. Rows and rows of half-baked men sat behind them. These as they had no glasses of their own, looked over the shoulders of the front rank watching them work. In this way they covered their canvases, stroke by stroke, after them, so that there was some resemblance in the manner of their pictures.

There were also crowds of common-looking men. Their glasses seemed to be placed so that only an ordinary, though pleasant enough view, could be seen through them. Some of these men copied their views quite nicely. I was puzzled, however, when the first man wrote A on his picture ; the next one L, and each in succession M, A, N, A, C, K. I was told the complete row formed a series which was called ALMANACK.

These Calendar fellows did not trouble me much, but there were others, very ill-favoured looking men, who did not even try to trace what they could see through their misty glasses.

Their hands had not the knack of forming the beautiful curves on the water surface so they represented them by straight white lines. They made but one pattern of the sky, because they continually looked at their pictures instead of through the glass. Some one told me they did these things because they had forgotten to switch on the nerve of the eye to that of the brain.

To my surprise, I came across a bevy of painters reading history or anecdotes. These had put up shutters over their sheets of glass. By their side were stuffed figures oddly clothed and set in attitudes. These, and some real faces, they painted, with the surroundings that they had learnt of in books. Their paintings looked so real that I was forced to admire their intelligence, though I also perceived that without a little treatise called " Perspective " they had been unable to produce the illusion.

I saw that there were many men in modern dress gazing intently through their glasses. I thought that it would have pleased my father who worshipped, and faithfully studied, the forms of nature. I was glad when a very, very old man in the front rank turned to give them a smile of encouragement.

I thought, too, that someone painted a nude woman so that she

had the form and dignity that belongs to Eve, and was not just a particular woman undressed. About her were children ; lovable and full of childhood, and the picture had a border of allegory, and whimsical notions thought out and drawn with consummate power. Sympathy and devotion to beauty showed in every line and stamped it as the work of Byam Shaw.

Some looking through little glasses made book pictures that the people who read could know the manner of things they read of, and they were true drawings. There were so many honest craftsmen I had nearly forgotten another group. They had tilted their glasses so that the full sunlight came through them, and hovered palpitatingly over their canvas, and the group said they did it for love of Monet.

Beyond the front rank men, among the golden mists of Nature herself, was a solitary figure. He was short in stature, and from pockets of his long coat there stuck out a roll of drawings. It was Turner. His brilliant and kindly eyes were taking in all Nature's secrets. They knew one another ; and she offered no resistance. For he had early won that right which others could not claim.

ENGRAVINGS AND BOOK ILLUSTRATIONS

The history of perspective would be incomplete without some mention of its use in books. In woodcuts of the fifteenth century, an example of the single print, " St. Christopher " (in the Spencer Library, Manchester), is a spirited design having the high horizon we commonly see in primitive work. The realistic drawing of the principal figures contrasts oddly with the bird's-eye view of the landscape. Each object tells its tale (and it does so even to the thatched roof of a house) quite independently of the matter of size or perspective of its neighbour.

The British Museum contains one of the " block books "—the " Biblion Pauperum," printed about 1440. Compared with many woodcuts of a later period the perspective is none so bad though very much behind that of the best painting when we remember it was the time of the Van Eycks.

The " Cologne Bible " (1475) has the usual signs of early work. Large people and rooms too small to stand up in ; here and there a piece of foreshortening seen correctly ; elsewhere receding parallel lines drawn converging, but not to the same point, and hardly ever towards the horizon. In fact an inkling of perspective but none of

its science. But the heads of the figures are not so monstrously big as in the " Biblia Pauperum."

In Caxton's books, such as " Game and Playe of the Chesse " and " Mirrour of the World," the drawings are very coarsely cut, but the direction of the lines on the figures is usually expressive of the foreshortening. The cuts in " Fyshynge with an Angle " (printed by Wynkyn de Worde) are very forcible though innocent of perspective.

Delicate and elaborate workmanship is seen in the French and Italian prints of the fifteenth century. A woodcut from " Paris et Vienne," published in 1495, shows the advance from the early German drawings both in the flatness of the ground the figures stand on, and some approach to correctness in the receding lines of the castle walls. The figures themselves are not correct in size one with another. A similar advance can also be noted in German cuts of the " Lubeck Bible " from the impossible perspective of say the " Hortus Sanitatis " of a few years earlier.

In the sixteenth century, by the genius of Dürer and Holbein and the talent of Burghmair, Aldegrever, Altdorfer, Lucas Van Leyden and others, a new epoch was opened up for engraving in wood and copper. The exquisite work of Dürer and Holbein is, I hope, a part of the education of every art student, while much can be learnt from their contemporaries ; though their perspective was not always faultless. Someone will tell me that in one of Holbein's Bible cuts —" Joab's Artifice "—the lines of the pavement, though it was intended to be level, meet at a point much below the horizon. So they do, but that does not take away from the idea of the whole scene looking correct. If beauty is appreciated and understood by an artist it is handed on by his work whether it is quite accurate or not.

One could, if one wished, teach every law of nature and perspective rule, by examples of its use, misuse, or neglect in picture-books. In doing so, we should run through the history of wood-engraving from the time when beautiful work was sent out from the publishers at Lyons, and by Plantin at Antwerp. We should mention its uses in London by John Daye (" Book of Martyrs," 1562), then follow it to the end of the seventeenth century ; show how copper-plate engraving superseded it ; illustrate Hogarth and give examples of the revival under Bewick in the eighteenth century, and of the talent later on in the engravers Linton and the brothers Dalziel.

That would bring us to the artists Blake and Calvert, Rowland-
son, to Doré, and presently to Sir John Gilbert, Tenniel, Birket
Foster, and Leech, followed by Charles Keene. We should be near-
ing the end of the men who drew for the wood-engravers with
Holman Hunt, Rossetti, Millais, Poynter, Sandys, and Caldecott.

It would be an inadequate list, though sufficient to connect on to
the introduction of mechanical process that ousted wood blocks,
though fortunately leaving us artists who kept up the traditions in
pen and ink. Here we should have an unlimited field for exploiting
our perspective, since pictures in any medium can be reproduced.

PAINTING OF SHIPS

It would be interesting (but life is short) to begin a sketch of the
perspective in shipping with the " red-checked " craft of Homeric
times ; followed by the naumachiæ of the Roman emperors as
engraved on their coins ; on till we arrived at the vessels of our
forebears. There are representations of these of the time of Harold
on the Bayeux tapestry, and others in the MS. illuminations of
the thirteenth and fourteenth centuries. The MS. of " Froissart's
Chronicle "[1] illustrates the mediæval galleys, as does also the
" Chronique de S. Denis " those of the time of Richard II.

The chief interest in the perspective of many of these drawings is
its unexpected adaptability in showing us the ship's construction
in places that should have been invisible !

A MS.[1] represents the galleys of the early fifteenth century but
no sign of perspective.

Henry VIII's time is depicted in the " Archæologia." Ships of
a later period are seen in the illustration of the essay by Halsius.

Augustine Ryther, in his series of the Armada engagements,
shows us galleons of the sixteenth century. We note the very
common mistake of the ship being seen from one view and the sea
from a higher level, a mistake by no means confined to early work.
Engravings of Dutch shipping by W. Hollar are of the middle of the
seventeenth century, with Dominic Serres of the eighteenth.

Not being myself a seafaring man, I asked Louis Paul (who is as
crafty with a pencil as he is handy with all craft) to tell us of the
perspective in the old paintings of ships. He began with a breezy
account of the early sea-fights to which his opening lines here
quoted refer.

[1] In the British Museum.

" The artistic conditions of the two centuries are as changed as
the calibre of the guns, and we shall never again look upon such
scenes as the old sea-fights—so let us cherish these old canvases,
and look with lenient eye upon their few technical shortcomings.

" The high standard of excellence in the drawing of the ships them-
selves is due, in some measure, to the fact that the best known of
these early painters had, at some time or other in their careers,
followed the sea as a profession. Richard Paton, Dominic Serres,
Thomas Luny, P. J. de Loutherbourg, Brooking, Nicholas Pocock
(well known by his excellent illustrations in the ' Naval Chronicle '),
and of a younger generation, Van de Velde (the famous sea-scapist
of the Restoration period, and esteemed as the most reliable
authority of his day), these men had, each of them, ' hardened in '
the lee braces, and felt the sting of the Western ocean spray. So
there is little fault to be found in poise of hull or belly of sail as
painted by them.

" A little lapse in Nature's laws may occasionally be discerned in
their work, but we have to search diligently to find such another as
Isaac Sailmaker's ' Battle of Malaga (1704),' in which that pains-
taking artist successfully overcomes his difficulty of representing a
huge concourse of stately battleships and rakish xebecs, by elevating
his point of sight a hundred feet or so, as necessary, until his horizon
is sufficiently high to include all and every one ot his ships—regard-
less of the disquieting fact that his foreground vessels must have
been drawn from the water's level ! "

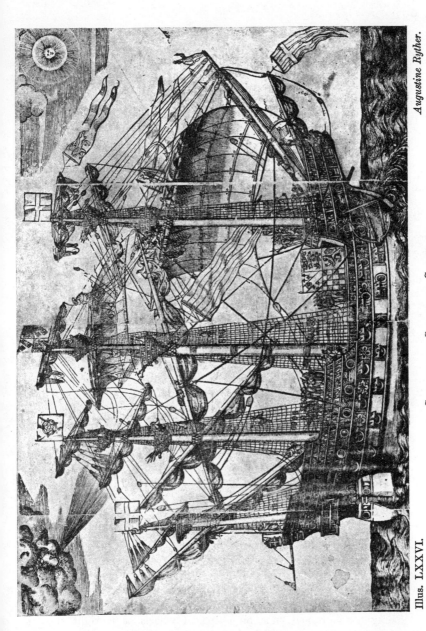

Illus. LXXVI.

SHIP OF THE SIXTEENTH CENTURY.

Augustine Ryther.

CHAPTER XXI

NOTES ON THE PERSPECTIVE OF THE JAPANESE

A FEW examples of Japanese art will suffice for our purpose of seeing in what manner their observation and rendering of Nature's laws (which we call perspective) coincides or differs from our rendering. Let us select illustrations from " The Painters of Japan," by Arthur Morrison. Beginning with the Tosa school, because of its purely national character, we have a masterpiece of drawing in the horses and fighting bulls of Toba Sojo (1053–1140). The perspective foreshortening of their bodies is expressed by over-lapping contours in lines that are equally perfect in their decision and subtleness of curves. The drawing shows the animals' passion and power with the fewest possible strokes ; it is naturalistic to a degree, and subject to no convention whatever.

At the end of the twelfth century Sumiyoshi Keion, another master of action, depicted the flight of the Imperial Court. A reproduction of a part of his *makimono*[1] is given in Mr. Morrison's book. The story of flight and pursuit is irresistibly told. We look on the scene from above, as is so often the case in Japanese works. There is movement in every horse and man ; clothes and horse-tails stream to windward with the pace ; carriages collide ; a horseman jams his hat on his head, another loses his. There is no end of rush and nothing could be added to make a greater stir. There is little of convention here but much art and realism, especially when we remember that light and shade are omitted. The figures near-to have space of ground between them, and appear densely packed further away, after the manner of every crowd. The bow-men sit their galloping steeds as our own huntsmen do. The carriages are foreshortened just as we should draw them now. But how can we explain the wheels ? Their axles run true with the body, and the long pointed hubs stand out at the correct angle. One carriage being foreshortened runs on elliptical wheels as is right that it

[1] The original is in the Boston Museum.

244

should, but others seen almost side view have wheels that are hardly more round. Was there some convention in the twelfth century persuading this great realist and accurate observer of Nature to make a wheel oval in shape instead of a circle ?

And now take note of this when you talk of modern impressionism. The ox drawing the central carriage has been pulled up sharp, to clear itself of another galloping past his head, so every spoke in the stationary wheel is drawn easy to see.

The other carriage travels so fast that the rotating spokes are invisible, and so are represented by countless circular lines ; lines that in those days as now, were equally expressive of the presence of the spokes and their blurred movement.

Passing on to the seventeenth century to Tosa Mitsuoki in his portrait of a saint writing at a table, we see a good instance of spaces as they recede being represented wider, instead of the side boundaries becoming narrower in the distance as our perspective teaches us. The far end of the table is drawn the same height as the near end, and to our eyes accustomed to heights appearing shorter as they are more distant, it appears even to be taller. However, as if to confuse us should we have theories to account for this manner of drawing, we see that the saint holds in his hand a half-rolled paper whose sides recede in the way we ourselves would draw them.

Leaving the Tosa school for that of the Chinese renaissance of the fourteenth century we find many masterpieces of landscape, birds, and animals that are useful for our enquiry. One and all they show a delight in the foreshortening of curved lines.

There is a white falcon painted by Oguri Sotan (fifteenth century) with the rows of the feathers beautifully expressing the modelling of the bird. The perch he sits on has an encircling band, the edges of which might be examples of a foreshortened circle.

The stripes on Noami's ideal tiger (Illus. LXXVII) construct the animal. Each stroke gives the rounding or a foreshortened surface of its body. Surely the perspective of curved lines was never put to so great a trial before ! The painter knowing their possibilities and his own power, used them in place of an outline ; and in short, has juggled with them where a lesser man would not even have known their significance.

The details of Nature have always been so perfectly and naturally represented by the Japanese of all schools, that there is no need to call attention to the fact.

All good drawings of dress by the Japanese show an intuitive selection of those folds that suggest the figure. The rounding of a shoulder, or the foreshortening of a side, is habitually given by a delicate but unerring line. It is the same appreciation of truth and beauty that we see in fine work of other nations. The portrait of a Chinese poet riding by Unkoku Togan will prove it to you.

JAPANESE COLOUR PRINTS

The aim of the Ukioye school, the designers of colour-prints to provide art for the people, is exactly expressed by E. F. Strange's translation of " Ukiyo-Ye " as " mirror of the passing world."

Fortunately we have in this country many faces of this mirror for our study and delight.

Hishigawa Moronobu was born in 1625, forty-seven years after the birth of Matabei, the founder of the school. There is a very delightful painting of dancers and musicians by him reproduced in Morrison's book. The joyous figures, full of animation and grace, dance round the old musician, who sedately pipes to them unconscious of the fact that he is sitting just off the edge of the carpeted platform, or that its top provides a violently sloping seat for the girl musicians behind him.

A print by Kiyonobu (1664–1729) in the British Museum shows the rendering, usual at his time, of receding edges of boxes, screens, etc., that would be parallel in Nature, represented by parallel lines in the picture. One of Koriusai's prints of a " Crow and the Heron," (Illus. LXXVIII), in the National Art Library, shows how well the solidity of the form can be shown by single lines that follow its modelling. Here the same lines draw the feathers and the contours of the birds. It is a beautiful example of the national appreciation of the perspective of curved lines.

A drawing by Shiba Kokan (1747–1818), in Mr. Morrison's collection, represents a labourer with a distant landscape, notable for its low horizon in contrast to the very high point of view usually selected by the Japanese ; in fact, a very usual custom of these early masters was to remove the roof of a house so that its interior arrangements could be better displayed. We have something nearly corresponding to this device in Dutch and English paintings of cottage rooms, where a wall must have been missing to allow of the view ; the arrangement was also adopted in the early European prints.

Katsugawa Shunsho (1726–1792) had the same habit of drawing

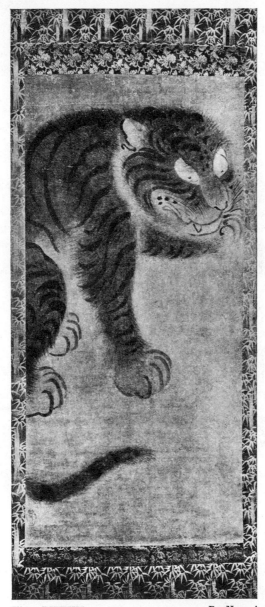

Illus. LXXVII. *By Noami.*

TIGER.

In the collection of Arthur Morrison. Reproduced
by his permission and the publishers of "The
Painters of Japan."

surfaces as they recede remaining the same size or even getting larger. We see innumerable examples throughout their schools of a right-angled object—a box, for instance, with one corner towards us—being represented by parallel lines for the receding edges of its

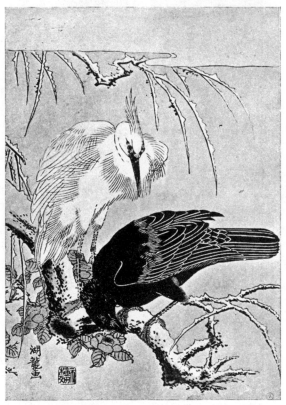

Illus. LXXVIII. *Print by Koriusai.*

CROW AND HERON.

(Victoria and Albert Museum.)

sides and top, as the object really has, but not as they appear. On the other hand, the meeting of the sides will be drawn not as a right angle (as in Nature) but as an obtuse one, like we should make it.[1]

[1] This closely resembles a deplorable modern manner of depicting objects. It is called isometric drawing. All lines that recede are drawn parallel to one

There is a print in South Kensington by Yeiri, "The house of a noble, with ladies looking through a screen." A staircase leads up to the balcony where the ladies sit. The boards are laid at right

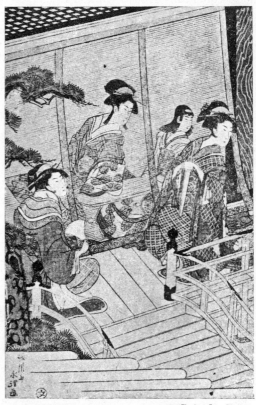

Illus. LXXIX. *Print by Yeiri.*

THE HOUSE OF A NOBLE, WITH LADIES LOOKING
THROUGH A SCREEN.

(Victoria and Albert Museum.)

angles to the stairs (Illus. LXXIX). We have just spoken of a similar treatment of similar lines, and the effect in this picture is curious.

One does not easily forget the "Arrest of Marubishi Chuya," a

another so that a box is represented the same height and width at the near and far end, but the corners instead of being right angles are drawn at 30° angle with the horizon.

print in South Kensington by Toyoharu. One would like to talk about the raving captive, but his cage only concerns us. It is an open framework of timber seen from above. The top and front surfaces of the receding rails remain parallel to one another where we should draw them converging to a distant vanishing point. The upright posts are equidistant, and of the same width, consequently the spaces between them are alike, both in shape and size. One comes to the conclusion that their accuracy of eye enabled them to draw curves and angles without hesitation, and that some convention compelled them to represent receding surfaces as they really are, but not as they saw them.

Knowing their power of foreshortening an arm, a foot, a branch or a dicky-bird's head, one cannot believe that such observers of Nature, and masters of drawing, could find a difficulty in following the lines of parallel-sided objects.

The Indian drawing reproduced in Illus. LXXX showed that the greatest care had been bestowed upon it. It is a good example of unruly perspective.

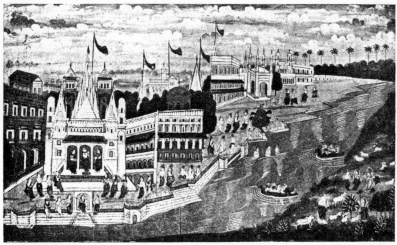

Illus. LXXX.

FROM A COLOURED INDIAN DRAWING.

PART III

MECHANICAL PERSPECTIVE

CHAPTER XXII

HITHERTO we have considered perspective as an aid to drawing. Usually we supposed that we had an object in front of us—we sketched it—and then corrected our lines by the observance of those laws of nature that science has formulated. In an occasional excursion we started with the principal object of our composition and built up others around it by the application of perspective rules, common sense, and a little reasoning. Mathematical deduction of theory and artistic rendering have so little in common that there is always the danger of the former usurping the place of the latter if any other course than the one we took is followed.

Architects' perspective.—At first sight perspective, as used by architects, seems a cold-blooded affair—a calculation of angles, a measuring of points ; the T-square and compasses for counsel ; while the man himself just rules the lines because he has not invented a machine to do it for him. But take his view of it. On a piece of tracing-paper are set out a ground plan, some elevations, and many details all measured out to scale. He and his centrolinead get to work and hey presto the blue smelly paper is converted to a drawing of a magnificent mansion which no man has ever seen ; substantial and realistic with every detail correct in its place—just as we should see it from the chosen point of view. Let us then apply the word mechanical to this branch of perspective not as an opprobrious epithet but just to distinguish it from its other and more tractable offshoot where our fancy and reason can have free play.

It was our habitual custom in Part I to discover the reason for the length, depth, or direction of a line, and then to draw it by the

method most applicable. It seems advisable instead of plunging into a different system for mechanical perspective to endeavour to keep up this good custom and even to pave the way by a compromise between the two methods.

Suppose we have to draw a right angle lying on level ground with its corner towards us. If we copy the direction of one of the

<div style="text-align:center">Fig. 353.</div>

receding lines (Fig. 353) and continue it until it meets the horizon we find the V.P. for that line. If from that V.P. we run a line to our feet (" Painter ") we represent the actual direction of the line as it would be if we were standing on its near end. If from " Painter " we take a line at right angles to the other end, and continue it to the horizon, we find the second V.P. for the right angle.

What we have done then is to set out a right angle at our feet in the actual position of the one we had to draw, but we copied the direction of one line first, in order to find V.P. 1, and consequently the position of the angle at " Painter."

We might reverse the order and first set out at " Painter " the angle and continue its lines (Fig. 354) to find the two V.P.'s, then mark the corner of the right angle we have to draw and take its lines to the V.P.'s found by the angle at our feet. This is just what we do when we have no object to copy from.

<div style="text-align:center">Fig. 354.</div>

A perspective drawing made from a plan and elevation of a building.—Let us (Fig. 355) represent the building we have to draw.

Practice (Fig. 356).—Set out the ground plan of the building in the position it is to be drawn. Decide on the distance it is to be seen at, and mark our station point "P." Rule a horizontal base line touching the near corner to represent the base line of the picture plane, and another at P. Rule the line of sight perpendicular to these from P, and mark the P.V.P.

From each corner of the plan take lines to P. In this way the

position of each corner will be marked on the base line of the picture plane, and consequently the length of the front and side of the building just as we should see them if the picture plane were transparent. At P set out the right angle of the front side of the

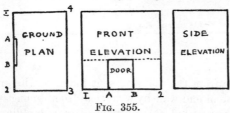

Fig. 355.

building in the same position as the plan (P–V.P. 2 parallel to 2–1 and P–V.P. 1 parallel to 2–3), and so find the two V.P.'s on the base line.

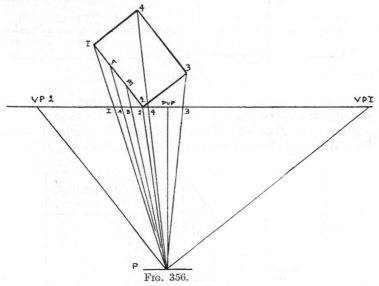

Fig. 356.

On a strip of paper[1] tick off each dimension found on the base line and mark them V.P.2, 1, A, B, 2, 4, P.V.P., 3, V.P.1 (Fig. 357). Transfer these measurements to the base line in Fig. 358. Where the near corner of the building is to come (at 2) raise its height by transferring the height of the side elevation. Decide how high up

[1] Fold a piece of paper quite flat, and use the folded edge for the measurements; it will be rigid, level, and straight.

this wall the horizon line should be and draw it. Raise the V.P.'s from the ground line on to the horizon.

Draw the bottom and top lines of the end wall to V.P. 2, and those of the front wall to V.P. 1. Cut off the length of the front wall by

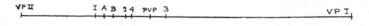

FIG. 357.

a vertical line from the measurement found on the ground line (1), and the length of end wall by a vertical from its measurement (3).

Fig. 355 represented the mere shell of a building, so that the explanation should be unmistakable.

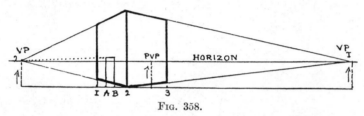

FIG. 358.

In Fig. 359 *et seq.*, we have the same house with a gable roof, windows, and doors—quite a mansion—so carry on thus :

Practice for Fig. 362.—Find measurement on ground as in Fig. 357, but add D for doorway and W for windows (Fig. 363).

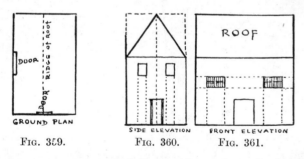

FIG. 359. FIG. 360. FIG. 361.

(The latter measurements being run down the wall of end elevation (dotted lines) to the ground plan.)

As these points added to the others on the ground (Fig. 363) might cause confusion, it is advisable to make a separate tracing of them and to mark them on its ground line. The tracing is then laid over

the perspective drawing, and these points pricked through on to its ground line when they are required.

The outlets on the front elevation are added as required in the same way.

The apex of the roof might have been included in the original drawing, but in the event of its having complicated features it is well to make a separate measurement on tracing-paper.

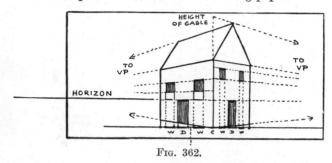

Fig. 362.

The height of the roof is obtained by the measurement of its front elevation, and adding that above the near corner of the house in the perspective drawing. A line from that height to V.P. 1 fixes the height of the gable above the centre of the end wall. A line from the gable apex to V.P. 2 determines the height and direction of the ridge.

With this method we need not use either measuring points or diagonals to find the length of a receding line as we did in Part I.

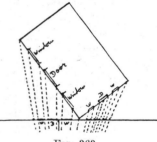

Fig. 363.

We simply raise a vertical line from each measured point on the ground line, and so cut off each receding line at the right place.

Heights

First method of measuring heights.—In a simple building all the heights can be measured off first on the elevation and then on to a vertical line at the near corner of the building on the perspective drawing. Each line starting from a measured height on the vertical (say of a chimney at the far corner) as it recedes to the V.P. will be

cut at the proper distance by the vertical lines carried up from points on the ground line. In Fig. 364 the height of the chimney is shown on the elevation. The same point appears in the perspective drawing (Fig. 366). The line receding from chimney is cut at 2

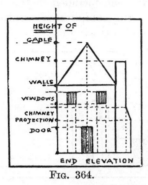

FIG. 364.

FIG. 365.

by the vertical from its position on the ground line, and so the height of the chimney is obtained.

Second way of measuring heights.—*Exercise.*—To find the height of the weather-cock on the **far** corner of the building (Figs. 367, 368),

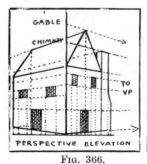

FIG. 366.

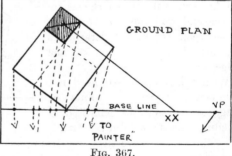

FIG. 367.

the other heights and the ground line measurements having been determined as in previous examples.

Practice.—From X, the position of the weather-cock on the plan (Fig. 367), carry a line parallel to the side of the building until it meets the base line (at XX). Mark it off on the ground line of the perspective drawing. Measure on the elevation the height of the weather-vane from the ground, and mark that height on an upright from X on the perspective drawing (Fig. 369). From its top carry a

MECHANICAL PERSPECTIVE
257

line to V.P. 2. Where it is cut by the upright which shews the
position of the weather-vane on the ground line will be the
desired height.

Fig. 368. Elevation.

Fig. 369. Perspective Drawing.

A shorter or longer perspective drawing is obtained by the building
not touching the ground line.

Usually the base line is drawn (as in Fig. 371) touching the near
corner of the building, and it is the most convenient method.

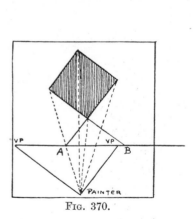

Fig. 370.

Fig. 371.

**If the ground line with its measurements should make too long a
line** on the perspective drawing it can be reduced by placing the
base line in the plan nearer to the painter (Fig. 370). But some
way of representing the distance from the near corner of the

building to the base line must be found. On the plan continue the side
and end of the building until they meet the base line (at A and B) ;
mark off these points with the others on the ground line of the
perspective drawing. Start the receding line of the side of the

house from B (taking it to V.P.
2) and the receding line of the
end from A (to V.P. 1) ; where
these lines cross will be the
house corner, at the correct

Fig. 372. Perspective Drawing.

distance from the ground line. The operation is equivalent to
continuing the house up to the base line of the plan, and conse-
quently starting it from the ground line in the perspective drawing.

A greater length can be obtained for the picture plane by placing
the plan in front of it, as shown by Fig. 373.

Fig. 373.

CHAPTER XXIII

MECHANICAL PERSPECTIVE—*continued*

BUILDING **seen with one face parallel to the picture plane.**—It is quite optional whether we make a perspective drawing showing the building as seen at an angle, or directly facing us, so that the front or side of it is parallel to our upright picture. The latter view is sometimes chosen to show off to advantage a decorative frontage. Very commonly it is used for drawings of interiors, court-yards, and gardens ; and it seems particularly suitable where attention is to be drawn to special formality or symmetry of arrangement.

Let us begin with the ground plan of a house (Fig. 374) and make a perspective drawing.

Practice for Fig. 374.—Decide on the station point (P). Use the near side of the house for the picture plane and rule the line of sight perpendicular to it till it meets the station point. Carry lines from each corner to P ; mark where they cut the picture plane and the position of the point of sight (P.S.) (where the line of sight meets the picture plane). Transfer all these points to the ground line of the perspective drawing (Fig. 375). Rule the horizon line the height you wish it to be above the ground (by scale in accordance with the measurements on the plan and elevations). Place the P.V.P. on horizon above P.S. ; take sides of building

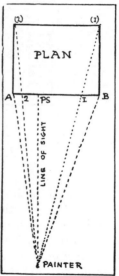

FIG. 374.

(because they are parallel in Nature to the line of sight) to it. From the point 1 carry up a vertical till it meets the side of the house (at 3). The point 3 will then represent the corner 1 on the plan. Carry up 2 to 4. Join 4 to 3 for back of house. The

259

heights are found by setting up a height measuring line at one corner (or both), the height having been measured off on to the line from the elevations. Thus if one wall was found in the

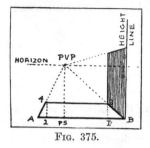

FIG. 375.

elevation to be 12 ft. high the height line would show that, and a line at its top receding to the P.V.P. would give a wall 12 ft. high from the near to the far end.

As there is no difficulty in raising walls in the perspective drawing once we have the foreshortened ground plan on which to build them, we will draw plans in perspective until they become a matter of ease.

Practice for Fig. 376.—Repeat working of Fig. 374 to obtain the lines of the walls.

To introduce the chimney breast, draw on plan the dotted line

FIG. 376.　　　　　FIG. 377.

(continuation of its front) to find its place on picture plane. From it (in perspective drawing) take line to P.V.P., then the front of chimney breast must be somewhere on that line. Certain points in the plan mark where lines from its near and far end touch the side walls, carry these to the base line, and in the perspective drawing raise verticals from them until they meet the side wall; there draw horizontal lines for the near and far end of the chimney.

PRACTICAL PERSPECTIVE COMPARED WITH MECHANICAL

If we draw a foreshortened square by mechanical perspective we transfer the length and the P.S. (Fig. 378) and one point representing the far corner to the ground line of the perspective drawing.

FIG. 378.

Having raised the P.S. to the horizon we join it with the near corners of the square and cut off one receding side line by raising a vertical from the base line. At the depth thus found we draw the horizontal back of the square. To divide the square into halves we mark the half on the base line and from its position there raise a vertical till it meets the side at AA, where we rule the horizontal dividing line.

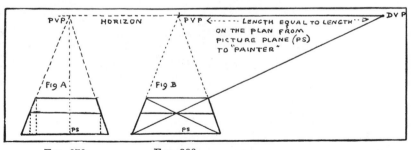

FIG. 379. FIG. 380.

In practical perspective (Fig. 380) we should have drawn our perspective square and then taken diagonal lines across to find the centre and through it ruled the dividing horizontal line.

It will be seen that the result in each case is identical. Further

comparisons would waste paper and ink, for have we not already drawn objects by more than one method ?

Drawings of interiors often fail from too wide an angle of vision being represented (see page 25). Receding lines which are drawn on the supposition that we, being close to them, saw them to right and left out of the corners of our eye, may in theory be correct but on paper look horrible.

We cannot see the whole of a room without altering our position, neither can we represent it by one drawing only.

Boats drawn from a Plan

In Chapter XVII we sketched a boat from a plan (Fig. 381), which shews how its dimensions could be obtained by mechanical perspective. The childish plan I have drawn is supplemented by the ship designer's drawings (Illus. LXXI, LXXII). Since in these each section, both vertically and horizontally, is given, a perfect perspective drawing could be made by one owning the qualifications for the job.

FIG. 381.

FIG. 382.

The upper diagram is a rough plan with some essential points ticked off on the picture plane. The lower diagram shows how these points could be found in the perspective drawing, such as the point C, first found on the picture plane, and then raised in the perspective drawing till it meets the top of the box. Similarly point 2 raised till it meets the receding (dotted) line that starts from the height line O. The heights are found as previously explained.

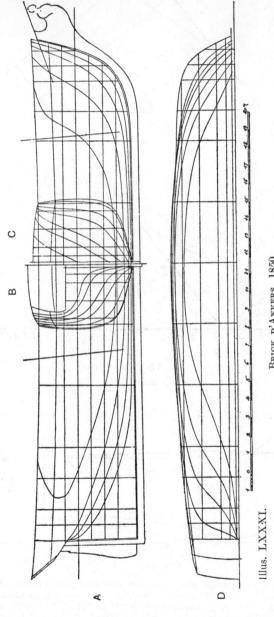

Illus. LXXXI.

BRICK D'ANVERS, 1850.

A. Side elevation (and in centre).
B. Sectional elevations seen from stern.
C. Sectional elevations seen from bow.
D. Plan of half the ship lengthways.

(Reproduced by permission of "Yachting Monthly.")

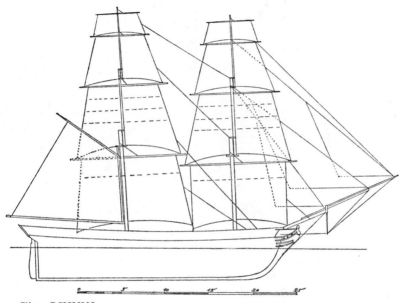

Illus. LXXXII.

BRICK D'ANVERS, 1850.

Ship-builders' Plan.

(Reproduced by permission of "Yachting Monthly.")

APPENDIX

NOTE 1.—*Enlarging a sketch on the same proportions.*

To Chapter I, "square up." A small sketch (Fig. 383) can more easily be re-drawn on a larger canvas (Fig. 384) if both of them are divided into sections of equal proportions. These sections can either be in divisions of half with further subdivisions of quarters, etc., or the guiding lines can be drawn through prominent features

FIG. 383.

FIG. 384.

of the sketch. Either method, or others that will present themselves, will answer, provided that the canvases are of similar proportions. Cotton threads stretched across the face of the sketch and attached to its sides by drawing-pins will save it from the disfigurement of drawn lines. Small working sketches can be drawn on "sectional paper" (paper ruled with faint blue squares used by mechanical draughtsmen), and the squares then repeated to scale on the canvas selected.

NOTE 2.—*How to divide a line into a number of given proportions.*

(A) To mark off on a line of indefinite length a certain number of divisions of a given length. The first division will be marked off and

FIG. 385. FIG. 386.

repeated as often as necessary by compasses, or by a piece of folded paper with that length marked on its folded edge.

267

(B) If, however, the length of the line is fixed and we have to divide it into a stated number of divisions we shall not know beforehand the length of those divisions (as in A).

Suppose the line 1–2 (Fig. 385) has to be divided into five divisions. From one end (Fig. 386) draw another line at a convenient angle and indefinitely long 2–3. On it mark off five equal divisions (of

FIG. 387.

any length). Join the last division with end of the given line (1). From each division draw lines parallel to 5–1. These will cut the given line 1–2 into five divisions of equal length. Unequal divisions could in similar fashion be marked off on the measuring line 2–3, and would be repeated in the same proportion on the given line (Fig. 387).

To subdivide a rectangular form.—The base line of a rectangular form (Fig. 388) can be divided into any number of even figures

FIG. 388.

(2, 4, B, etc.) by using diagonals to find the half of the whole form, and successively the half of each division.

NOTE 3.—*How to transfer in the same proportion the divisions of a line on to another of greater or lesser length.*

Problem (Fig. 389).—The short line 3–4 is to be divided in the same proportions as the long line 1–2.

Practice (Fig. 390).—Draw 1–2 parallel to 3–4. Join the ends 1–3 and 2–4, continue these connections till they meet (at A). Join

FIG. 389.

each division with A, and then the line 3–4 will be divided proportionally to the line 1–2.

The proportions of a short line can be transferred to a larger line in the same way. Call 3–4 the short divided line, and 1–2 the long

line to be divided. Join their ends and continue the connections till they meet (at A). Join A with each division on line 3–4 and

Fig. 390.

continue the joining lines till they cut the line 1–2 into similar proportions.

NOTE 4.—*How to estimate the measurements of a canvas that is to be proportionately larger than another.*

We have often to transfer a sketch on to a larger canvas and wish it to bear the same proportions.

Practice (Fig. 391).—Continue the side of the small canvas A until it is the required length (say B–C). Take a diagonal from B of indefinite length. From C draw line at right angles to B–C and continue it till it meets the diagonal. The line thus obtained C–D will be the width of the larger canvas. This workman's practice arises out of the method of drawing concentric squares. If absolute exactness is necessary "proportion" in arithmetic might be employed instead.

Fig. 391.

BIBLIOGRAPHY

No date. JESUIT, pseud.: for Jean Dubreuil. "Practical Perspective." Illus.

1440. BARTOLOMEO BRAMIANTINO, "Regole di Prospettiva e Misure delle Antichità di Lombardia."

1494. F. LUCA PACCIOLI, "Summa d'Aritmetica e Geometria."

1525. ALBRECHT DÜRER, "Institutiones geometriceœ" (fourth book of geometry).

1560. J. COUSIN, "Livre de Perspective."

1600. GUIDO UBALDI (GUIDO UBALDO) (GUIDUS UBALDUS). Passaro.

1612. SOLOMON DE CAUSE (CAUX ?), "Perspective avec la raison des ombres." London and Frankfort.

1608. ⎱ SEBASTIANO SERLIO, "Opere d'architettura e Prospettiva
1619. ⎰ di S. D. Scamozzi." 4to. Wood engravings.

1619. SAMUEL MAROLAIS, "La Perspective contenant la théorie et la practique."

1625. H. HOUDIN, "Institution en la Perspective."

1642. S. J. DUBREUIL (published by), without author's name, "La Perspective." Paris. Three vols. ("The Jesuits' Perspective.")

1651. LEONARDO DA VINCI, "Trattato della Pittura." Folio. Engravings in the text. (See Hawkins' translation, 1802.)

1652. PÈRE NICERON, "La Perspective curieuse."

1661. PÈRE BOURGOING, "La Perspective Affranchie de l'embarras du point du vue." Paris.

1669. DANIEL BARBARO, "Practica di Prospettiva." Folio. Venice.

1671. ANDRÉ ALBERTI, "Deux livres sur la Perspective." Nuremberg.

1672. GIULIO TROGLI, "Parodossi della Prospettiva." Bologna.

1673. PÈRE DESCHALESQUE, "La Perspective du; qui se trouve dans son Cursus Mathematicus." Lyons.

1693. POZZO, "La Perspectiva pictorum et architectorum." Rome.

272 BIBLIOGRAPHY

1701. Père Lami, "Le Traité de Perspective où sont contenus les
 fondements de la peinture." Paris.
1711. S. Gravesande, "L'Essai de Perspective." Amsterdam.
1731. Dr. Brook Taylor, "Linear Perspective."
(1715).
1745. Père Jacquier, "Elementi di Prospettiva." Rome.
1748. Hamilton, "Stereography, or a general Treatise of Per-
 spective in all its branches." London.
1749. Brook Taylor, "New Principles of Linear Perspective."
 3rd edition. London, 1749.
1750. Petitot, "Raisonnement sur la Perspective pour en faciliter
 l'usage aux artistes." Parme.
1750. Jeaurat, "De l'Académie des Sciences. Traité de Perspec-
 tive pratique à l'usage des artistes." Paris.
1754. John Joshua Kirby, "Dr. Brook Taylor's method of Per-
 spective made easy both in theory and practice." In
 two books. Illustrated with 50 copper plates. Dedicated
 to W. Hogarth. Two parts in vol. 4to. Ipswich.
1757. Le Roi, "Essai sur la Perspective practique par le moyen
 du calcul." Paris.
1776. Thomas Malton, "A complete Treatise on Perspective in
 theory and practice on the Principles of Dr. Brook
 Taylor." Folio. London.
1770. Priestley, "Familiar introductions in the theory and prac-
 tice of Perspective." London.
1874. Henriet, "Cours Rational de Dessin."
1781. "The Jesuits' Perspective." 4th edition. London, 1781.
 4to. 150 plates.
1800. James Malton, "The Young Painters' Maulstick ; being a
 practical treatise on Perspective." Dedicated to Ben-
 jamin West. 4to. 23 plates. London.
1802. Leonardo da Vinci, "Treatise on Painting, translated and
 digested by John Francis Rigaud." Illustrated with 23
 plates and other figures. With a life by John Sidoney-
 Hawkins. 8vo. Portrait and plates. London.
1803. Edward Edwards, A.R.A., "Practical Treatise on Per-
 spective on the Principles of Dr. Brook Taylor." 4to.
 Plates. London.
1805. T. Hodson, "The Cabinet of the Arts." Illus.
1808. T. Noble, "Practical Perspective."

1832.? BARBARO, "Practica della Prospettiva." (Reprint ?) Folio.
 Florence.
1837. JOHN BURNET, F.R.S., "The education of the eye with
 reference to Painting."
1852. "Perspective for Beginners, by George Pyne, artist."
 London.
1862. BURCHETT, "Linear Perspective."
1872. AARON PENLEY, "Elements of Perspective" (Winsor and
 Newton.)
1873. M. A. CASSAGNE, "Traité Practique de Perspective." Paris.
1883. W. R. WARE, "Modern Perspective Plates."
1884. G. TROBRIDGE, "The Principles of Perspective."
1886. ARMAND CASSAGNE, translated from the French by
 S. Murray Wilson. "Practical Perspective applied to
 artistic and industrial design." Le Chertier Berbe.
 London.
1888. HENRY JAMES, "Handbook of Perspective."
1891. F. O. FERGUSON, "Architectural Perspective."
1892. J. CARROLL, "Principles and Practice of Perspective."
1897. S. POLAK, "Theory and Practice of Perspective Drawing."
1901. R. PRATT, "Perspective," including the Projection of Shadows
 and Reflections.
1902. R. G. HATTON, "Perspective for Art Students."
1902. J. PETTY, "Perspective and the Projection of Shades."
1903. W. L. WYLLIE, R.A., "Nature's Laws and the Making of
 Pictures."
1903. G. A. T. MIDDLETON, "The Principles of Architectural
 Perspective."
1904. J RUSKIN, Works, "The Elements of Perspective." Illus.
1905. F. R. SHEARER, "Perspective Tables."
1906. W. H. ROBERTS, "Architectural Sketching and Drawing in
 Perspective." Illus.
1906. R. "R.'s Method ; Perspective at Sight."
1908. VICTOR T. WILSON, "Freehand Perspective—for use in
 manual training colleges." London and New York.
1910. G. A. STOREY, A.R.A., "The Theory and Practice of Per-
 spective." Clarendon Press.
1917. A. NOELLI, "La Prospettiva per gli sculptori il bassorilievo."
 Illus.

INDEX

A

Airship, Perspective from, 214
Angles—
 How to copy, note to p. 38
 Angle of vision, 30, 52, 215, 222, 227, 229, 246, 262
Animals—
 Drawing of, 64, 65, 130
 by the Japanese, 244, 245
Arcade, 49
Arches—
 Types of, 112–114
 Full-face, 117, 118
 Foreshortened, 116, 120
 Details of, 121
 of groined roof, 122, 123
 Thickness of, 120
 Sunlight through, 186, 191
Architects' perspective. 251–258

ARTISTS MENTIONED (their pictures, when illustrated, are shewn in brackets)—
 Agatharchus, 216
 Aldegrever, 240
 Altdorfer, 240
 Angelico, Fra, 218
 Apelles, 217
 Apollodorus, 217
 Baldinucci, 226
 Beccafumi, 223
 Bellotto, 232
 Berchem, Nicholas, 230
 Bril, Paul, 228
 Brooking, 242
 Burghmair, 240
 Canaletto, 232 (illus. p. 229)
 Caravaggio, 26, 228
 Castagno, Andrea, 222
 Cimabue, 218
 Claude, 224, 226, 228
 Cole, George (illus. pp. 25, 126, 162)
 Cole, Vicat, R.A. (illus. pp. 43, 131)
 Constable, 237

ARTISTS MENTIONED—
 Cooke, E. W. (illus. p. 41)
 Cotman, 237
 Credi (illus. p. 129)
 Cristoforo, 224
 Degas, 233
 Duccio, 218
 Duncan, E. (illus. p. 207)
 Dürer, 223, 240
 Etty, 237
 Euphranor, 217
 Eupomus, 217
 Eyck, Jan van, 223 (illus p. 27)
 Fuseli, 216
 Gainsborough, 237
 Ghirlandaio, Domenico, 222
 Giorgione, 223
 Giotto, 218
 Giovanni, Bellini, 223
 Guardi, 232 (illus. p. 39)
 Hals, Frans, 224
 Hills, R. (illus. p. 130)
 Hishigawa Moronobu, 246
 Hobbema, 232
 Hogarth, 233, 234 (illus. p. 235)
 Holbein, 240
 Holland, James, 236
 Hollar, W., 241
 Hooge, P. de, 232 (illus. p. 35)
 Jordaens, Hans, 230 (illus. p. 61)
 Keion, Sumiyoshi, 244
 Kirby, 234
 Kiyonobu, 246
 Kokan, Shiba, 246
 Koriusai, 246 (illus. p. 248)
 Leonardo da Vinci, 26, 220, 223
 Leyden, L. van, 240
 Lippi, Filippino, 223
 Loutherbourg, P. J. de, 242
 Luny, Thomas, 242
 Malton, Thomas, 236
 Manet, 233
 Mantegna, Andrea, 223
 Maratti (illus. 129)

275

A CATALOGUE OF SELECTED DOVER BOOKS
IN ALL FIELDS OF INTEREST

A CATALOGUE OF SELECTED DOVER
BOOKS IN ALL FIELDS OF INTEREST

RACKHAM'S COLOR ILLUSTRATIONS FOR WAGNER'S RING. Rackham's finest mature work—all 64 full-color watercolors in a faithful and lush interpretation of the *Ring*. Full-sized plates on coated stock of the paintings used by opera companies for authentic staging of Wagner. Captions aid in following complete Ring cycle. Introduction. 64 illustrations plus vignettes. 72pp. 8⅝ x 11¼. 23779-6 Pa. $6.00

CONTEMPORARY POLISH POSTERS IN FULL COLOR, edited by Joseph Czestochowski. 46 full-color examples of brilliant school of Polish graphic design, selected from world's first museum (near Warsaw) dedicated to poster art. Posters on circuses, films, plays, concerts all show cosmopolitan influences, free imagination. Introduction. 48pp. 9⅜ x 12¼.
23780-X Pa. $6.00

GRAPHIC WORKS OF EDVARD MUNCH, Edvard Munch. 90 haunting, evocative prints by first major Expressionist artist and one of the greatest graphic artists of his time: *The Scream, Anxiety, Death Chamber, The Kiss, Madonna,* etc. Introduction by Alfred Werner. 90pp. 9 x 12.
23765-6 Pa. $5.00

THE GOLDEN AGE OF THE POSTER, Hayward and Blanche Cirker. 70 extraordinary posters in full colors, from Maitres de l'Affiche, Mucha, Lautrec, Bradley, Cheret, Beardsley, many others. Total of 78pp. 9⅜ x 12¼. 22753-7 Pa. $5.95

THE NOTEBOOKS OF LEONARDO DA VINCI, edited by J. P. Richter. Extracts from manuscripts reveal great genius; on painting, sculpture, anatomy, sciences, geography, etc. Both Italian and English. 186 ms. pages reproduced, plus 500 additional drawings, including studies for *Last Supper,* Sforza monument, etc. 860pp. 7⅞ x 10¾. (Available in U.S. only)
22572-0, 22573-9 Pa., Two-vol. set $15.90

THE CODEX NUTTALL, as first edited by Zelia Nuttall. Only inexpensive edition, in full color, of a pre-Columbian Mexican (Mixtec) book. 88 color plates show kings, gods, heroes, temples, sacrifices. New explanatory, historical introduction by Arthur G. Miller. 96pp. 11⅜ x 8½. (Available in U.S. only) 23168-2 Pa. $7.50

UNE SEMAINE DE BONTÉ, A SURREALISTIC NOVEL IN COLLAGE, Max Ernst. Masterpiece created out of 19th-century periodical illustrations, explores worlds of terror and surprise. Some consider this Ernst's greatest work. 208pp. 8⅛ x 11. 23252-2 Pa. $5.00

CATALOGUE OF DOVER BOOKS

TONE POEMS, SERIES II: TILL EULENSPIEGELS LUSTIGE STREICHE, ALSO SPRACH ZARATHUSTRA, AND EIN HELDEN-LEBEN, Richard Strauss. Three important orchestral works, including very popular *Till Eulenspiegel's Marry Pranks*, reproduced in full score from original editions. Study score. 315pp. 9⅜ x 12¼. (Available in U.S. only) 23755-9 Pa. $7.50

TONE POEMS, SERIES I: DON JUAN, TOD UND VERKLARUNG AND DON QUIXOTE, Richard Strauss. Three of the most often performed and recorded works in entire orchestral repertoire, reproduced in full score from original editions. Study score. 286pp. 9⅜ x 12¼. (Available in U.S. only) 23754-0 Pa. $7.50

11 LATE STRING QUARTETS, Franz Joseph Haydn. The form which Haydn defined and "brought to perfection." (*Grove's*). 11 string quartets in complete score, his last and his best. The first in a projected series of the complete Haydn string quartets. Reliable modern Eulenberg edition, otherwise difficult to obtain. 320pp. 8⅜ x 11¼. (Available in U.S. only) 23753-2 Pa. $6.95

FOURTH, FIFTH AND SIXTH SYMPHONIES IN FULL SCORE, Peter Ilyitch Tchaikovsky. Complete orchestral scores of Symphony No. 4 in F Minor, Op. 36; Symphony No. 5 in E Minor, Op. 64; Symphony No. 6 in B Minor, "Pathetique," Op. 74. Bretikopf & Hartel eds. Study score. 480pp. 9⅜ x 12¼. 23861-X Pa. $10.95

THE MARRIAGE OF FIGARO: COMPLETE SCORE, Wolfgang A. Mozart. Finest comic opera ever written. Full score, not to be confused with piano renderings. Peters edition. Study score. 448pp. 9⅜ x 12¼. (Available in U.S. only) 23751-6 Pa. $11.95

"IMAGE" ON THE ART AND EVOLUTION OF THE FILM, edited by Marshall Deutelbaum. Pioneering book brings together for first time 38 groundbreaking articles on early silent films from *Image* and 263 illustrations newly shot from rare prints in the collection of the International Museum of Photography. A landmark work. Index. 256pp. 8¼ x 11. 23777-X Pa. $8.95

AROUND-THE-WORLD COOKY BOOK, Lois Lintner Sumption and Marguerite Lintner Ashbrook. 373 cooky and frosting recipes from 28 countries (America, Austria, China, Russia, Italy, etc.) include Viennese kisses, rice wafers, London strips, lady fingers, hony, sugar spice, maple cookies, etc. Clear instructions. All tested. 38 drawings. 182pp. 5⅜ x 8. 23802-4 Pa. $2.50

THE ART NOUVEAU STYLE, edited by Roberta Waddell. 579 rare photographs, not available elsewhere, of works in jewelry, metalwork, glass, ceramics, textiles, architecture and furniture by 175 artists—Mucha, Seguy, Lalique, Tiffany, Gaudin, Hohlwein, Saarinen, and many others. 288pp. 8⅜ x 11¼. 23515-7 Pa. $6.95

THE PHILOSOPHY OF HISTORY, Georg W. Hegel. Great classic of Western thought develops concept that history is not chance but a rational process, the evolution of freedom. 457pp. 5⅜ x 8½. 20112-0 Pa. $4.50

LANGUAGE, TRUTH AND LOGIC, Alfred J. Ayer. Famous, clear introduction to Vienna, Cambridge schools of Logical Positivism. Role of philosophy, elimination of metaphysics, nature of analysis, etc. 160pp. 5⅜ x 8½. (Available in U.S. only) 20010-8 Pa. $1.75

A PREFACE TO LOGIC, Morris R. Cohen. Great City College teacher in renowned, easily followed exposition of formal logic, probability, values, logic and world order and similar topics; no previous background needed. 209pp. 5⅜ x 8½. 23517-3 Pa. $3.50

REASON AND NATURE, Morris R. Cohen. Brilliant analysis of reason and its multitudinous ramifications by charismatic teacher. Interdisciplinary, synthesizing work widely praised when it first appeared in 1931. Second (1953) edition. Indexes. 496pp. 5⅜ x 8½. 23633-1 Pa. $6.00

AN ESSAY CONCERNING HUMAN UNDERSTANDING, John Locke. The only complete edition of enormously important classic, with authoritative editorial material by A. C. Fraser. Total of 1176pp. 5⅜ x 8½.
20530-4, 20531-2 Pa., Two-vol. set $14.00

HANDBOOK OF MATHEMATICAL FUNCTIONS WITH FORMULAS, GRAPHS, AND MATHEMATICAL TABLES, edited by Milton Abramowitz and Irene A. Stegun. Vast compendium: 29 sets of tables, some to as high as 20 places. 1,046pp. 8 x 10½. 61272-4 Pa. $12.50

MATHEMATICS FOR THE PHYSICAL SCIENCES, Herbert S. Wilf. Highly acclaimed work offers clear presentations of vector spaces and matrices, orthogonal functions, roots of polynomial equations, conformal mapping, calculus of variations, etc. Knowledge of theory of functions of real and complex variables is assumed. Exercises and solutions. Index. 284pp. 5⅝ x 8¼. 63635-6 Pa. $4.50

THE PRINCIPLE OF RELATIVITY, Albert Einstein et al. Eleven most important original papers on special and general theories. Seven by Einstein, two by Lorentz, one each by Minkowski and Weyl. All translated, unabridged. 216pp. 5⅜ x 8½. 60081-5 Pa. $3.00

THERMODYNAMICS, Enrico Fermi. A classic of modern science. Clear, organized treatment of systems, first and second laws, entropy, thermodynamic potentials, gaseous reactions, dilute solutions, entropy constant. No math beyond calculus required. Problems. 160pp. 5⅜ x 8½.
60361-X Pa. $2.75

ELEMENTARY MECHANICS OF FLUIDS, Hunter Rouse. Classic undergraduate text widely considered to be far better than many later books. Ranges from fluid velocity and acceleration to role of compressibility in fluid motion. Numerous examples, questions, problems. 224 illustrations. 376pp. 5⅝ x 8¼. 63699-2 Pa. $5.00

THE EARLY WORK OF AUBREY BEARDSLEY, Aubrey Beardsley. 157 plates, 2 in color: *Manon Lescaut, Madame Bovary, Morte Darthur, Salome,* other. Introduction by H. Marillier. 182pp. 8⅛ x 11. 21816-3 Pa. $4.50

THE LATER WORK OF AUBREY BEARDSLEY, Aubrey Beardsley. Exotic masterpieces of full maturity: *Venus and Tannhauser, Lysistrata, Rape of the Lock, Volpone,* Savoy material, etc. 174 plates, 2 in color. 186pp. 8⅛ x 11. 21817-1 Pa. $4.50

THOMAS NAST'S CHRISTMAS DRAWINGS, Thomas Nast. Almost all Christmas drawings by creator of image of Santa Claus as we know it, and one of America's foremost illustrators and political cartoonists. 66 illustrations. 3 illustrations in color on covers. 96pp. 8⅜ x 11¼. 23660-9 Pa. $3.50

THE DORÉ ILLUSTRATIONS FOR DANTE'S DIVINE COMEDY, Gustave Doré. All 135 plates from Inferno, Purgatory, Paradise; fantastic tortures, infernal landscapes, celestial wonders. Each plate with appropriate (translated) verses. 141pp. 9 x 12. 23231-X Pa. $4.50

DORÉ'S ILLUSTRATIONS FOR RABELAIS, Gustave Doré. 252 striking illustrations of *Gargantua and Pantagruel* books by foremost 19th-century illustrator. Including 60 plates, 192 delightful smaller illustrations. 153pp. 9 x 12. 23656-0 Pa. $5.00

LONDON: A PILGRIMAGE, Gustave Doré, Blanchard Jerrold. Squalor, riches, misery, beauty of mid-Victorian metropolis; 55 wonderful plates, 125 other illustrations, full social, cultural text by Jerrold. 191pp. of text. 9⅜ x 12¼. 22306-X Pa. $6.00

THE RIME OF THE ANCIENT MARINER, Gustave Doré, S. T. Coleridge. Dore's finest work, 34 plates capture moods, subtleties of poem. Full text. Introduction by Millicent Rose. 77pp. 9¼ x 12. 22305-1 Pa. $3.00

THE DORE BIBLE ILLUSTRATIONS, Gustave Doré. All wonderful, detailed plates: Adam and Eve, Flood, Babylon, Life of Jesus, etc. Brief King James text with each plate. Introduction by Millicent Rose. 241 plates. 241pp. 9 x 12. 23004-X Pa. $5.00

THE COMPLETE ENGRAVINGS, ETCHINGS AND DRYPOINTS OF ALBRECHT DURER. "Knight, Death and Devil"; "Melencolia," and more—all Dürer's known works in all three media, including 6 works formerly attributed to him. 120 plates. 235pp. 8⅜ x 11¼. 22851-7 Pa. $6.50

MAXIMILIAN'S TRIUMPHAL ARCH, Albrecht Dürer and others. Incredible monument of woodcut art: 8 foot high elaborate arch—heraldic figures, humans, battle scenes, fantastic elements—that you can assemble yourself. Printed on one side, layout for assembly. 143pp. 11 x 16. 21451-6 Pa. $5.00

THE COMPLETE WOODCUTS OF ALBRECHT DURER, edited by Dr. W. Kurth. 346 in all: "Old Testament," "St. Jerome," "Passion," "Life of Virgin," Apocalypse," many others. Introduction by Campbell Dodgson. 285pp. 8½ x 12¼. 21097-9 Pa. $6.95

DRAWINGS OF ALBRECHT DURER, edited by Heinrich Wolfflin. 81 plates show development from youth to full style. Many favorites; many new. Introduction by Alfred Werner. 96pp. 8⅛ x 11. 22352-3 Pa. $4.00

THE HUMAN FIGURE, Albrecht Dürer. Experiments in various techniques—stereometric, progressive proportional, and others. Also life studies that rank among finest ever done. Complete reprinting of Dresden Sketchbook. 170 plates. 355pp. 8⅜ x 11¼. 21042-1 Pa. $6.95

OF THE JUST SHAPING OF LETTERS, Albrecht Dürer. Renaissance artist explains design of Roman majuscules by geometry, also Gothic lower and capitals. Grolier Club edition. 43pp. 7⅞ x 10¾ 21306-4 Pa. $2.50

TEN BOOKS ON ARCHITECTURE, Vitruvius. The most important book ever written on architecture. Early Roman aesthetics, technology, classical orders, site selection, all other aspects. Stands behind everything since. Morgan translation. 331pp. 5⅜ x 8½. 20645-9 Pa. $3.75

THE FOUR BOOKS OF ARCHITECTURE, Andrea Palladio. 16th-century classic responsible for Palladian movement and style. Covers classical architectural remains, Renaissance revivals, classical orders, etc. 1738 Ware English edition. Introduction by A. Placzek. 216 plates. 110pp. of text. 9½ x 12¾. 21308-0 Pa. $7.50

HORIZONS, Norman Bel Geddes. Great industrialist stage designer, "father of streamlining," on application of aesthetics to transportation, amusement, architecture, etc. 1932 prophetic account; function, theory, specific projects. 222 illustrations. 312pp. 7⅞ x 10¾. 23514-9 Pa. $6.95

FRANK LLOYD WRIGHT'S FALLINGWATER, Donald Hoffmann. Full, illustrated story of conception and building of Wright's masterwork at Bear Run, Pa. 100 photographs of site, construction, and details of completed structure. 112pp. 9¼ x 10. 23671-4 Pa. $5.00

THE ELEMENTS OF DRAWING, John Ruskin. Timeless classic by great Viltorian; starts with basic ideas, works through more difficult. Many practical exercises. 48 illustrations. Introduction by Lawrence Campbell. 228pp. 5⅜ x 8½. 22730-8 Pa. $2.75

GIST OF ART, John Sloan. Greatest modern American teacher, Art Students League, offers innumerable hints, instructions, guided comments to help you in painting. Not a formal course. 46 illustrations. Introduction by Helen Sloan. 200pp. 5⅜ x 8½. 23435-5 Pa. $3.50

DRAWINGS OF WILLIAM BLAKE, William Blake. 92 plates from Book of Job, *Divine Comedy, Paradise Lost,* visionary heads, mythological figures, Laocoon, etc. Selection, introduction, commentary by Sir Geoffrey Keynes. 178pp. 8⅛ x 11. 22303-5 Pa. $4.00

ENGRAVINGS OF HOGARTH, William Hogarth. 101 of Hogarth's greatest works: *Rake's Progress, Harlot's Progress, Illustrations for Hudibras, Before and After, Beer Street and Gin Lane,* many more. Full commentary. 256pp. 11 x 13¾. 22479-1 Pa. $7.95

DAUMIER: 120 GREAT LITHOGRAPHS, Honore Daumier. Wide-ranging collection of lithographs by the greatest caricaturist of the 19th century. Concentrates on eternally popular series on lawyers, on married life, on liberated women, etc. Selection, introduction, and notes on plates by Charles F. Ramus. Total of 158pp. 9⅜ x 12¼. 23512-2 Pa. $5.50

DRAWINGS OF MUCHA, Alphonse Maria Mucha. Work reveals draftsman of highest caliber: studies for famous posters and paintings, renderings for book illustrations and ads, etc. 70 works, 9 in color; including 6 items not drawings. Introduction. List of illustrations. 72pp. 9⅜ x 12¼. (Available in U.S. only) 23672-2 Pa. $4.00

GIOVANNI BATTISTA PIRANESI: DRAWINGS IN THE PIERPONT MORGAN LIBRARY, Giovanni Battista Piranesi. For first time ever all of Morgan Library's collection, world's largest. 167 illustrations of rare Piranesi drawings—archeological, architectural, decorative and visionary. Essay, detailed list of drawings, chronology, captions. Edited by Felice Stampfle. 144pp. 9⅜ x 12¼. 23714-1 Pa. $7.50

NEW YORK ETCHINGS (1905-1949), John Sloan. All of important American artist's N.Y. life etchings. 67 works include some of his best art; also lively historical record—Greenwich Village, tenement scenes. Edited by Sloan's widow. Introduction and captions. 79pp. 8⅜ x 11¼. 23651-X Pa. $4.00

CHINESE PAINTING AND CALLIGRAPHY: A PICTORIAL SURVEY, Wan-go Weng. 69 fine examples from John M. Crawford's matchless private collection: landscapes, birds, flowers, human figures, etc., plus calligraphy. Every basic form included: hanging scrolls, handscrolls, album leaves, fans, etc. 109 illustrations. Introduction. Captions. 192pp. 8⅞ x 11¾. 23707-9 Pa. $7.95

DRAWINGS OF REMBRANDT, edited by Seymour Slive. Updated Lippmann, Hofstede de Groot edition, with definitive scholarly apparatus. All portraits, biblical sketches, landscapes, nudes, Oriental figures, classical studies, together with selection of work by followers. 550 illustrations. Total of 630pp. 9⅛ x 12¼. 21485-0, 21486-9 Pa., Two-vol. set $14.00

THE DISASTERS OF WAR, Francisco Goya. 83 etchings record horrors of Napoleonic wars in Spain and war in general. Reprint of 1st edition, plus 3 additional plates. Introduction by Philip Hofer. 97pp. 9⅜ x 8¼. 21872-4 Pa. $3.75

ART FORMS IN NATURE, Ernst Haeckel. Multitude of strangely beautiful natural forms: Radiolaria, Foraminifera, jellyfishes, fungi, turtles, bats, etc. All 100 plates of the 19th-century evolutionist's *Kunstformen der Natur* (1904). 100pp. 9⅜ x 12¼. 22987-4 Pa. $4.50

CHILDREN: A PICTORIAL ARCHIVE FROM NINETEENTH-CENTURY SOURCES, edited by Carol Belanger Grafton. 242 rare, copyright-free wood engravings for artists and designers. Widest such selection available. All illustrations in line. 119pp. 8⅜ x 11¼.
23694-3 Pa. $3.50

WOMEN: A PICTORIAL ARCHIVE FROM NINETEENTH-CENTURY SOURCES, edited by Jim Harter. 391 copyright-free wood engravings for artists and designers selected from rare periodicals. Most extensive such collection available. All illustrations in line. 128pp. 9 x 12.
23703-6 Pa. $4.00

ARABIC ART IN COLOR, Prisse d'Avennes. From the greatest ornamentalists of all time—50 plates in color, rarely seen outside the Near East, rich in suggestion and stimulus. Includes 4 plates on covers. 46pp. 9⅜ x 12¼. 23658-7 Pa. $6.00

AUTHENTIC ALGERIAN CARPET DESIGNS AND MOTIFS, edited by June Beveridge. Algerian carpets are world famous. Dozens of geometrical motifs are charted on grids, color-coded, for weavers, needleworkers, craftsmen, designers. 53 illustrations plus 4 in color. 48pp. 8¼ x 11. (Available in U.S. only) 23650-1 Pa. $1.75

DICTIONARY OF AMERICAN PORTRAITS, edited by Hayward and Blanche Cirker. 4000 important Americans, earliest times to 1905, mostly in clear line. Politicians, writers, soldiers, scientists, inventors, industrialists, Indians, Blacks, women, outlaws, etc. Identificatory information. 756pp. 9¼ x 12¾. 21823-6 Clothbd. $40.00

HOW THE OTHER HALF LIVES, Jacob A. Riis. Journalistic record of filth, degradation, upward drive in New York immigrant slums, shops, around 1900. New edition includes 100 original Riis photos, monuments of early photography. 233pp. 10 x 7⅞. 22012-5 Pa. $6.00

NEW YORK IN THE THIRTIES, Berenice Abbott. Noted photographer's fascinating study of city shows new buildings that have become famous and old sights that have disappeared forever. Insightful commentary. 97 photographs. 97pp. 11⅜ x 10. 22967-X Pa. $4.50

MEN AT WORK, Lewis W. Hine. Famous photographic studies of construction workers, railroad men, factory workers and coal miners. New supplement of 18 photos on Empire State building construction. New introduction by Jonathan L. Doherty. Total of 69 photos. 63pp. 8 x 10¾.
23475-4 Pa. $3.00

GEOMETRY, RELATIVITY AND THE FOURTH DIMENSION, Rudolf Rucker. Exposition of fourth dimension, means of visualization, concepts of relativity as Flatland characters continue adventures. Popular, easily followed yet accurate, profound. 141 illustrations. 133pp. 5⅜ x 8½.
23400-2 Pa. $2.75

THE ORIGIN OF LIFE, A. I. Oparin. Modern classic in biochemistry, the first rigorous examination of possible evolution of life from nitrocarbon compounds. Non-technical, easily followed. Total of 295pp. 5⅜ x 8½.
60213-3 Pa. $4.00

THE CURVES OF LIFE, Theodore A. Cook. Examination of shells, leaves, horns, human body, art, etc., in "the classic reference on how the golden ratio applies to spirals and helices in nature "—Martin Gardner. 426 illustrations. Total of 512pp. 5⅜ x 8½. 23701-X Pa. $5.95

PLANETS, STARS AND GALAXIES, A. E. Fanning. Comprehensive introductory survey: the sun, solar system, stars, galaxies, universe, cosmology; quasars, radio stars, etc. 24pp. of photographs. 189pp. 5⅜ x 8½. (Available in U.S. only) 21680-2 Pa. $3.00

THE THIRTEEN BOOKS OF EUCLID'S ELEMENTS, translated with introduction and commentary by Sir Thomas L. Heath. Definitive edition. Textual and linguistic notes, mathematical analysis, 2500 years of critical commentary. Do not confuse with abridged school editions. Total of 1414pp. 5⅜ x 8½. 60088-2, 60089-0, 60090-4 Pa., Three-vol. set $18.00

DIALOGUES CONCERNING TWO NEW SCIENCES, Galileo Galilei. Encompassing 30 years of experiment and thought, these dialogues deal with geometric demonstrations of fracture of solid bodies, cohesion, leverage, speed of light and sound, pendulums, falling bodies, accelerated motion, etc. 300pp. 5⅜ x 8½. 60099-8 Pa. $4.00

Prices subject to change without notice.

Available at your book dealer or write for free catalogue to Dept. GI, Dover Publications, Inc., 180 Varick St., N.Y., N.Y. 10014. Dover publishes more than 175 books each year on science, elementary and advanced mathematics, biology, music, art, literary history, social sciences and other areas.